THE **ART LOVERS'** GUIDE
LONDON

SAM PHILLIPS

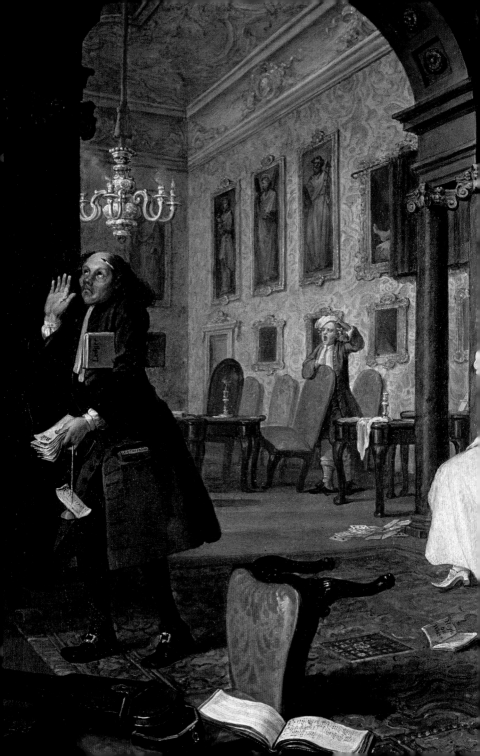

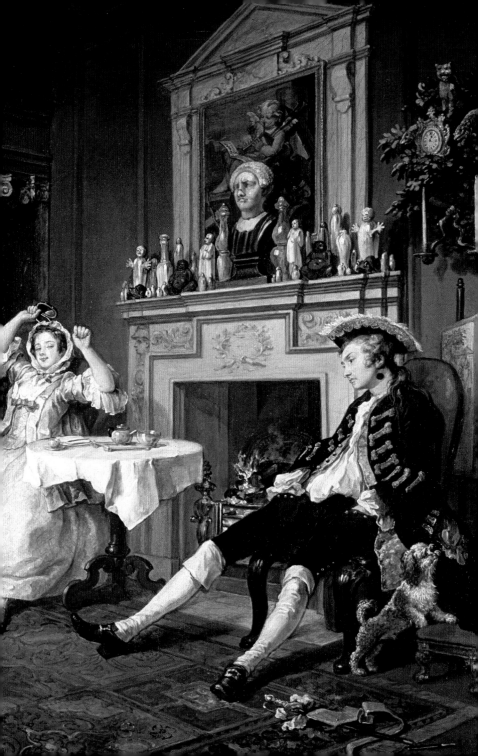

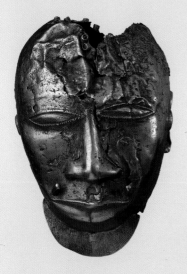

MODERN ART

REFERENCE SECTION

London's status as a world city stems not just from its global influence but also from the sense that within its boundaries the whole world is represented, from the diversity of the city's inhabitants to the cosmopolitan character of its culture. Its museums and galleries, just like its theatre and music venues, are dedicated to this openness and internationalism, and can reflect the richness of world art, not just the concerns and tastes of British artists and collectors.

In that spirit, this guide to London's art collections aims for something wider and more ambitious than a list of locations: it attempts an accessible history of Western art, shaped by the works one can see in the city. Each of the main chapters covers a different genre, in chronological order, starting with the ancient objects of the Mesopotamians and Egyptians and moving gradually all the way to modern and contemporary art. Two Artist in Focus chapters concentrate on arguably the two most important British artists: JMW Turner and Francis Bacon.

The book has been produced as a portable companion to gallery visits, but it also seeks a place by your bed or on your bookshelf. Even the most ardent appreciators of art will find it hard to visit every venue within these pages, but this does not mean those pages are redundant: they can be read independently of any visit, by anyone keen to fill in the gaps in their knowledge of art history.

This history, however, like any other, can only give a partial and particular view. It focuses on those artists and artworks one can find in London as opposed to any other city. Read the companion guide to New York and a different story of art will be told, because the Big Apple's collections differ in many important respects from those in London. Both the strengths and limitations of London's art collections are reflected in the book, demonstrating another of the many ways in which the story of art can be told, this time as a reflection of the particular nature of a city's cultural investment.

Wherever possible the book focuses on artists who are established in the acknowledged canon of Western art, but there are some, such as the enfant terrible of modern Austrian art Egon Schiele, whose paintings are missing from London's public collections. The city also inevitably has more high-quality works from American and European artists than those of other continents and, in turn, more from British artists than other nationals. Frenchman Jacques-Louis David has just as important a place in the European Neoclassical tradition as British painter Joshua Reynolds, but it is Reynolds whose works predominate in London and, therefore, his painting that commands more focus in this book.

The works in the main sections of each chapter, which focus on a particular gallery, are not written about in the order in which they are hung in that gallery. Pieces often move around, rendering overly detailed gallery directions obsolete, so the priority has been to make meaningful narrative links between different artworks and art movements in a collection rather than slavishly moving from room to room in a set trajectory.

On occasion works mentioned may not be on display at a venue when a reader visits, as they are either undergoing restoration or out on loan to a temporary exhibition. Although this is always disappointing, it gives the opportunity to see another, maybe less well-known work that has been put in its place. This reminds us that the story told in this guide is only one story, and only one place to start. On every new visit a different work on view can find a place in the heart of the art lover, helping to sustain a lasting infatuation for London's world-class art collections.

AS A HISTORY OF ART

Read through this book from beginning to end to gain a complete chronological overview of the history of art. If you like art and wish to learn more, the guide offers an accessible, fully illustrated introduction to periods, movements, artists and masterpieces, with no prior knowledge assumed.

BY GENRE

The book is divided into three volumes – Early Art, The Western Tradition and Modern Art – and a reference section, and most chapters within each volume cover a different period or style of art, with two dedicated to a single British artist. Access the content that interests you the most, whether it is Greek and Roman art or Impressionism. After an introduction that sets the scene for each chapter there is a main section on the key collection where the type of art being covered is represented, followed by a See Also section – a round-up of other relevant venues and works to see in the city. An exception is the final chapter on public art, where there is only one, admittedly expansive venue: the streets and public spaces of London.

AS AN IN-DEPTH GALLERY GUIDE

For every period or style of art, there is one location in London that stands out above the rest. This book surveys at length and in detail the key collection to visit for each genre, revealing which works to see and explaining why they changed the face of art. Several major pieces from the collection are illustrated with extended captions.

AS A SURVEY OF ALL PUBLIC COLLECTIONS OF GENRE OR PERIOD OF ART

After the in-depth guide to a single major collection, each chapter includes an illustrated section entitled See Also, which recommends other galleries and works that will expand one's knowledge of the subject area. Enjoy the in-depth guide in the morning and use the See Also section in the afternoon to show you some of the city's hidden gems, many of which are overlooked by both tourists and long-time Londoners.

BY LOCATION

You can find out the locations of all the collections on the user-friendly maps at the back of the book. These are organised to allow you to tour some of the galleries nearby with the minimum of time wasted in transit.

BY ARTIST

This history of art is also a history of artists. If you want to know where to see your favourites, flick to the Index of Artists at the back of the book. Some artists, such as Picasso, are featured across more than one chapter.

BY GALLERY

Most of London's major galleries specialise in more than one period of art. If you only have time to visit one gallery, this book can help you make the most of your visit, revealing different highlights on view across different genres. Using the Index of Museums & Galleries in the reference section at the back of the book, one can quickly move to the relevant pages for each gallery.

EARLY ART

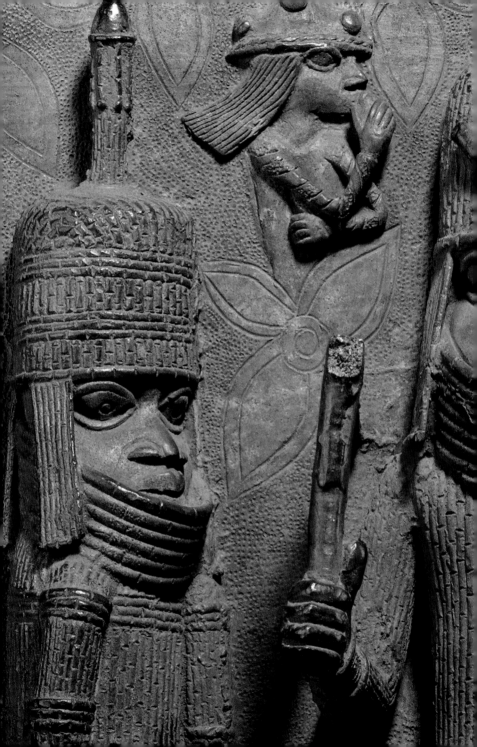

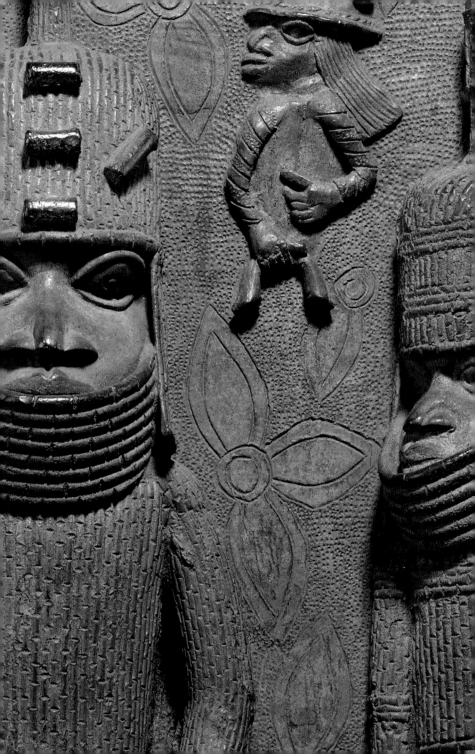

EGYPTIAN, MIDDLE EASTERN & ISLAMIC ART

Slap-bang in the centre of the city, rising up over the river between Waterloo and Hungerford bridges, is one of London's most curious landmarks, more fitting to flank the Nile than the Thames. Cleopatra's Needle is a giant granite obelisk that dates to the golden age of Pharaoh Thutmose III (1493–1479 BC), the expansionist Egyptian ruler who conquered most of what is now Israel, Lebanon, Syria and Sudan. Two centuries later, the 20-metre-high spire was inscribed with hieroglyphs to extol the military victories of Ramesses II and, in 12 BC, was one of a pair moved from Heliopolis to the Caesareum in Alexandria, the temple that had been built by Cleopatra in honour of her ally and father to her children, the Roman general Mark Antony.

However surreal it is to see an ancient Egyptian monument set today on Victoria Embankment, its location also represents something fundamental about London. Cleopatra's Needle was a gift from Egypt, given in 1819 to commemorate British victories over France in the Battles of Alexandria and the Nile; it does not just speak of Egyptian antiquity, but symbolises London's international influence over the centuries. Military muscle, consolidated with cultural expansionism and exchange, has helped establish the city as a world as well as national capital, and is one of the reasons it now houses so many international works of art and antiquity.

The obelisk also reminds us of London's exemplary scholarship when it comes to understanding the past. The city's fascination with all things pharaonic has been nurtured by the **BRITISH MUSEUM**, founded in 1753 as the first national public museum in the world. After the British victories, the museum's Egyptian collections expanded apace, boosted by confiscations from the French and later excavations by the British consul-general in Cairo, Henry Salt. Its biggest draw is the Rosetta Stone (196 BC), an inscribed rock that allowed 19th-century scholars to understand Egyptian hieroglyphs – and thus Egyptian society – for the first time. The world-renowned museum is now one of the most popular attractions in the country and, with roughly 7 million objects in its collections, remains an essential port of call for anyone with an interest in ancient history and culture.

The museum's earliest works of art tend to date to around 12,500 years ago and include engravings by hunter-gatherers in bone and rock.

Artists gained status with the rise of more densely populated city-states in Mesopotamia, the area between the rivers Tigris and Euphrates largely corresponding to Iraq, from approximately the sixth millennium BC. City-states became expansive empires and a succession of peoples took turns to dominate the region over the next five millennia – from the Sumerians, Assyrians, Babylonians and Persians to the Greeks, Romans and Arabs – each bringing distinct artistic developments.

Cleopatra's Needle
1493–1479 BC
VICTORIA EMBANKMENT

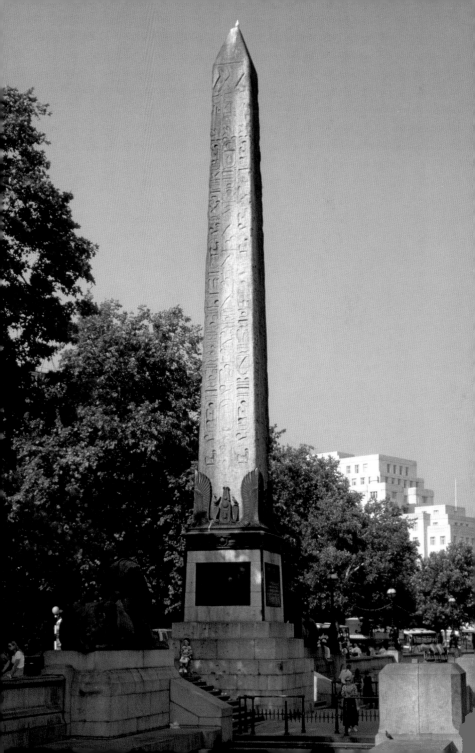

The collections of Egyptian antiquities are separated over two floors of the British Museum. The most spectacular works, including statues, sarcophagi and the Rosetta Stone, are spread over three large, conjoined spaces to the west of the Great Court, the museum's magnificent internal courtyard. These are given context by displays upstairs of funerary objects, papyri, pottery, jewellery and other smaller artefacts.

A selection of ceramics from Egypt's pre-dynastic period (before its unification under the first Pharaoh in 3100 BC) reveals the centrality for the Egyptians of the River Nile, which provided irrigation and bound communities around an essential transport artery. For instance, on a pink clay pot from this period a boat is represented in hatched marks of red-ochre dye, with waved lines at the top of the pot hinting at the movement of water.

The museum's collections focus in depth, however, on the pharaonic rule that followed, revealing its giant leaps forward in social, technological and cultural achievement. What becomes clear is that Egypt's burgeoning artistic accomplishment was soon regulated by a fixed set of pictorial rules, features that remained characteristic of art from the fourth dynasty (c 2575–2467 BC) – the age of the Pyramids, from one of which the museum hosts a rare building block – until Greek and Roman rule. This consistency for more than 2,000 years was more than a question of taste: it was a matter of life and death or, more specifically, afterlife and death.

The vast majority of the works on view were previously enclosed in the tombs of rulers and other wealthy individuals. The Pharaohs believed that preservation through mummification could not alone ensure passage to the afterlife; the spirits of the dead would remain alive and well by dwelling in images, as long as standards of artistry were met.

The paintings and reliefs therefore depict subjects in a combination of multiple perspectives, as one perspective was not deemed sufficient for a representation soon to house a spirit. Egyptians are shown with head and legs in profile, but shoulders and chest straight on, to do justice to the whole of the human form. Other rules one can discern are the use of horizontal and vertical axes to order the action, and the alliance of image and hieroglyphic text.

The 11 wall fragments from the tomb-chapel of Nebamun, a wealthy accountant of the 18th dynasty (c 1550–1292 BC), are the finest Egyptian paintings in the museum and are pinnacles of the civilisation's artistry. To ensure an ideal afterlife for the dead, tomb art avoided any vision of ugliness, decay or imperfection, and the most impressive of the wall paintings shows a paradise-like pastoral scene with Nebamun hunting birds in the marshes with his wife and daughter. The unified composition of disparate elements here and the exquisite detailing of the wildlife are lifted further by vivid colour tones working in harmony across the pictorial area. The Egyptian eye for colour can also be seen on funerary objects; look for example, at the kaleidoscopic cartonnage case that enclosed the priest Nesperennub from the 22nd dynasty (c 943–720 BC).

Colossal bust of Ramesses II, the 'Younger Memnon'
19th dynasty (Egypt),
c 1250 BC
This seven-tonne statue was one of the first Egyptian objects considered a work of art in the eyes of 19th-century commentators, including poet Percy Shelley who took it as the inspiration for his famous sonnet *Ozymandias*. The two-coloured granite is exploited to dazzling effect, with the lighter tone framing the head.

Nebamun hunting in the marshes: Fragment of a scene from the tomb-chapel of Nebamun (overleaf)
Late 18th dynasty (Egypt),
c 1350 BC
Fertile marshes were associated with rebirth, making them a perfect subject for tomb paintings intended to provide the dead with an afterlife. The deceased, 'enjoying himself and seeing beauty' in the words of the hieroglyphic caption, is reborn in an Egyptian Eden represented in extraordinary colour and detail.

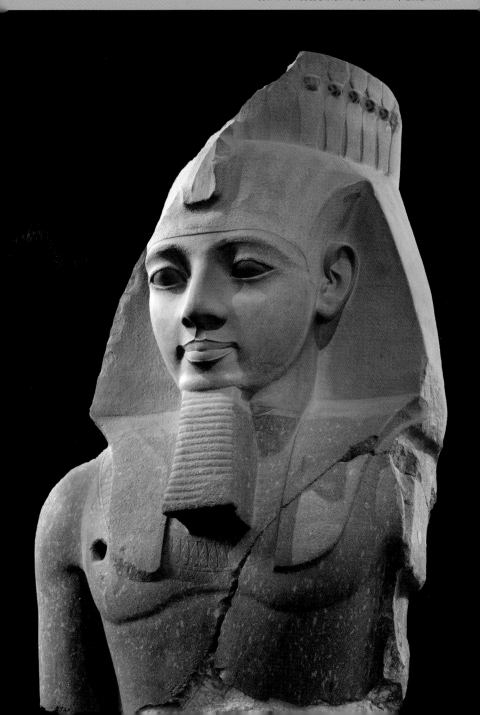

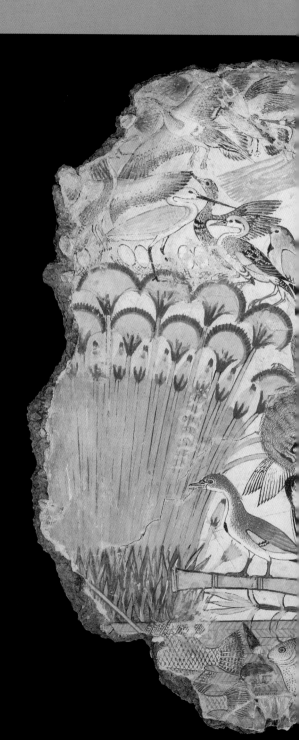

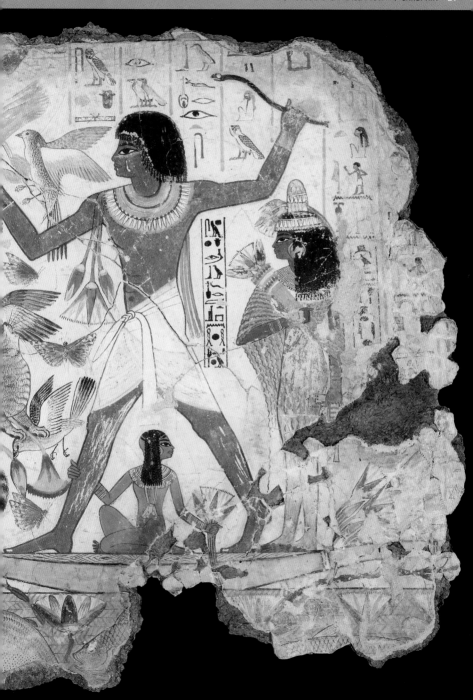

Gold griffin-headed armlet
Achaemenid Persian
(Tadjikistan), 5th–4th
century BC
This bracelet would have
been given as a gift at the
ancient Persian court, with the now-empty spaces
in the precisely carved
griffin figures full of
glass and semi-precious
stones. It is part of the
incomparable Oxus
Treasure of gold and silver.

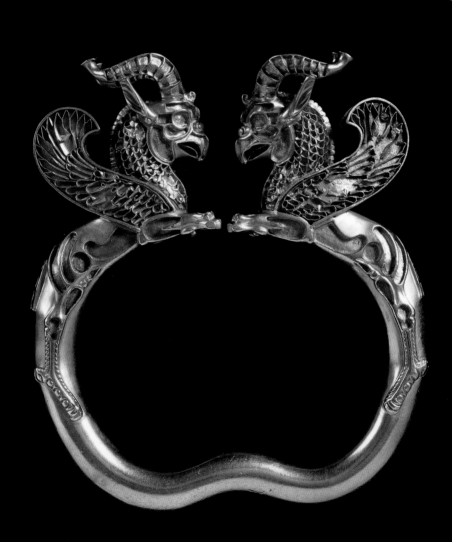

Colossal statue of a winged lion from the North-West Palace of Ashurnasirpal II
Assyrian (Nimrud, northern Iraq), 883–859 BC
The Assyrians believed evil spirits could enter through gateways. Guardians called *lamassu*, sculpted on a huge scale, took up protective positions through palaces. This example is in the hybrid form of a lion, bird and human, epitomising strength, swiftness and intelligence respectively.

The application of a different set of strictures to portrait sculpture achieves a rigid yet serene beauty. Viewpoints are always frontal, handling of the stone impeccably smooth, and poses restricted to a few graceful forms. Some of the most interesting on display are the idiosyncratic block statues, where a seated figure bears a commemorative inscribed slab of stone, or stela; a block statue of the nobleman Sennefer in polished black stone is a sumptuous example. The museum's most jaw-dropping sculptures are the monumental works that were placed in and around temples, such as the colossal bust of Ramesses II taken from his mortuary temple at Thebes in the 19th dynasty (c 1295–1186 BC).

Although the ancient Egyptians have greater fame today, the collections reveal that the Mesopotamians got there earlier in terms of fine art and craft. High-quality Halafware pottery is presented, popular across Northern Iraq and Syria from around 5500 BC for its ornate geometric designs and expert standard of firing.

The museum emphasises that the independent Mesopotamian communities that thrived from this time were united by a common language and culture. This early civilisation, called Sumer in its dialect, gained real momentum from 3500 BC with the rapid expansion of its cities. There are several examples on show of Sumerian cuneiform, the earliest known form of writing made by incisions in clay. The carvings from the period lack the sinuous lines of the Egyptian holdings, but Sumerian art has highpoints, including accomplished inlay works such as the museum's mysterious Standard of Ur (c 2500 BC), a mosaic box made from lapis lazuli, red limestone and shell that represents a war scene

on one side and a peaceful scene of a banquet on the other.

The Assyrian Empire swept in waves across the region during the second and first millennia BC. Some of the most exquisite of its works on display at the museum are inch-high cylinder seals, rolled across clay to claim possession. These imprint more than simple symbols; a particularly fine example in garnet (720–700 BC) renders a complex scene featuring Ishtar, goddess of warfare and sexuality.

This level of craftsmanship is translated to a far larger scale in the ground-floor rooms dedicated to Assyrian narrative reliefs from the palaces at Nimrud and Nineveh, arguably the finest collection of such works outside Iraq. Entry to the rooms is guarded by two immense human-headed, winged lion sculptures that once protected the throne room of Ashurnasirpal II (king of Assyria from 883–859 BC) from malevolent forces.

While the Pharaohs used art to aim for immortality, Assyrian kings had history at heart – the reliefs are dedicated to marking their military triumphs for posterity. The action moves from left to right across the museum's walls, oscillating up and down, chariots charging into battle, arrows raining down on the enemy. Even stripped of the paint that once enlivened them, the reliefs' subtle shifts of the sculptural plain and attention to expression make you feel the strain of every sinew. Some historians have discerned attempts at foreshortened perspective, where elements recede or expand to give the viewer the illusion of greater depth.

The renowned sophistication of Babylon, Assyria's competing sister-state, is affirmed by

Underglaze-painted tiles
Ottoman (Iznik, Turkey),
c 1550
In the superlative ceramics
produced in Iznik during the
16th century, the formal
repetition of Islamic
decorative art is heightened
with an expressive handling
of paint and a lavish colour
palette – fixed to blue,
turquoise, purple, green and
red on a white background.

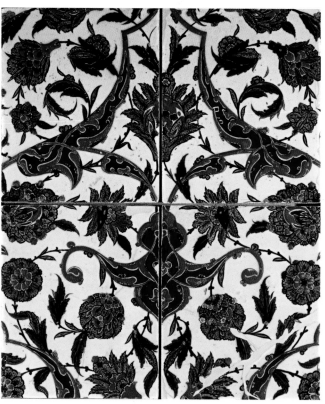

The galleries suggest that there were few places where an indigenous Middle Eastern culture remained in a vacuum; colonisation, migration and trade across the region led to constant artistic fusion. Spaces focusing on the ancient peoples of Turkey, the Levant and Arabia demonstrate this interconnection. Incense burners in the latter space remind us that even the Sabaean kingdom, located in the southeastern deserts of Yemen from the early second millennium, was firmly in the loop with other cultures through its lucrative trade of frankincense and myrrh.

Move forward to the 8th century AD, however, and there were more than camels bearing spices heading north from the Arabian peninsula. As a room dedicated to Islamic art discloses, a hundred years after Muhammad had taken control of Mecca, the Muslim armies of the Umayyad caliphate had swept over the Middle East, North Africa and the Iberian peninsula.

The exhibits reveal that, even across such a vast area, Islamic art developed defined features over the centuries. A key characteristic is the rarity of figurative images of humans and animals, following from the belief that the creation of living forms was unique to God. This constraint, however,

a variety of important pieces, including an intriguing map of the ancient world inscribed on a rock, with Babylon at its centre, and an elegant globe that mapped the stars, shaped in brass.

The Persians, who swept west from Iran from the 6th century BC, conquering Babylon as well as Egypt and Anatolia, are shown to have similarly advanced skills in working metal. The museum displays jewellery and other objects from the Oxus Treasure, the most important collection of gold and silver to have survived, representing ancient Persian court style at its most eye-catching.

precipitated the extraordinary creativity in the non-representational pieces on view. The reverence of the word of God, in the form of the Koran revealed to Muhammad, led to the elaboration of beautiful Arabic scripts to copy the holy book. This calligraphy leaves the page and adorns ceramics, metalwork and textiles in innovative ways, bringing the sublime to both religious and secular objects on display.

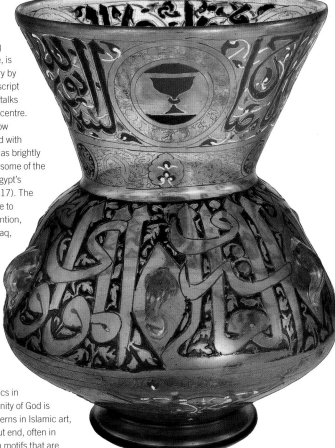

A simple white earthenware bowl from Iraq (11th century), for instance, is lifted into the realm of luxury by its ornamentation, a black script whose elongated, slender stalks reach down into the bowl's centre. A variety of objects show how calligraphic talent was allied with production expertise, such as brightly enamelled mosque lamps, some of the finest examples dating to Egypt's Mamluk dynasty (1250–1517). The application of metallic lustre to pottery was an Islamic invention, pioneered in 9th-century Iraq, and is exemplified by the decorated glass of the Egyptian Fatimid dynasty (969–1171).

The museum's finest Islamic holdings are its international-class collection of Iznik tiles and pottery from 16th-century Ottoman Turkey, where flowers and leaves interweave over the ceramics in distinctive colours. The infinity of God is signified by decorative patterns in Islamic art, repeating seemingly without end, often in perfect symmetry, and with motifs that are either geometric or echoing forms from nature.

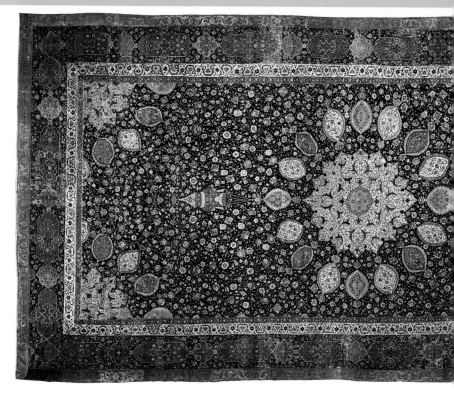

The **PETRIE MUSEUM OF EGYPTIAN ARCHAEOLOGY** at University College London (UCL) is the second most important collection of Egyptian antiquities in the city after the British Museum. Its design is delightfully anachronistic – small artefacts are cramped in cabinets, ordered often by archaeological site, labels handwritten or typed, with little interpretative material. The lack of curatorial intrusion enables a certain freedom for visitors, who can wander the aisles and focus on whatever piques their interest. Highlights include a selection of eerie Greco-Roman era mummy portraits, which were painted on either linen or wood to lie on top of the head of the deceased.

One masterpiece of Egyptian antiquity that was deemed too pricey for purchase by the British Museum back in 1824 was the sarcophagus of Seti I (c 1290 BC). Instead, for £2,000, the inscribed, white-limestone coffin was snapped up by the eminent English architect and obsessive collector John Soane (1753–1837). Soane celebrated his coup quietly, inviting nearly a thousand people to three evening parties on the object's arrival. The sarcophagus' setting today, in **SIR JOHN SOANE'S MUSEUM**, Soane's Neoclassical home-turned-treasure-trove of a museum, is exactly as it was on the day the architect died. Egyptologists may debate whether the work is as historically significant as the British Museum's sarcophagus of Nectanebo II, the last native king of Egypt who reigned from 360–343 BC, but its display in the Sepulchral Chamber in the Soane's basement Crypt – a dark, narrow room, designed by the architect to recall of a Roman burial chamber – is certainly more atmospheric.

There are no other galleries to rival the British Museum's collections of ancient Mesopotamian art, but a lead for further research is the **LONDON CENTRE FOR THE ANCIENT NEAR EAST** at the School of African and Oriental Studies, which promotes a large programme of related events. The school owns some impressive Islamic ceramics

The Ardabil Carpet
Maqsud of Kashan (Iran),
1539–40
V&A
Named after the Iranian town
of Ardabil, where it was one
of a pair created for a 16th-
century shrine, this Islamic
carpet is one of the largest
and finest in existence. The
remarkable density of the pile
– 340 knots per square inch
– allowed the team of
weavers to create particularly
precise patterns.

A 15th-century Egyptian pulpit at the museum, made from wood and inlaid ivory carved in stars and polygons, bears testimony to the fact that the highest expression of Islamic patternmaking was in the ornamentation of architecture. A visit by prior appointment to the **LONDON CENTRAL MOSQUE** is recommended to witness this form first-hand. The prayer hall is an interesting synthesis of traditional Islamic design with the pared-down, Modernist aesthetic of the 1970s, when the mosque was built. Victorian artist Frederic Leighton (1830–96) was an avid collector of Middle Eastern art, and the centrepiece of his home, Leighton House, now the **LEIGHTON HOUSE MUSEUM**, is an Arab Hall adorned with Iznik and Syrian tiles; the Islamic acquisitions of his contemporary, Thomas Gambier Parry (1816–88), are on view at the **COURTAULD GALLERY**. The **PRINCE'S SCHOOL OF TRADITIONAL ARTS** keeps traditional Islamic art alive today, running courses all year round and staging exhibitions of work during the summer.

and manuscripts, on permanent display space in its **BRUNEI GALLERY**.

The **BRITISH LIBRARY** holds an extensive collection of Korans, the most magnificent being Sultan Baybar's Koran from 14th-century Cairo, its seven volumes written in gold. The city's best introduction to Islamic art, however, is the Jameel Gallery at the **VICTORIA AND ALBERT MUSEUM (V&A)**. It covers similar ground to the British Museum, but the size of the space allows for more drama with the display of some truly breathtaking, large-scale works. Chief among these is the gallery's centrepiece, the Ardabil Carpet (1539–40). It is the world's oldest dated carpet and considered one of its very finest, with its entire 50-square-metre surface covered in exceptionally dense, decorative patterns.

Sarcophagus of Seti I
19th dynasty (Egypt),
c 1290 BC
SIR JOHN SOANE'S MUSEUM
The hieroglyphics inscribed
on the interior and exterior of
the sarcophagus tell the story
of the soul's passage to the
underworld. On the inside
base is a large depiction of a
noble-looking Goddess Nut,
to whose keeping the body of
the dead Seti was committed.

ARTS OF ASIA, AFRICA, OCEANIA & THE AMERICAS

Mesopotamia is described as 'the cradle of civilisation' on the basis of its early city-states and written language. But the term is misleading: human settlement and social advancement developed after the Ice Age in a multiplicity of independent locations across the continents, in some cases at similar or earlier times. If agriculture is taken as the defining factor for civilisation, for instance, one can point to Papua New Guinea, where there are signs of developments concurrent with the Middle East.

Art follows the same pattern, with different breakthroughs in production and expression taking place in different centres of early settlement. Pottery was pioneered in ancient Japan from around 10,000 BC, with shells and sticks used to carve patterns into the clay before firing. In the same millennium, the ancient peoples of Peru started spinning together simple fibres, beginning what is the world's longest continuous history of textile production.

The **BRITISH MUSEUM** excels at bringing together these and other diverse developments from Asia, Africa, Oceania and the Americas under one roof – and sometimes in just one gallery – in the case of its permanent thematic exhibitions entitled 'Living and Dying' and 'Enlightenment'. The latter is installed in the Neoclassical grandeur of the restored King's Library, originally built in 1827 for King George III's book collection. As revealing as the objects themselves is the way they have been arranged to reflect the 18th-century ethnographic scholarship at the origin of the museum's collections.

Artefacts as various as a Moche ceramic pot (Peru), Taino ritual seat (Dominican Republic), Aboriginal shield (Australia) and a Hindu sculpture (India) fill the voids in the glass-fronted, mahogany bookcases, alongside works from Greek and Roman antiquity. This creates an atmosphere reminiscent of the cabinets of curiosities that became popular with European collectors during the Enlightenment, when one display room would mix together a vast range of items from different periods in general rather than historical classifications. Indeed, the cabinet of curiosities of the physician and botanist Hans Sloane formed the founding collection of the British Museum.

From Sloane's time until the 20th century, an imperialist mentality and a lack of archaeological information created a bias against earlier non-European cultures. Many of these works are now rightfully acclaimed as exceptional examples of art, rather than mere curiosities, but mysteries remain about both the objects and the societies that produced them. This has led to some interesting speculation. Some academics, for example, have suggested that societies as removed as China's Shang dynasty and the Native Americans of the Pacific Northwest must have had either common origin or direct contact, so similar is their use of symmetry in their carvings. Any gaps in knowledge are not necessarily a disadvantage for the art lover: they allow an appreciation in aesthetic rather than archaeological terms. After you visit the British Museum, make sure you explore the world-class collection of Asian art at the **VICTORIA AND ALBERT MUSEUM (V&A)**.

Moche warrior pot
Moche (Peru), c 100–700
BRITISH MUSEUM

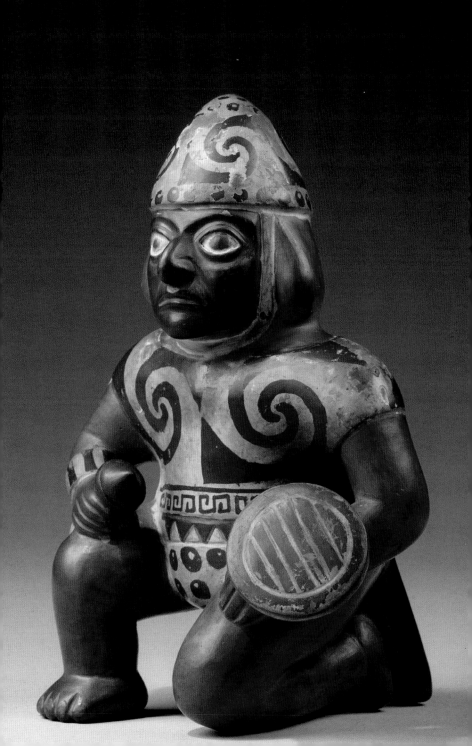

The British Museum has a small but significant collection of artefacts from the Indus Valley civilisation, which encompassed most of Pakistan and Northern India in the third millennium BC and ranked in advancement with ancient Egypt and Mesopotamia. A selection of steatite seals feature fine, miniature depictions of animals, including elephants, alongside pictographic script that has yet to be decoded.

Buddhist and Hindu art dominates the works from South and Southeast Asia, comprising sacred sculpture, architectural ornamentation and reliquaries. A highlight is a room dedicated to ornate relief scenes from the life of Buddha, excavated from a stupa at Amaravati in India, dating from the 2nd century BC. These early Buddhist works focus on the Buddha's teachings rather than his image, and make an interesting point of comparison to sculpture from the influential Gupta dynasty of northern India (320–550), where the classical depiction of Buddha developed. Hindu masterpieces on view include a magnificent 12th-century sculpture of the

deity Shiva as Nataraja, Lord of the Dance, with the large figure skilfully cast in a single piece of bronze.

Ceramic art of the highest quality has always been central to the museum's Chinese collections and since 2009 these have been boosted by the Sir Percival David Collection of Chinese Art, the finest private collection of Chinese ceramics in the world. China's unbroken cultural evolution from ancient to modern times is reflected in these displays, with sublime examples from every important period to show the art form's aesthetic development.

Jade *cong*, mysterious oblong receptacles used in rituals by the Neolithic Chinese (c 2500 BC), open a gallery dedicated to a stone with which Chinese art has long been synonymous. The Shang dynasty (c 1500–1050 BC) and Zhou dynasty (1045–256 BC) further perfected this early jade work, as well as pioneering the use of bronze vessels in ancestor worship. Lacquer works also became markedly more sophisticated during these periods; the material then moved into mass production in the Han dynasty (206 BC–AD 220) and reached its creative zenith in the carved

David Vases
Yuan dynasty (China), 1351
Although Chinese blue-and-white porcelain is most closely associated with the Ming dynasty (1368–1644), it was developed a century earlier during the Yuan dynasty. These magnificent vases have a pre-eminent place in art history in having the earliest dated dedication inscribed on their necks.

Sandstone figure of the Buddha
Gupta period (northern India), 5th century
This standing Buddha is characteristic of the influential religious sculpture developed in Sanarth, India, during the cultural golden age of the Gupta period (320–550). Decorative elements were reduced and a smoothness of execution was introduced that evoked in art the Buddha's message of peace and serenity.

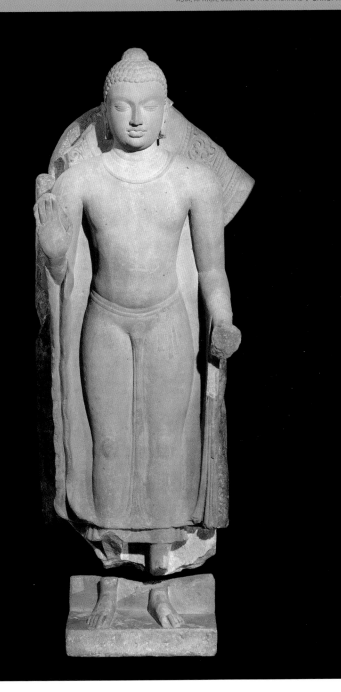

Benin plaque: the Oba with Europeans
Edo peoples (Nigeria), 16th century
The Royal City of Benin, in Nigeria, was a hub for artistic production from the 15th century. More than 900 brass plaques covered the palace of the king (the Oba). This example shows the Oba accompanied by two attendants, with representations of long-haired European traders either side of his head.

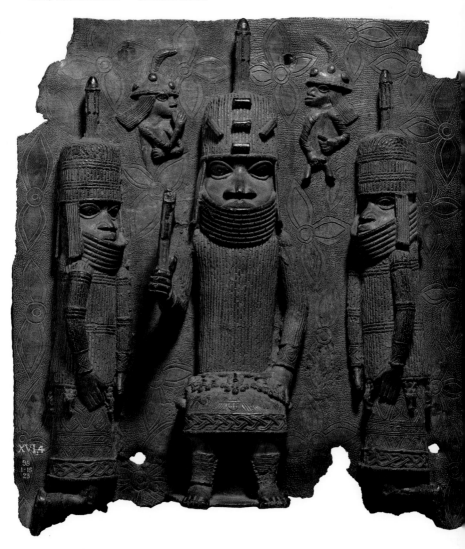

Hoa Hakananai'a
Easter Island, Polynesia,
c 1000
Hakananai'a (meaning
'hidden friend') is one of
more than 800 *moai*,
mysterious sculptures
produced by inhabitants of
Easter Island many centuries
ago. Twice life-size, with
heavy, ridged features, the
arresting figures were carved
out of basalt, a dense
volcanic rock that is
exceptionally difficult to
sculpt.

pictorial dishes on view from the Ming dynasty
(1368–1644).

The David Vases (1351) are the most famous
examples of Ming blue-and-white porcelain in the
world, with the pair's rare dated inscriptions. During
the Qing dynasty (1644–1911), decoration became
further refined and highly symbolic. However,
earlier ceramics from the Song dynasty (960–1279)
win any contest in terms of pure beauty,
supplanting ornament for elegance of form and
colour.

One can encounter ancient Japanese sculpture
in the haunting form of *Haniwa*, tall terracotta
figures with hollowed-out features that guarded
Shinto tombs in the Kofun period (*c* 250–538).
Buddhism from China had a major impact on
Japanese culture, but painting remained secular
rather than religious. The collections include scroll
and screen works influenced by the Yamato-e
school from the Heian period (794–1185), notable
for narratives in gold and brilliantly coloured
pigment. These replaced the imported tradition of
Chinese painting, which privileged monochrome
landscapes above all. The Japanese also absorbed
and then adapted Chinese calligraphy, creating
their distinctive brushwork style called *Hiragana*.
For both cultures, calligraphy was considered
equal in status to painting and poetry; indeed, the
displays show that it was common for all three art
forms to be combined in one work.

Prints are another undoubted strength in the
Japanese holdings, which represent the full range
of 18th- and 19th-century *Ukiyo-e* ('pictures of the
floating world'), from woodblocks of Kabuki actors,
courtesans and geisha to landscapes by artists
Katsushika Hokusai (1760–1849) and Utagawa
Hiroshige (1797–1858). A gallery also spotlights
high points in Korean art, including acclaimed
Celadon ceramics from the Koryo dynasty (918–
1392) as well as porcelain from the Choson dynasty
(1392–1910), exemplified by an exquisite white
'moon jar' which was previously in the collection of
British master potter Bernard Leach (1887–1979).

Some of the earliest African art in the collection
is from ancient Sudan, whose culture was so
intertwined with Egypt that the majority of works
closely resemble that of its northern neighbour. An
exception is the sublime ceramics from the Kerma
culture (2500–1500 BC), characterised by black
tops and rich red-brown bases, separated by a
purple-grey band.

Art from sub-Saharan Africa tended to be
produced in materials such as fabric and iron liable
to decompose or corrode in an unfavourable
climate. The museum lacks significant works from
the early West African cultures of the Nok (1000–
300 BC) or Igbo-Ukwu (*c* 900), but it does display
a stunning portrait head in brass from the Yoruban
city of Ife. Dating from the 14th century, the head is
so naturalistic in its depiction of a ruler that it has
drawn comparisons with masterpieces of the
European traditions.

Also on view is an excellent collection of brass
and ivory works from the Royal City of Benin
(Nigeria), a pre-eminent centre of African material
culture that traded with Europe
from the 15th century. The
highlight is a large group of
brass reliefs taken from the
city's palace. The plaques
celebrate aspects of Benin
kinship, history and ritual,
which all revolved around
the veneration of their king
and spiritual leader, the
Oba. The graphic
stylisation of the figures
is in contrast to works of
more realism, such as a
portrait head of Queen
Mother Idia.

Other important
works of African art
history include
sculptures from Sierra
Leone that depict

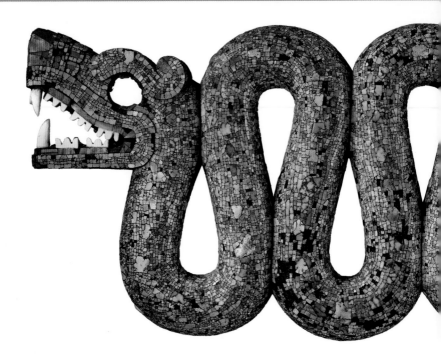

humans and animals with exaggerated features (*c* 1200–1500), 18th-century statuettes carved immaculately in wood by the Kuba (Democratic Republic of Congo), and thousands of important textiles works, including Kente cloths from Ghana.

One of the earliest Oceanic objects is a stone pestle from Papua New Guinea, perhaps more than 8,000 years old, whose elegant, elongated handle is shaped in the form of a bird. Fragments of pottery (1500–800 BC), stamped with simple repeating motifs, have been attributed to the ancient Lapita culture, an important common ancestor for several later Pacific societies.

European settlers eager to spread Christianity routinely destroyed Polynesian art that depicted deities. An extraordinary wood carving of the ancestor-god A'a, found in the Austral Islands in the 19th-century, gives an idea of this unfamiliar religious art; tiny carved figures, perhaps representing progeny, take the place of the deity's eyes, nose and other features.

The most crowd-pleasing Pacific work, however, is Hoa Hakananai'a, one of the famous gigantic stone figures, or *moai*, from Easter Island, dating to around AD 1000. Other highlights include Maori woodwork from New Zealand, such as a prow from a 19th-century *tuere* (war canoe) decorated with asymmetrical spirals, and mixed-media masks from Melanesia and Micronesia. Indigenous Australian art has a painting tradition dating back over 40,000 years to Palaeolithic rock paintings, and it is represented in the collections by a number of 19th-century Aboriginal bark paintings, with figures sketched in white clay, red ochre and charcoal.

The Native American art on display also tends to date to more recent times, an exception being a fascinating range of zoomorphic pipes (200 BC– AD 100). Two 19th-century totem poles from British Columbia, made by the Haida and Nisga'a peoples, are so tall that they seem to reach the glass ceiling of the museum's Great Court. Both are unpainted, allowing one to admire the craft in the carving of the intertwined bodies. Rugs, pottery, basketry and clothing are also all featured, as well as illustrated buffalo skins; one by a Blackfoot

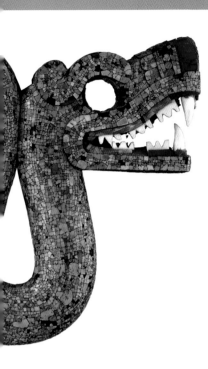

Double-headed serpent turquoise mosaic
Aztec (Mexico), 15th–16th century
The Aztecs are acclaimed for their production of turquoise mosaics as masks, armour and ornaments. This pectoral mosaic, worn on the chest, takes the form of a snake, a central symbol of transformation in Mexican art due to its ability to shed its skin and move between forest, earth and water.

A selection of small-scale Olmec works (1200–400 BC) introduces a theme characteristic of ancient Mexican art: identity and its fluidity. Humans became one with animals, often jaguars and eagles, in strange hybrid images on tools and ornaments. Masks were revered, created to enable the wearer to take a new form, perhaps that of a deity or ancestor.

The finest Mayan art on display is a series of well-preserved limestone lintels dating from the Late Classic period (600–800) and taken from the ancient city of Yaxchilán. The reliefs portray royal and religious ritual and myth, and are not for the faint of heart, encompassing bloodletting ceremonies, warfare and an apparition of a serpent. The panels' hallucinatory power is only topped by the Aztec turquoise mosaics on view, from the 15th and 16th centuries, such as fearsome masks and a double-headed serpent ornament that has become an iconic image in Mesoamerican art.

artist (c 1868) shows exploits of war in primary colours.

The museum has interesting holdings of Pre-Colombian Peruvian art that reach far back before the Incas. The Paracas culture (600–150 BC), one of the earliest known South American societies, venerated textiles as a means to share stories. One can witness their skills in some superb textile fragments, which depict supernatural figures in flight in finely woven detail and vibrant colour. Polychrome pottery from the Nasca civilisation (200 BC–AD 600) is another revelation. The ceramics are burnished to a gloss finish, giving their images of gods, humans and animals a singular graphic impact.

The master goldsmiths of Colombia, the Quimbaya (600–1100), are represented by a range of objects, including ornaments, masks, figurines and helmets. The Incas (1200–1533), of course, were synonymous with the same material, and the museum has on view a miniature gold llama figurine that was created as an offering to accompany human sacrifice.

North American otter pipe
Hopewell culture (Ohio), 200 BC–AD 100
Finely carved pipes featuring birds, aquatic mammals and other animals were smoked by Native American ancients, perhaps for purification or to ensure the health of the community. A large number have been found in burial mounds, indicating that they may have been used for other ceremonial purposes.

Trophy head
Asante tribe (Ghana), 19th
century or earlier
WALLACE COLLECTION
The Asante tribe became
dominant over areas of
modern-day Ghana from the
17th century. Enemy leaders
who were slain were
commemorated with metal
death masks, which often
took striking, naturalistic
form, such as this golden
head taken from the treasure
of Asante ruler King Kofi
Kakari.

The immense collections of Asian art at the **V&A** complement, and in many areas surpass, those of the British Museum. The two museums – combined with the British Library – make London the most important centre for the appreciation of Asian art outside the countries of origin.

More than 10 large galleries at the V&A focus on the development of art, craft, design and decoration across the continent. There is strength and depth in many spheres, such as textile works from China, Japan and India (the museum has the largest and most wide-ranging textile collection in the world) and Mughal art.

The latter is a fascinating fusion of Iranian compositional techniques and Indian colour, exemplified by the beautiful paintings on view, such as the series that illustrate the epic *Hamzanama* (1562–77) – crucially important to the development of Mughal image-making – and later, less heroic narratives that shows the pleasures of court life. The opulence of the emperors' world is also evident in objects from jewellery to jade of the period, including Shah Jahan's delicate wine cup (1657), the finest known example of Mughal jade-carving.

The **BRITISH LIBRARY** is a pilgrimage point for those interested in sacred Asian texts. It holds the Chinese Buddhist *Diamond Sutra* (868) – the world's earliest surviving dated printed book, which has a wonderful woodblocked frontispiece – as well as an illustrated copy of the *Devimahatmya*, a masterpiece of Hindu art. The **BRUNEI GALLERY** displays the *Anvar-i Suhayli* (1570), a tour de force of early Mughal book art. The **MUSEUM OF CROYDON** is the custodian of the formerly private Riesco Collection, which includes Tang dynasty tomb models and Ming dynasty porcelain, and the

historic hoards of Greenwich's **FAN MUSEUM** incorporate Chinese and Japanese illustrated examples.

The exceptional holdings of public galleries have encouraged a buoyant commercial sector. The city boasts more dealers in Asian art than any other Western capital, and holds the week-long festival **Asian Art in London** every autumn. There are also several cultural institutions, such as **ASIA HOUSE**, the **NEHRU CENTRE** and **ROYAL ASIATIC SOCIETY**, dedicated to exhibition and event programmes. Indian craftsmanship is illustrated on a grand scale by Neasden's **BAPS SHRI SWAMINARAYAN MANDIR**, Europe's first traditional Hindu temple.

Victorian tea trader and collector Frederick John Horniman amassed thousands of natural history specimens, world cultural artefacts and musical instruments, and the consequent **HORNIMAN MUSEUM**, in the suburb of Forest Hill, is an enjoyable hotch-potch of all three strands. Celebrated exhibits are 16th-century Benin plaques, a 15th-century Hindu figurine of Kali with Shiva and – most popular of all – a huge stuffed walrus.

A large number of Kerma ceramics are on view in the cabinets of the **PETRIE MUSEUM OF EGYPTIAN ARCHAEOLOGY** at University College London (UCL); the university also holds the **ETHNOGRAPHY COLLECTIONS** that encompass material as diverse as Nasca pottery, Inuit carvings and Asante stools from Ghana. African and Oceanic carvings collected by Modernist British artist Roger Fry (1866–1934) are held by the **COURTAULD GALLERY**, and the **WALLACE COLLECTION**, known best for European fine and decorative art, unexpectedly boasts a remarkable Asante death mask in gold.

Hamza, Killed in Battle at Mount Uhud from *Hamzanama*
Mughal (India), 16th century
V&A
The Mughal Emperor and art connoisseur Akbar commissioned the royal painting studio to complete 1,400 images of the life of the legendary Hamza. The 15-year project involved more than a hundred artists and set inspiring new standards for composition, gesture, colour and detail.

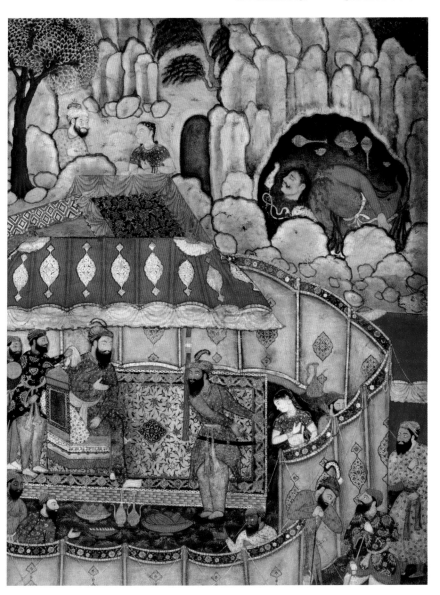

GREEK & ROMAN ART

The history of ancient Greece's influence on Britain is a study of how one culture can come to transform another, not directly and immediately, through conquest, but gradually, tangentially, via many different intermediaries and over centuries, to perhaps an even greater, more lasting effect.

The Greek arts started to seep second-hand into Britain from the 6th century BC with the arrival of Celts from across the English Channel, their craft bearing the influence of the Greek outposts with whom they traded. Although it was Rome that took control of the Greek peninsula in 147 BC and not vice-versa, the Hellenic world 'made a slave of her rough conqueror' when it came to culture, in the words of the Roman poet Horace. The Romans were enthralled by the ideals of Greek art and architecture, adopting them faithfully and exporting them to new territories, such as Britain, where they established Londinium in the 1st century.

The city would discover the Classical canon anew in the 17th and 18th centuries, but then by several degrees of separation. Architects, artists and writers would return from Italy inspired by the Renaissance, which itself was indebted to the Roman replication of Greek culture. So prevalent is Neoclassical art and architecture in London today that one could be forgiven for thinking it is more British than Italian or Greek.

But what exactly was Greek art? The web of influence and appropriation over the centuries makes it even more important for the art lover to ask this question. The collections of the **BRITISH MUSEUM**, aptly housed in a 19th-century Greek Revival-style building, crowned with a pediment and supported by Ionic columns, have the answer – or close to the answer, considering most of ancient Greece's paintings and the vast proportion of its sculptures, especially those cast in bronze, have not survived.

Roman copies of Greek works shed some light on what is missing, although their faithfulness to the standards of the originals is a subject of constant debate. The Romans were not only copyists; they were responsible for some notable artistic innovations. However, there is nothing in the Roman holdings that competes in significance with the Parthenon sculptures, known as the Elgin Marbles (447–432 BC). At the start of the 19th century, these remarkably naturalistic works were removed by the diplomat Lord Elgin from the Parthenon temple on the Athens Acropolis – with the help of bribery and fraud, in the opinion of those who want them returned.

The poet Lord Byron lamented their exile to Britain as early as 1812 in *Childe Harold's Pilgrimage*: 'Dull is the eye that will not weep to see / Thy walls defac'd, thy mouldering shrines remov'd / By British hands.' But wherever one stands on their repatriation, a visit to see the Parthenon sculptures is a duty for anybody interested in art. They live up to their billing as some of the most beautiful works ever made, reminding us that Greek art's visual power is the key reason why its spirit has persisted across the centuries. The **MUSEUM OF LONDON**, in turn, reveals how Roman culture transformed a small settlement into a cosmopolitan city.

The Portland Vase
Rome, *c* 5–25
BRITISH MUSEUM

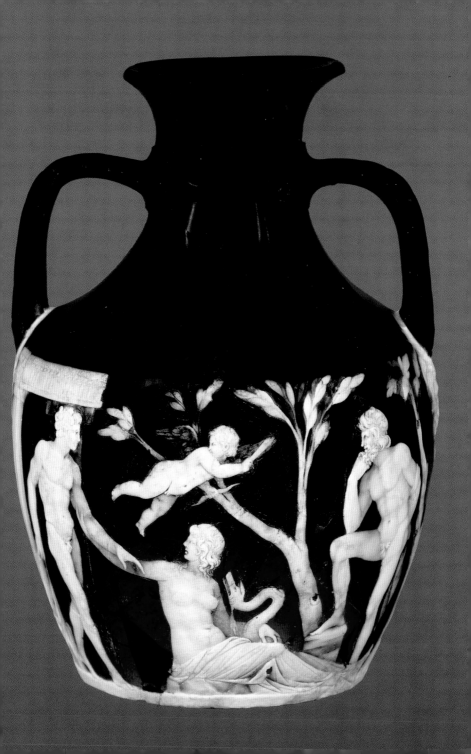

Marble figurine of a woman
Cyclades Islands,
2600–2400 BC
The Bronze Age inhabitants
of the Cyclades fabricated
statuettes in a striking,
uniform style. The graphic
clarity of such carvings, with
simple shapes signifying
body parts, makes them
attractive to the modern eye
– indeed, they inspired the
work of 20th-century artists
including Brancusi and
Modigliani.

No written records exist from the venerable culture of the Cycladic Islands (3200–1450 BC) to the southeast of mainland Greece, so one must turn to the art on display to gain an insight into the way they lived. The stylised female statuettes on view were found at graves across the archipelago, indicating their use in funerary ritual. These figurines are often sculpted in marble, revealing that the Greek predilection for the luminous material goes back millennia.

The collections make a case that the Minoans of Crete (3200–1450 BC) had a formative influence on their conquerors, the Mycenaeans of mainland Greece (posing an interesting symmetry with the Greek influence on the Romans centuries later). A miniature bronze of an acrobat somersaulting from a bull – an activity of perhaps religious importance for the Minoans – anticipates the mainland's emphasis on accurate representation, as do a variety of seal works that are just as accomplished as those of ancient Indus and Assyria.

However, with an absence of surviving painting, the clearest visual link is via ceramics. The carefree patterns and figures on Minoan jars and flasks appear inspired by the natural world. The Mycenaeans refined this influence further, developing a pictorial style that depicted more clearly the bodies of animals and humans; a vase decorated with bulls and birds from about 1300 BC, exported to Cyprus, is one of the finest examples.

The subsequent five centuries constitute the Dark Ages for ancient Greece with tribal wars causing the destruction of communities and decline of trade. The re-emergence in approximately 800 BC of what had been lost during this time, including writing, art and craft, was accompanied by political evolution. *Poleis* (city-states) such as Athens and Corinth were established, some of which gave citizens democratic powers for the first time.

The museum's holdings from the Archaic period (c 800–500 BC) affirm that citizenship encouraged freethinking in culture as well as politics. As Homer reinvigorated Mycenaean legend through epic poetry, artists breathed new life into ceramic traditions. The Geometric pottery of Athens on display takes the horizontal lines of Mycenaean vases in a bold, new direction, spreading them across the entire surface, interjected with precision bands of lozenges, chequers and chevrons. In the vases from Corinth, patterns are amalgamated with black-figure motifs of animals, influenced by pottery from Greece's trade partners in the Middle East (the style of decoration is known as Oriental).

The black-figure ceramics on view show ever more sophistication, incorporating scenes from mythology as typical of Greek art. But late in the 6th century there is a change in technique, with figuration on a red ground replacing black. This innovation, pioneered by the Athenian painter Andokides (active c 530–515 BC), demonstrates that Greek artists favoured any technique that could help with accurate representation. Black-figure vases were visually very potent due to the contrast of light pigments painted on black silhouettes, but painters eagerly swapped to red-ground work when they discovered it could depict details in figures and faces more authentically.

The museum's vase paintings therefore become more naturalistic in the years after Andokides. One can infer that their style, which includes attempts at foreshortening, reflects other painting work in Greece of the time, such as frescoes. The pieces are virtuosic and often signed, consequences of a Greek art world where artists would compete for patronage. An exemplar is a red-figured water jar by the Athenian painter Meidias (active c 420–400 BC) that illustrates two important myths.

The Elgin Amphora
Athens, *c* 750 BC
Ceramic vases with two handles and a narrow neck, termed 'amphorae', spread across the ancient world from Syria and became popular with the Greeks. This example is covered from top to bottom in the type of geometric decoration fashionable in Athens at the time.

MEIDIAS
Red-figured water jar
Athens, 420–400 BC
The Athenian painter Meidias
divides this *hydria* into two
pictorial zones. The upper
illustrates the abduction
of Leukippos's daughters,
the lower Heracles

receiving the golden apples.
There is poetry in both the
composition of the scene
and the delicate expression
of the details: more than in
the finest Egyptian painting,
one steps into the
imagination of the artist.

The Strangford Apollo
Anáfi, Cyclades Islands,
500–490 BC
This less than life-size
kourous is an early
illustration of the idealised
naturalism that came to
characterise ancient Greek
sculpture. Even with its limbs
missing, the statue seems
perfectly poised, thanks
to its relatively accurate
proportion, symmetry of
torso and measured facial
expression.

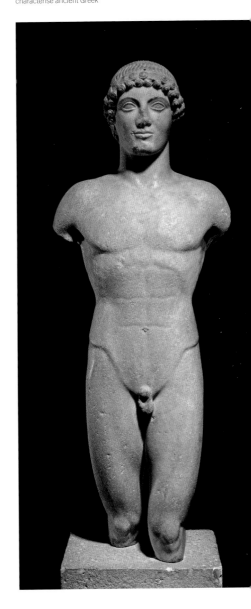

Meidias was active in what is now considered to be the golden age of Greek art, the Classic period (c 500–338 BC), led by the cultural and economic dominance of Athens. In sculpture, the name of Phidias (c 480–430 BC) comes to the fore, whose Athenian studio was responsible for many of the Parthenon sculptures. The museum's Elgin Marbles constitute roughly half those that survive.

A visit to encounter these masterpieces is best prefaced by a wander through the galleries of the Archaic period. The standing marble nudes (termed *kouroi*) reveal that the Greek fascination with the bare body was, at first, restricted to the young male. Artists learnt how to carve these large works by looking at older Egyptian sculpture, although their pieces differed in purpose. *Kouroi* commemorated the living as well as the dead, and also the god Apollo (gods took human characteristics for the Greeks).

The Strangford Apollo (c 500–490 BC) is a particularly accomplished *kouros*, its body parts in natural proportion. *Kouroi* of this standard were the first works of antiquity that, if one glances at quickly, could be alive. Sculptors soon seemed to have this trick down to a fine art. The Vaison Diadumenos is a handsome Roman copy of a famous Greek bronze (c 440 BC) that portrayed an athlete tying a victory ribbon around his head. Works such as these show how Greek artists could animate their figures as if they were in motion, without losing naturalism. They are not realistic in the strict sense, as they depict ideal human forms. Strong facial expressions are rare, as if they could taint the ideal with base feeling; the museum's impressive bronze head of Apollo – the Chatsworth Head – has a countenance that is calm, its lips in neither smile nor frown.

The Elgin Marbles prove that figurative sculpture does not need a face to be expressive. The headless reclining body of a river god moves the viewer with its musculature, the ripples of flesh guiding the eye from right to left and back again. But even more sensual are the pediment

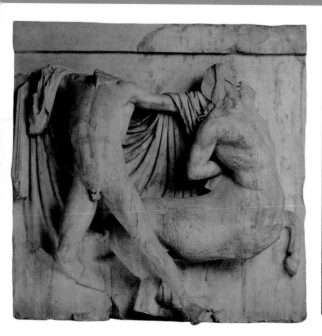

sculptures that are fully clothed, the seated goddesses of Hestia, Dione and Aphrodite. The drapery is carved in thick ridges known as 'modelling lines', forming swirls and undulations that emphasise the shapes of the breasts and thighs underneath.

If this drapery, especially that of the reclining Aphrodite, tends towards a kind of excess, the metopes (high-relief panels taken from outside the Parthenon) retain an unparalleled sense of equilibrium. The series details the legendary battle between the Lapith people and half-horse, half-human Centaurs, with each metope depicting a Lapith and Centaur in an individual struggle. The variety of compositions is highly ambitious and executed with brilliance, the Lapith and Centaur always in balance with one another as if in a perfectly choreographed dance.

The 75-metre frieze of a procession that wraps around the gallery walls is around half of the original created for the Parthenon. Like a frieze from the Temple of Apollo Epikourios (c 420–400 BC), another highlight of the museum's collection, it displays all the representational achievements of

standalone sculpture. Several hundred figures are held together in a rhythmic composition, all carved with naturalism and empathy, whether a warrior or herdsmen, horse or cow. The layering of up to four figures on top of each other creates an illusion of depth.

The museum also holds later highlights of the Classic period, such as a caryatid (a column in the form of a female figure) from the Erechtheion temple at the Acropolis and lavish sculpture from what is now Turkey, including statues from the Nereid Monument at Xanthos and colossal works of a man, woman and horse from the Mausoleum at Halicarnassus, one of the Seven Wonders of the Ancient World.

By the late 4th century, the art on display begins to reflect that of the Hellenic Empire of Alexander the Great, whose united Greece annexed territory all the way to India. One can note more elaborate art that bears the influence of conquered cultures, as well as the emergence of the female nude; the collection includes a Roman replica of a celebrated nude of Aphrodite by Praxiteles (4th century BC). Historical and portrait works are also in

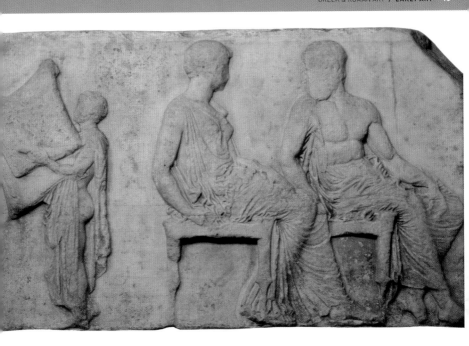

evidence, and they often forsake serenity for a new sense of expressive drama. Alexander is depicted like a heroic god following his military feats, examples ranging from a bronze statue of him as a huntsman to his representation on a silver decadrachm coin, the only image of the leader to survive from his lifetime.

The collections demonstrate that this trend for portraiture came to fuller fruition in the art of the Roman Empire. As well as collecting Greek 'Old Master' sculptures as status symbols, or acquiring copies – such as the Roman replica on view of the seminal discus-thrower by Myron (active c 480–440 BC) – the Roman elite commissioned busts depicting themselves and their families. Many mimic the heroic style of bust produced by a succession of Hellenic and Roman rulers, but an unflattering 'warts and all' marble of an old man (c 60–40 BC) tells us that portrait artists could also break free from the conventions of Greek idealisation.

The Romans step out of the Greek shadow in two other types of exhibit: mosaic art and luxury glasswork. While the small number of Roman paintings on view at the museum have little skill in

Marble metope from the Parthenon
Athens, c 440 BC
This daring, beautifully poised composition is one of the finest in a group of high-reliefs that are part of the Elgin Marbles. The series illustrates the mythical battle between the human Lapiths and the Centaurs, the latter symbolic of the Persians who invaded the Greek peninsula half a century earlier.

Central scene of the east frieze of the Parthenon
Athens, c 438–432 BC
The Parthenon temple was dedicated to Athena and this frieze section, from the facade above its great doorway, shows the sacred robe (or peplos) of the goddess delivered to the temple at the climax of a procession. Athena sits with Hephaistos, the blacksmith to the gods whose advances she spurned.

comparison to Greek vase paintings, the mosaics – more durable if more expensive to produce than frescoes – are to a standard unseen in previous cultures. The best include the well-preserved 4th-century Hinton St Mary Mosaic, which frames in patterns perhaps the earliest mosaic image of Christ. The collections of Roman glass reach two peaks with the exquisite Portland Vase (c 5–25), antiquity's finest cameo-glass work, and the 4th-century Lycurgus Cup, an extraordinary vessel that changes colour from green to red when held up to the light.

The Ephesian Diana
Roman copy of Greek
original, 2nd century
SIR JOHN SOANE'S MUSEUM
The cult image of Diana from
the Greek temple at Ephesus
(Turkey) – an Ancient
Wonder of the World – was
prominent as a source for
sculpture in Imperial Rome.
According to ancient authors,
the original was on a huge
scale, sculpted in either palm
wood or ebony and
encrusted in gold.

SIR JOHN SOANE'S MUSEUM reflects how highly London's 18th-century collectors prized the classical world. As the building's architect, Soane created a structure informed by those of ancient Greece and Rome; as its curator, he arranged his Classical sculpture and ceramics by taking inspiration from etchings of Roman ruins. Highpoints include a fragment from the Erechtheion's frieze, the only major piece of the relief outside Greece, and a 2nd-century replica sculpture of the famed Ephesian Diana.

The VICTORIA AND ALBERT MUSEUM (V&A) holds some splendid ceramics, ranging from Mycenaean to Athenian to Roman, as well as a wide selection of beautiful jewellery. However, the essential stop after the British Museum for Roman enthusiasts is the MUSEUM OF LONDON, the world's largest urban history museum, which holds rich Roman collections that comprise approximately 50,000 objects.

The most accomplished mosaic on view at the museum of is the 4th-century Bucklersbury Pavement, the largest surviving Roman example from London. The 20-square-metre work has been impressively restored and re-laid on the floor of the museum, allowing the visitor to view it as it was intended. The principal sculptures are a group of marbles from Londinium's Temple of Mithras, the 3rd-century remains of which were discovered in the City of London in the 1950s. Mithras himself – the idol of a mysterious cult popular with the Roman military – is the subject of a bust, as is the Egyptian god Serapis, whose characteristic thick hair is vividly sculpted. The museum has the most extensive British collection of Samian pottery, known for its bright-red colour, and important metalwork that includes cutlery, tools and even toilet implements.

Those of an archaeological inclination can visit the few Roman remains still visible in the city centre, such as the **Temple of Mithras**, fragments of the defensive **London Wall** – some of which can be seen in the grounds of the Museum of London – and the **Roman Amphitheatre** unearthed near and then integrated with the **GUILDHALL ART GALLERY**. The latter is the most interesting, as the gallery has created a reconstruction around the ruins that imagines how the amphitheatre was once used. There is an insight into the domestic life of the Romans at the remains of **CROFTON ROMAN VILLA** in Orpington, the only villa site open to the public in Greater London.

A second-century mosaic floor was discovered when the Bank of England was rebuilt during the 1930s, and it can now be seen at the **BANK OF ENGLAND MUSEUM**, alongside Roman pottery pieces, coins and rare gold bars.

Indeed, in light of London's history, it is no surprise that Classical antiquities turn up in small numbers in a wide variety of the city's collections. The **ROYAL COLLECTION** – on display to the public on rotation at the official residences of Her Majesty the Queen (including **BUCKINGHAM PALACE**, the former's **QUEEN'S GALLERY**, **HAMPTON COURT PALACE** and **KENSINGTON PALACE**) – holds sumptuous cameo jewellery, the **ROYAL ACADEMY OF ARTS (RA)** a Roman statue, the **SCIENCE MUSEUM** a range of vessels and instruments, University College London's **INSTITUTE OF ARCHAEOLOGY COLLECTIONS** ceramics, and the **FREUD MUSEUM** several statuettes and vases. One can also stumble upon interesting artefacts in relatively minor, local London museums such as Southwark's **CUMING MUSEUM** and the **BROMLEY MUSEUM**.

The Bucklersbury Pavement
London, 4th century
MUSEUM OF LONDON
This 20-square-metre Roman mosaic floor – the largest ever found in London – combines multicoloured, geometric patterns and floral motifs in a decorative style that prefigures Islamic art. Figurative scenes were also very common, with more wealthy patrons commissioning religious, mythic and historical designs.

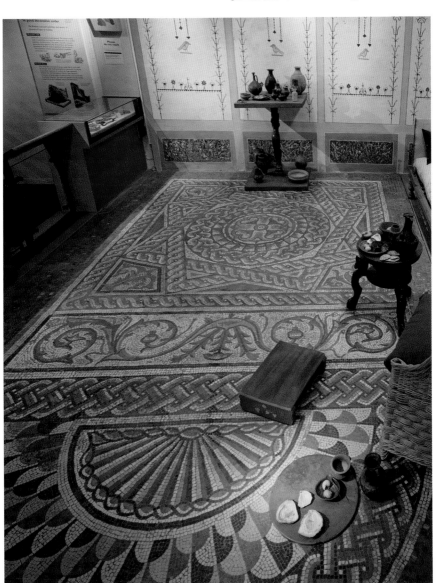

The term 'the Middle Ages', which describes the period from the decline of the Roman Empire in the 5th century to the early Renaissance in the 14th, was first coined by the Italian historian Flavio Biondo in 1483. Biondo – as all historians – was a product of the times in which he lived, when Renaissance artists and thinkers dedicated themselves to reviving the culture of Classical antiquity. The previous thousand years in Europe was seen as at best an interlude, at worst a metaphorical 'night of error', a time of 'darkness and dense gloom', in the words of the poet Petrach.

These words stuck, with the epoch denigrated as the 'Dark Ages', and opinions of the period remained negative until the 20th century, when archaeological discoveries and a more open-minded intellectual climate helped turn the critical tide.

Treasures unearthed in 1939 at Sutton Hoo, a group of burial mounds in Suffolk, were pivotal in the positive reinterpretation of early Medieval England. The Anglo-Saxon tribes from Northern Europe who settled in England after the Romans had long been seen as artistically backward. The wealth of artefacts that were discovered, dating to the early 7th century, revealed that Anglo-Saxon royalty enjoyed a material culture that, in many ways, was as exquisite as that which preceded and followed.

The **BRITISH MUSEUM** displays the objects from Sutton Hoo and has been involved in the conservation of the Staffordshire Hoard, the largest known stockpile of Anglo-Saxon gold, found in 2009. Although both collections encompass objects that are mainly martial in purpose, the latter includes crosses, reminding us that the polytheistic Anglo-Saxons converted to Christianity under the influence of missionaries from Italy and the Celtic Christians that remained after Roman withdrawal.

The narrative of European art is, indeed, indivisible from that of Christian art. The Roman emperor Constantine had converted to the faith at the start of the 4th century and, even as Roman power receded and regrouped around Constantinople, the religion he promoted continued to entrench across the continent.

Early Christianity was based on text, but religious images became popular in both the East Roman, or Byzantine, Empire, which was newly anchored at Constantinople, and the territories of Northern and Western Europe, whose faith was increasingly led by the Bishop of Rome, the Pope. As Pope Gregory I wrote: 'What scripture is to the educated, images are to the ignorant.' Art could vividly illustrate the Bible stories for the illiterate masses. At its most consummate it could evoke God's divinity, or even be the object of devotion itself, in the case of Byzantine icons.

The collections of the **VICTORIA AND ALBERT MUSEUM (V&A)** communicate the extraordinary effort and expense directed towards religious art and architecture by the Medieval Church. The museum's holdings do not include the city's most significant paintings, illuminated manuscripts or icons – the **NATIONAL GALLERY**, **BRITISH LIBRARY** and British Museum excel in these media respectively – and emphasise Western and Northern European art over Byzantine. However, their chronological breadth allows an overview of the entire period.

Helmet from the ship-burial at Sutton Hoo
Suffolk, England, early 7th century
BRITISH MUSEUM

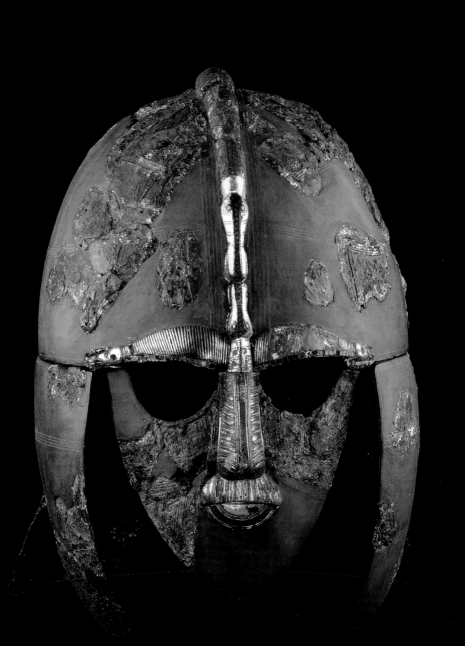

Virgin Hodegetria
Istanbul, 1050–1100
The Virgin has been prominent in Christian art since 431, when an ecumenical council pronounced her the Mother of God. This icon is embossed with her representation as the Hodegetria (literally 'She who shows the way'), pointing to the infant Christ as the source of salvation.

The Medieval collections are mainly displayed in the museum's Medieval and Renaissance galleries, which are exceptional in their space and natural light, as well as the way they afford a combined perspective on two epochs of art that are more often than not put in opposition to each other.

The timeline begins downstairs in the early 4th century, the period when Christianity was adopted across the Roman Empire. Some of the earliest art on display evokes the anxiety that Christians had in depicting the image of Jesus. A decorative earthenware tile from Spain (400–600) is carved with the Chi Rho emblem to represent his presence; the symbol is formed by the Greek letters chi and rho (X and P), the first two letters of the Greek name of Christ. Other noticeable signs for Jesus on view include the fish, which forms the shape of a broach from France (500–600), and a lamb, the centre of a reliquary cross from England (c 1050).

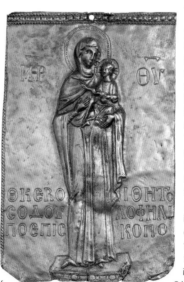

The prevalence of such symbols in Christian art can be partly explained by both the fact that its formative years were as an underground religion, shaped by the need to hide itself from persecution, and the Old Testament's prohibition of images of the divine, which took some time to be disavowed across the Christian world and, at certain periods, became a powerful force in theology once more.

A relatively early representation of Jesus is exhibited in the mosaic fragment (c 545) from Ravenna, the seat of the Byzantine government in Italy from the 6th century. Christ is pictured as a young man and without the beard that was to give later representations more gravitas. The combination of glass and gold is typical of Byzantine mosaic work, more lavish than the Roman tradition that it adapted.

A copper-gilt plaque embossed with the Virgin and Child (1050–1100), made in Constantinople, shows that this opulence would continue to be a feature of religious art during the Byzantine era. Icons showing the Virgin, Christ or the saints became extremely popular across the eastern empire, normally in painted form, with egg tempura applied to a gold-leaf background on a wooded panel. Their attraction was their accessibility, both physically, as small, portable objects, and pictorially. The representations are simple and front facing, encouraging an immediate and intimate connection with the viewer. This meant that they were often objects of devotion in themselves, rather than a mere aid to prayer. They fell foul of the Byzantine emperor Leo the Isaurian, who thought them idolatrous and initiated their destruction, as well as the torture of those who harboured them. This state-sanctioned iconoclasm was repealed in 843, although statues remained a step too far: they are not to be found in Byzantine art.

An ivory panel depicting the Crucifixion and other scenes (850–75) was produced in Metz, a centre for the Carolingian dynasty that dominated central Europe during the 9th century. The work illustrates the fundamental shift in figuration that had taken place since the decline of Roman Classicism. Naturalistic representation was no longer the priority. Instead, the religious content

The Crucifixion and Other Scenes
Metz, c 850–75
The Carolingian and Byzantine nobility commissioned works in ivory because of the rare material's popularity with the Roman elite. This relief illustrates the Passion of Christ in typical Medieval fashion, using a language of poses, gestures, personifications and symbols.

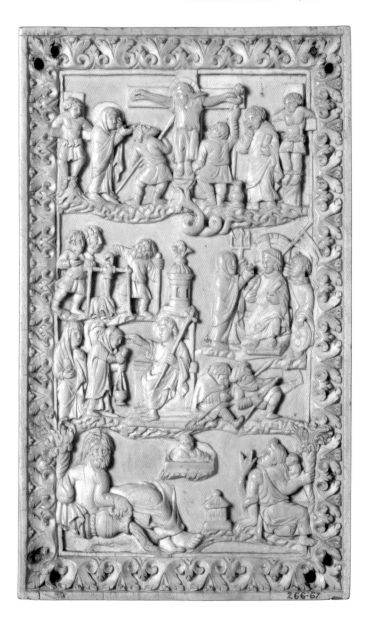

Christ's Temptation in the Wilderness
Troyes, *c* 1223
This panel from France demonstrates the two levels of artistry involved in Medieval stained glass: the layout of coloured glass in a lead lattice and the application of pigment to work-up details. It represents the New Testament story where the Devil tempts Christ to relieve his hunger by turning stones into bread.

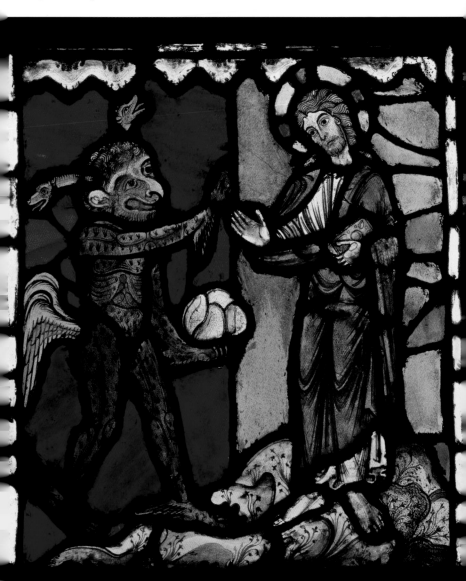

The Gloucester Candlestick
England, 1104–13
Candlesticks first took their
place on religious altars in
England in the 12th century.
This example is the earliest
known and is remarkable for

the intensity of its decoration.
The thick foliage is
interspersed with figures of
humans, serpents and
winged beasts, and dragons
form the candlestick's three
feet.

was key, its extent and meaning taking precedence over the realism of the work's form. In the Metz example, the artist's task was to represent the full complexity of a New Testament narrative in a pictorial area only 17 centimetres high. While clarity is necessary, it only needs to be enough to tell the story – naturalism is entirely sacrificed as an ideal. The contrived gestures, expressions and poses of the figures act as a shorthand for their intentions.

A variety of symbols add extra layers of meaning; symbolism was less important in the simple, devotional iconography of the Byzantine world, but the collections show that it persisted across the rest of Medieval Europe.

But the museum corrects the misconception that Classicism was entirely lost during the Middle Ages. Instead, it seems that societies were selective in its application. The Carolingians, in fact, were avid admirers of the Roman world. Their most successful leader, Charlemagne, was crowned Roman Emperor by Pope Leo III in a papal attempt to transfer the office from Constantinople, and his court replicated elements of Classical culture in order to promote themselves as the natural heirs to ancient Rome, precipitating what has been termed the Carolingian Renaissance. Indeed, the museum is unsure whether the ivory Andrews Diptych is a late Roman work or a Carolingian copy, so closely do they resemble each other in style. The front cover ivory on view from the Lorsch Gospels (c 810), a masterpiece of Carolingian carving, also demonstrates this sympathy, with the Virgin and Child, St John and the prophet Zacharias framed by Corinthian columned arches.

The collections establish that sacred and ceremonial objects would often be fine works of art. Chief among these were

crosses. A 10th-century reliquary cross is compelling evidence that the Anglo-Saxons in England had religious objects as sumptuous as their Norman conquerors. An elegant carving in walrus tusk of Christ on the Cross is mounted on a background of gold and enamel. The pain of Jesus is not here the focus; it was not until the turn of the second millennium that his suffering became central to representations of the Crucifixion.

The Gloucester Candlestick is the museum's finest example of Norman metalwork, a unique piece where a dense labyrinth of branches and leaves wrap around the entire object. Interweaving decoration was typical of the Romanesque period of the 11th and 12th centuries, but it is prefigured in the earlier Celtic-inspired Insular art of Britain and Ireland, where entwined lines – known as interlace – would knot and coil. One can see this on the Anglo-Saxon rings on view, as well as the Easby Cross (800–20), one of the finest surviving examples of the monumental, free-standing crosses that were found solely in the British Isles.

A remarkable whalebone panel from Spain (1120–40), carved with a scene showing the three kings visiting the Virgin and Child, shows another characteristic of the Romanesque genre: the squeezing of figures into tight, irregular shapes without any care for naturalistic scale. The Virgin is the central, striking presence, almost double the size of the kings. This compositional technique was developed in Romanesque architecture, where figures were scrunched into the tympanums and capitals of churches.

Perhaps more than any object, it is surely such architecture that defines our idea of the Medieval, and the museum's collections emphasise its connection to art.

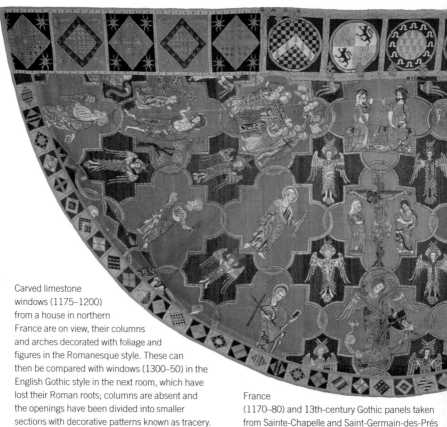

Carved limestone
windows (1175–1200)
from a house in northern
France are on view, their columns
and arches decorated with foliage and
figures in the Romanesque style. These can
then be compared with windows (1300–50) in the
English Gothic style in the next room, which have
lost their Roman roots; columns are absent and
the openings have been divided into smaller
sections with decorative patterns known as tracery.
The pointed, or ogival, shape of the windows, so
definitive of Christian Gothic architecture, was an
appropriation from the sophisticated Islamic world,
which reached far into Spain and Portugal during
the Middle Ages.

The museum's stained-glass collection is the
largest in the world and enables enthusiasts to
chart the development of the medium from
Medieval to Renaissance to more modern times.

Medieval highlights include a rare
Romanesque series from the Cathedral of Troyes in
France
(1170–80) and 13th-century Gothic panels taken
from Sainte-Chapelle and Saint-Germain-des-Prés
in Paris. In these earlier pieces, one can watch as
the artists form the medium's visual language for
the first time. Figures are fairly flat and static, red
and blue glass predominates, and the patterns of
Romanesque and Gothic architecture find their
way into the work.

The finest examples of the embroidery on
display are English: *opus anglicanum*, or 'English
work', was famous across Medieval Europe (alas
the Bayeux Tapestry, the world-famous work that
depicts the Norman invasion, is housed in

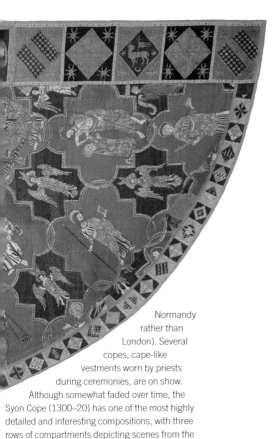

Nicola PISANO
The Archangel Gabriel,
1260–70
The Tuscan sculptors, father
and son Nicola and Giovanni
(c 1250–1319) Pisano, gave
a Classical impetus to Italian
Gothic art. This statue of
Gabriel has the stiffness of
earlier Medieval work, but its
drapery shows how carefully
Nicola studied Roman
sculpture.

Normandy
rather than
London). Several
copes, cape-like
vestments worn by priests
during ceremonies, are on show.
Although somewhat faded over time, the
Syon Cope (1300–20) has one of the most highly
detailed and interesting compositions, with three
rows of compartments depicting scenes from the
Life of the Virgin, the Life of Christ and the Apostles.

The museum spotlights the 13th-century
sculpture of Tuscany, and more particularly Pisa, as
a transitory stage from the art of the Middle Ages to
the Renaissance. Two of the earliest examples are a
pair of statuettes of the Archangels Michael and
Gabriel (1250–75) by the workshop of Nicola
Pisano (c 1255–84), a pioneer in the rebirth of
Classical techniques. One can see in their
modelling a renewed attempt at accurate
proportion.

Lindisfarne Gospels:
Gospel of St Mark
Eadfrith, Bishop of
Lindisfarne, late 7th or early
8th century
BRITISH LIBRARY
Unlike many Medieval
manuscripts, this beautiful

New Testament Bible was the
work of one man, Eadfrith.
The labour involved in
producing its intricate
patternwork would have had
spiritual value for the English
monk, being akin to religious
mortification.

One can directly encounter English Medieval history in either the intimidating form of the **TOWER OF LONDON**, the fortress built by William the Conqueror following the Norman invasion in 1066, or in the sublime **WESTMINSTER ABBEY**, the soaring Gothic church where the country's monarchs have been baptised, married and buried for centuries. In the latter, 13th-century artistry survives in a grand mosaic pavement, some rather worn wall paintings and several bronze tomb effigies, including one that captures a serene-looking Henry III. However, the Abbey's earliest stained glass has been lost – iconoclasts destroyed most that existed in the city during the 16th-century Reformation.

For a more significant art-historical experience, the art lover can spend time studying the 8th-century *Lindisfarne Gospels* in the **BRITISH**

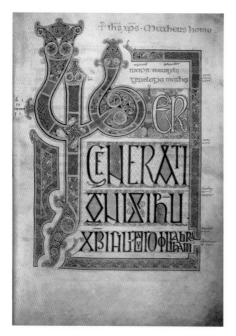

LIBRARY. The illuminated Latin manuscript is the country's very finest example of Insular art, notable for mesmeric interlace patterns filled with fantastic colour. Other important Medieval works in the library include a highly illustrated Jewish book for Passover (*c* 1320), known as the *Golden Haggadah* due to its luxuriant use of gold leaf. Jewish decorative art, especially ceremonial metalwork, can be further explored at Camden's **JEWISH MUSEUM LONDON**. **LAMBETH PALACE LIBRARY** holds treasures such as the *Lambeth Bible* (*c* 1140–60), a masterpiece of Romanesque illustration.

As well as its Anglo-Saxon treasures, the **BRITISH MUSEUM** houses a large range of significant Medieval objects from across the continent – its collections offer an alternative to the V&A as an introduction to the period. One of its strengths is in Byzantine icons: the museum holds the largest public collection of the art form in Britain. The **MUSEUM OF LONDON** tells the story of the Medieval city through Anglo-Saxon, Viking and Norman artefacts, while the **MUSEUM OF THE ORDER OF ST JOHN** displays works including coins minted by the Christian crusaders who sought to wrestle control of the Holy Land from Muslim rule. The **COURTAULD GALLERY** owns an important group of small ivories, the finest example being the Passion Diptych, as well as some late Medieval paintings.

The **NATIONAL GALLERY** houses the national collection of Western European paintings, starting in the 13th century. The opening rooms on the second level offer an international-class insight into late Medieval art. The boundaries often blur between Gothic and early Renaissance. Some Italian artists, such as Duccio and Giotto, are so ahead of their time that they are more clearly contextualised by the Renaissance tradition than the Middle Ages.

However, there are early masterpieces that, while innovative and exquisite in their own right, have yet to shift fundamentally back towards

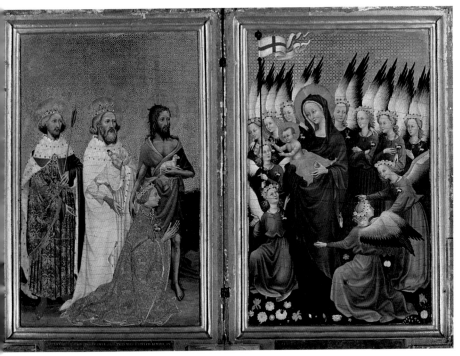

The Wilton Diptych,
1395–9

This portable altarpiece –
known as a diptych because
of its two panels – shows all
the extravagance of the
English court of Richard II,
pictured here presented to
the Virgin and Child. No
English painting of the
period matches it for its
wealth of detail and colour in
paint and gold.

Classicism. These show the considerable influence
of Byzantine icons, with formal religious figures
painted on a bright-gold ground. An example is the
panel *The Virgin and Child Enthroned with Two
Angels* (1265–80) by Cimabue (*c* 1240–1302), the
only work by the Florentine master in the country;
the wooden throne hints at three-dimensional
space, but does not define it with clarity. Cimabue's
14th-century successors in Florence, the brothers
Andrea (*c* 1320–68), Nardo (*c* 1320–65) and
Jacopo (*c* 1330–99) di Cione, emphasised surface,
making works of intense precision, colour and
decoration. This approach – characteristic of a style
known as International Gothic – reached its apogee
in England with the Wilton Diptych, which shows
Richard II kneeling to the Virgin and Child and a
chorus of angels.

THE
WESTERN
TRADITION

REY DŌ SĀCHO
ABARQVA

Y DŌ GARCIA
NHEGEZ

As we have seen in the last chapter, Classical culture remained just under the surface of the Medieval period, breaking for air in various forms of art before submerging once again. Why, then, did a renewed interest in antique civilisation in 14th-century Italy prove so much more powerful, not only defining the art of that period but precipitating the Western Tradition, a progression of techniques and ideas that lasted right up until the late 19th century?

One of the most significant factors was the way Italians, for the first time since the ancient Greeks and Romans, celebrated the individual brilliance of the artist. During the Middle Ages, artists were the anonymous members of monasteries, workshops or guilds. From the Italian Renaissance onwards, they became known as individuals, generating a hierarchy based on fame and reputation across the continent.

This change can be partly explained by patronage. Unlike the rest of Europe, Italy boasted a concentration of independent city-states, such as Florence, Venice and Milan, made rich by trade. The rulers of these cities, and the merchants who made their urban economies tick, vied with one another for painters, sculptors and architects who could reflect their status. This competition strengthened the hands of artists, setting them free from interference. They could indulge their own vision and cultivate their skills on commissions with little constraints. Rivalry between artists set in motion a sense of progress, and an emphasis on originality, as each work would try and outdo another.

The mechanical printing press, invented during the 15th century, ensured this artistic explosion was not just a local event soon to be forgotten. Printed texts celebrated the 'rebirth' of Classical ideas in culture as well as politics and philosophy, and reproductions of Italian works were distributed widely. Art had previously been seen on the walls of churches; now it could be held in the hand.

Perhaps the most important art-publishing phenomenon was Giorgio Vasari's *Lives of the Most Eminent Painters, Sculptors and Architects* (1550). These biographies were like nothing that had come before. Their position as the founding texts of art history has helped sustain the idea that art only really started with the Renaissance. Vasari's subjects define our stereotypes of genius: Leonardo (1452–1519), the polymath whose art also conquered the paradigms of science and maths, and Michelangelo (1475–1564), the moody, independent spirit capable of superhuman efforts.

These reputations draw crowds to the collection of Italian Old Masters in the **NATIONAL GALLERY**. There is no doubting the worth of the gallery's holdings of the genre, which are some of the very finest outside Italy. The **ROYAL COLLECTION** also has outstanding holdings, with masterpieces hung on rotation at **BUCKINGHAM PALACE**, **KENSINGTON PALACE** and **HAMPTON COURT PALACE**, as well as in exhibitions at the former's **QUEEN'S GALLERY**. Works on paper are housed in the Print Room of Windsor Castle, not far from London.

RAPHAEL
Madonna of the Pinks,
c 1506–7
NATIONAL GALLERY

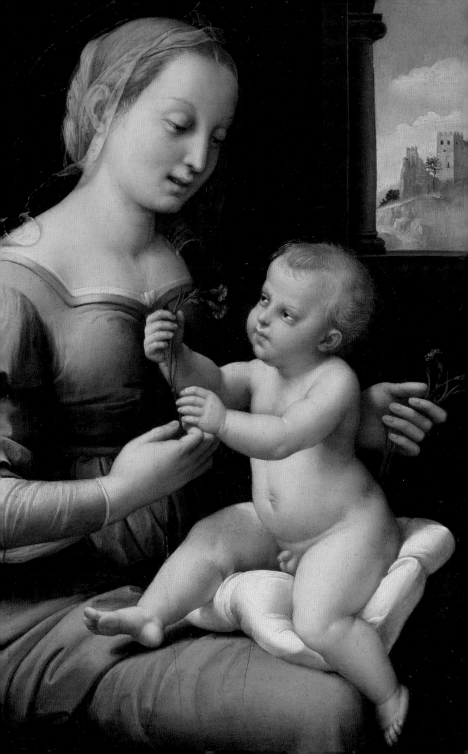

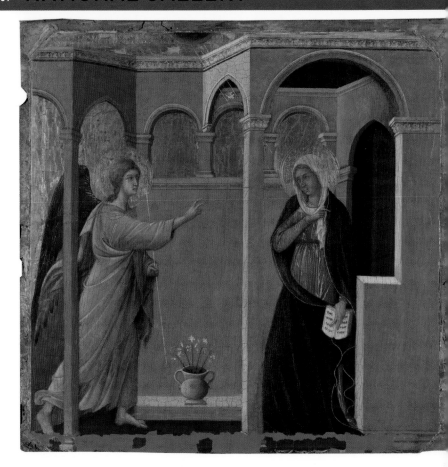

Athree-sectioned panel, *Virgin and Child with Saints Dominic and Aurea* (*c* 1315) by the Sienese painter Duccio (1255–1319) is, at first glance, a typical, tempura-on-gold leaf Byzantine-style icon. But the depiction of Jesus pulling on Mary's headdress reveals Duccio's fascination with both naturalistic emotion – a child's need for its mother – and perspective, in the way the drapery folds outwards towards the viewer. Duccio articulated space more concretely in the three panels on view that were once part of the *Maestà* (1311), his famous altarpiece for Siena Cathedral. In *The Annunciation*, the room where the angel Gabriel meets the Virgin is composed in rudimentary perspective, giving the sense of a three-dimensional stage.

The Florentine artist and architect Giotto (1267–1337) had already gained fame across the region for his remarkably naturalistic frescoes in the Scrovegni Chapel in Padua – works that for the first time in the history of art made the viewer feel that they were looking through a window on to real life. A rare panel attributed to the master, *Pentecos* (1306–12), unfortunately does not reach the heights of these frescoes. A later piece by Ugolino di Nerio (*c* 1280–1349), the *Santa Croce Altarpiece* (1324–5), perhaps better builds on the frescoes' achievements. In its scenes of the Passion there is an attention to the texture of drapery that is reminiscent of Classical sculpture and gives the figures in the fresco more weight, volume and vitality.

DUCCIO
The Annunciation, 1311
This panel by the influential Sienese master Duccio shows an early ambition to render perspective that was to characterise Renaissance art. Depth is constructed by the architectural space, with the sides shown as if in recession, as well as the drapery that appears to twist around the angel Gabriel.

Fra Angelico (c 1395–1455) was to pioneer this approach in the next century, but the gallery holds only some of his early panels, paintings that do not advance matters much further. It is his fellow Florentine Masaccio (1401–28/9) whose abilities appear to mark a watershed. In his panel *Saints Jerome and John the Baptist* (1428–9), light and shade (chiaroscuro) renders his subjects with palpable, flesh-and-blood faces – a compelling alternative to the flat and contorted poses of Medieval art.

Masaccio was one of the first painters to use a vanishing point, a technique pioneered in Florence by the early 15th-century architect Filippo Brunelleschi (1337–1446). Instead of roughly foreshortening subjects, artists would systematically recede them in unison towards one point on the horizon. Known as linear perspective, this method offered an overarching approach to the organisation of objects in pictorial space so that, at last, their arrangement matched the clarity of real visual experience.

According to Vasari, Florentine painter Paolo Uccello (1397–1475) would stay up all night experimenting with this new technique. His immense *The Battle of San Romano* (1438–40) shows how linear perspective could give some order to even the most chaotic scene. In the works on display by Tuscan artist Piero della Francesca (1415–92), such as *The Baptism of Christ* (1450s), one can encounter even greater harmony. Piero believed the geometry of perspective had a metaphysical truth. The painter was influenced by the idea of the 'golden ratio', a formula for the perfect visual relationship between forms first explored by the ancient Greek mathematician Euclid (c 300 BC).

The paintings of the Florentine friar Filippo Lippi (1406–69) demonstrate how much religious art was energised by perspective, even though the method was Classical in its roots and mathematical in procedure. In Lippi's panel *The Annunciation* (1450–3), the technique gives

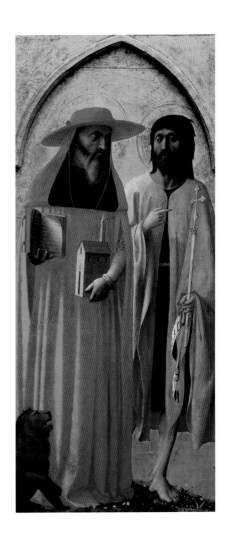

MASACCIO
Saints Jerome and John the Baptist, 1428–9
In Medieval art, faces had been animated, at best, with just a simple pink hue around the cheeks. Masaccio – influenced by the work of the sculptor Donatello – made his faces appear three-dimensional by using radical amounts of shade for the first time.

PIERO della Francesca
The Baptism of Christ,
1450s
This early work by Piero reveals the Tuscan painter's preoccupation with perspective and Classical geometry. The artist has used a grid to orientate the action: a central vertical axis aligns the figure of Christ, his hands in prayer and a white dove (the Holy Spirit) above his head.

Giovanni BELLINI
Doge Leonardo Loredan,
1501–2
Portraits became more common from the 15th century onwards, as patrons rediscovered a form once popular with the elite of ancient Rome. This likeness of the ruler of Venice by Bellini, with its immaculate skin and costume, is head and shoulders above others in the collection.

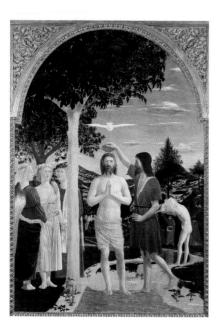

a clear representation of place for Gabriel and Mary's encounter, fitting for a scene considered to have really occurred.

The gallery's strong holdings of Sandro Botticelli (1445–1510) further merge the pagan and Christian worlds. In his circular panel *The Adoration of the Kings* (1470–5), the Biblical narrative takes place among the remains of Roman architecture. Botticelli's wistful masterpiece *Venus and Mars* (c 1485) is overtly Classical, in both subject matter and style: the Roman god of war rests nearly naked, his muscular torso given the perfection of a Greek sculpture.

The Venetian painter Andrea Mantegna (1430–1506) applies this Classical idealism to the depiction of a handsome St John in his altarpiece *The Virgin and Child with Saints* (1490–1505). Mantegna's study of antique sculpture is clear in his two vertical panels *Two Exemplary Women of*

Antiquity (c 1495–1506). The subjects' drapery recalls the statues of goddesses from the Parthenon, on show at the **BRITISH MUSEUM**.

Mantegna's brother-in-law, Giovanni Bellini (c 1430–1516), is represented by a superb selection of works. The most poetic is the melancholy *Madonna of the Meadow* (c 1500), which shows the artist's singular lightness of touch in the handling of skin, drapery and landscape. This delicacy reaches its zenith in his depiction (1501–2) of the Venetian ruler Doge Leonardo Loredan, one of the greatest Renaissance portraits. The portrait form had become increasingly popular with the rise of private patronage.

There are no portraits by Bellini's Florentine contemporary Leonardo da Vinci, but the skill of the revered master is present in both a painting and a full-scale preparatory work, or cartoon. *The Virgin of the Rocks* (1491–1508) is a perfect demonstration of the artist's groundbreaking use of chiaroscuro. The darkness of the rocks grounds the entire scene and shade is used to such an unprecedented degree on flesh (the infant Jesus is more shadow than light) that the dynamically posed figures seem to flow into one another, reinforcing their emotional connections.

The gallery has become a centre for scholarship on the High Renaissance master Raphael (1483–1520) thanks to a group of more than 10 works by the Urbino-born artist. The paintings demonstrate how Raphael synthesised the styles of others during his career. For example, *The Mond Crucifixion* (1502–3) shows the formative influence of Perugino (c 1450–1523) in the lightness of its approach and balance of design; one can compare it to several pieces on view by the Umbrian master. This harmony is then combined with a Leonardo-like attention to emotion in *The Madonna of the Pinks* (c 1506–7), a composition based on one of the older artist's works.

Michelangelo accused Raphael of plagiarism, and there is a hint of it in Raphael's musculature for Jesus and St John in *The Garvagh Madonna*,

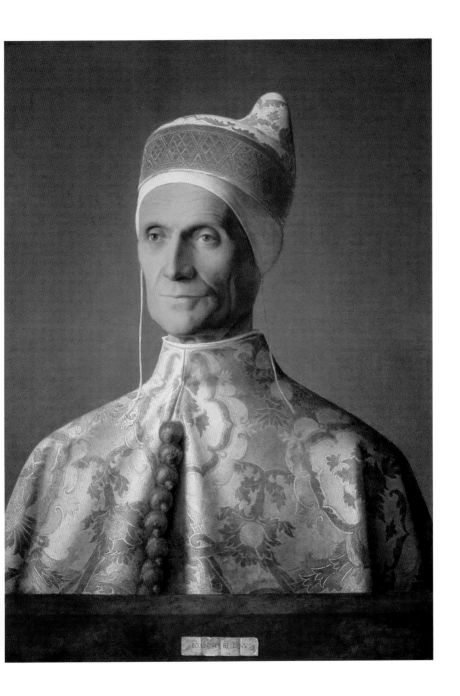

Leonardo DA VINCI
The Virgin of the Rocks,
1491–1508
All four of Leonardo's figures have expressions that are ambiguous, which invests each character with an added sense of reality. Drama is added to their features by blending light with shade, in the words of the artist 'without lines or borders in the manner of smoke'.

TITIAN
Bacchus and Ariadne,
1520–3
This masterpiece shows Titian's skill in using brilliant colour to serve narrative. Highlight tones, from the light-green tree in the right background to the bright-white cloud on the left, move the eye across the canvas in the same direction as the god of wine leads his followers.

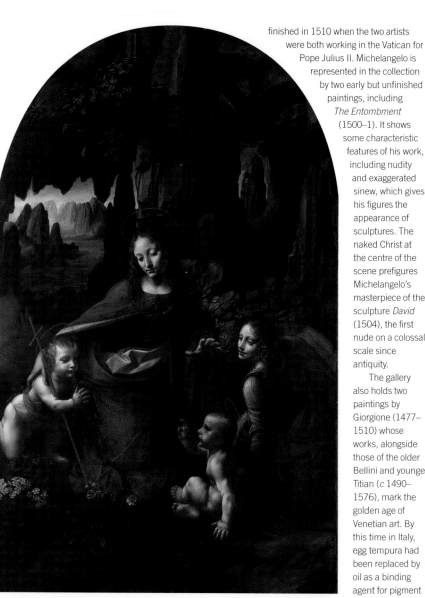

finished in 1510 when the two artists were both working in the Vatican for Pope Julius II. Michelangelo is represented in the collection by two early but unfinished paintings, including *The Entombment* (1500–1). It shows some characteristic features of his work, including nudity and exaggerated sinew, which gives his figures the appearance of sculptures. The naked Christ at the centre of the scene prefigures Michelangelo's masterpiece of the sculpture *David* (1504), the first nude on a colossal scale since antiquity.

The gallery also holds two paintings by Giorgione (1477–1510) whose works, alongside those of the older Bellini and younger Titian (*c* 1490–1576), mark the golden age of Venetian art. By this time in Italy, egg tempura had been replaced by oil as a binding agent for pigment

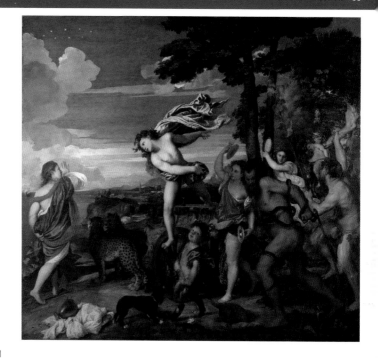

(thanks to the influence of 15th-century Flemish painters) and canvas had become popular, particularly in Venice. Allied together, these two developments allowed a wide new range of painterly effects.

One can see that as more artists mastered perspective, landscapes in the background of paintings became far more detailed and realistic. Giorgione's oil on canvas *The Sunset* (1506–10) goes one stage further: the landscape is more important than the figures, its soft mood the motor for the viewer's response.

The gallery's collection of Titians represents the outstanding range of the artist's abilities, a variety that marked him out as the greatest Renaissance painter for Europe's most important patrons. Early portraits, in particular *Portrait of a Young Man* (*c* 1515–20), reveal Titian's skill in careful observation and subtle tonal variations. In contrast, his first great mythological piece, *Bacchus and Ariadne* (1520–3), is a work of real drama due to its composition and exceptional colour. His late style, seen as proto-Modernist in its impressionistic handling of paint, is prefigured in *Diana and Actaeon* (1556–9) and epitomised by *The Death of Actaeon* (1559–75), both of which are on view.

The Origin of the Milky Way (1575) by fellow Venetian Jacopo Tintoretto (1518–94) combines a palette typical of Titian with a violent foreshortening of figures, a technique pioneered by Michelangelo in his frescoes for the Vatican's Sistine Chapel.

Tintoretto's contemporary, Paolo Veronese (1528–88), is shown to have developed a more decorative approach, lavishing attention to colour and drapery, even in religious scenes such as *The Adoration of the Kings* (1573).

Other 16th-century artists, often described as Mannerists, hone an even more individual sense of style. *The School of Love* (1525) by Parmesan painter Correggio (1489–1534) shows an artist with a fascination for flesh, able to evoke the warmth of body tissue with his brush strokes. His local rival, Parmigianino (1503–40), forsakes naturalism for elegance – note the elongation of both the finger of St John and the figure of infant Jesus in the painter's *The Madonna and Child with Saints* (1526–7). Florentine artist Bronzino (1503–72) takes artificiality further with *An Allegory with Venus and Cupid* (*c* 1545), whose figures are posed unnaturally in an erotic reverie. The way these painters abandon Classical form and decorum anticipates an emphasis on stylistic experimentation to emerge with Baroque art.

GIAMBOLOGNA
Samson and a Philistine,
c 1562
V&A
The Flemish-born sculptor
Giambologna is the missing
link between the formal

mastery of Michelangelo and
the greater excess of
Baroque sculptors like
Bernini. This bravura work is
the only large marble by the
sculptor outside of Florence.

MICHELANGELO
The Fall of Phaeton, 1533
THE ROYAL COLLECTION
Michelangelo's 'presentation
drawings' – gifts to his friend
Tommaso de' Cavalieri – are
considered some of the finest

graphic works in Western art.
This example shows all the
artist's ability with chalk, as
both horses and a human are
foreshortened with
astonishing skill as they fall
from the sky.

The medium of sculpture was of fundamental importance to Italian Renaissance artists, especially in terms of source material, as sculptures rather than paintings had survived from the classical world. The exceptional collection of Italian sculpture at the **VICTORIA AND ALBERT MUSEUM (V&A)** is apt, therefore, for comparison with pieces from ancient Greece and Rome in the **BRITISH MUSEUM**.

One can conclude that Italian sculptors were intent on surpassing rather than merely imitating the examples of the antique world. The V&A's vast Cast Courts, which are filled floor-to-ceiling with plaster casts and electrotype reproductions, include a facsimile of the groundbreaking *Gates of Paradise* (1425–52), the doors created for Florence Cathedral by Lorenzo Ghiberti (1378–1455). This early Renaissance work has a detail of representation and mastery of perspective unknown in the Classical era.

The museum has plenty of originals too, including rare works by Ghiberti's acclaimed pupil Donatello (1386–1466). *The Ascension with Christ Giving the Keys to St Peter* (1428–30) is an exemplar of the extremely low reliefs pioneered by the sculptor. Donatello's doctor, Giovanni Chellini, is chiselled out in marble in a portrait bust by Antonio Rossellino (1427–79), one of the masters of a genre revived from Roman times. Donatello paid Chellini for treatment with the superb roundel *The Chellini Madonna* (*c* 1456).

Donatello's work has a depth of emotion in contrast to that of some of his contemporaries, whose statues and altarpieces aim at a more restrained form of naturalism. The 16th century sees works of greater drama, such as the monumental *Samson and a*

Philistine (*c* 1562) by the Mannerist sculptor Giambologna (1529–1608).

The museum also holds sumptuous stained glass, statuettes, medals, domestic objects, a portrait (*c* 1470) by Botticelli, and – one of its top draws – seven painted cartoons by Raphael, on long-term loan from the **ROYAL COLLECTION**. Such studies were a Renaissance innovation, necessary for accurate representation. Other highlights from the Royal Collection include the nine-strong series *The Triumphs of Caesar* (*c* 1485–1506) by Mantegna, at **HAMPTON COURT PALACE**, and paintings by 16th-century artists including Bellini and Bronzino. Its collection of prints and drawings is world class, as is that of the British Museum. Both include works by the High Renaissance triumvirate of Leonardo, Raphael and Michelangelo; examples include the outstanding 'presentation drawings' by Michelangelo, such as *The Fall of Phaeton* (1533), which were intended as gifts rather than studies.

The **ROYAL ACADEMY OF ARTS (RA)** has on permanent display Michelangelo's superb *Taddei Tondo* (1504–6), his only marble outside Italy. The **COURTAULD GALLERY** holds drawings by the master, as well as paintings by artists including Botticelli and some decorative art from the time. Two Titians are on show at the **WALLACE COLLECTION**, alongside brasses, bronzes and maiolica, a type of painted pottery, while **DULWICH PICTURE GALLERY**, London's oldest purpose-built gallery, presents pieces by Raphael and Veronese. **UCL ART COLLECTIONS**, located in the university's Strang Print Room, holds engravings by Mantegna, and the **BRITISH LIBRARY** owns a notebook by Leonardo which, complete with sketches, gives an insight into the artist's inquisitive mind.

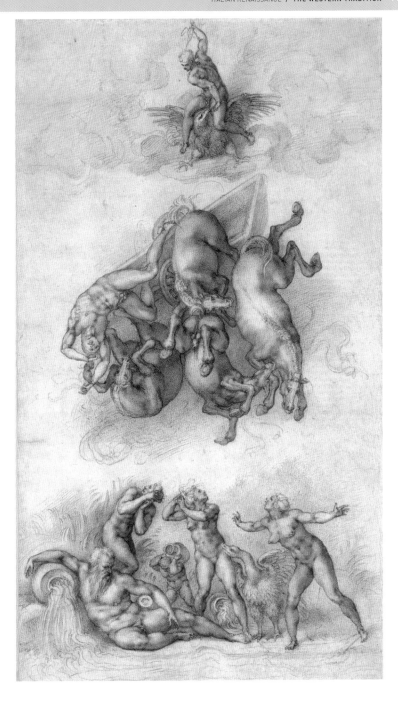

Interspersed with the **NATIONAL GALLERY**'s rooms of 15th-century Italian art are four spaces focusing on accomplishments in the Netherlands, Belgium, Germany and Austria during the same period. This is more than just paying lip service to what else was going on in Europe at the time. The revolution of the Italian Renaissance was, in several significant ways, precipitated by the experiments of artists hailing from the North.

Until the later years of the century, Florentines would prize the work of Flemish painters as highly as that of their own. The Medici dynasty, perhaps the most famous Renaissance patrons who, as well as owning the largest bank in Europe, rose to rule Florence and produced four Popes, hung pieces in their palaces by acclaimed figures from Flanders such as Jan van Eyck (1390–1441). The Bruges-based artist, together with Robert Campin (1378–1444), perfected the use of oil paint, a medium that was to transform European art.

A tug-of-war of artistic appropriation continued across the Alps over the century, embodied by prolific German artist Albrecht Dürer (1471–1528), who both took influence from and influenced Italian masters. The incipient practice of printmaking in the two countries was key. Dürer would have encountered Mantegna's engravings before using the same method to distribute his own work. The **BRITISH MUSEUM** holds one of the world's finest collections of Dürer's graphic art, exemplified by detailed engravings such as *St Eustace* (1501) and his famous drawing and woodcut of an Indian rhinoceros.

There was also a symbiosis between Italian and Northern European humanist writers. In the same way that artists used Classical methods to reinvigorate Christian art, thinkers including the Italian Giovanni Pico della Mirandola and Desiderius Erasmus of Rotterdam used Classical scholarship, from the philosophy of Greek thinker Plato, to Pliny, the writer of the history of Rome, to reform Christian thought. This spirit crystallised in the North with the Protestant Reformation, precipitated when the priest Martin Luther nailed his arguments against Catholic theology to Wittenberg's Castle Church in 1517.

Although there was no definitive uniform Northern Renaissance style, Protestantism and its antipathy towards certain types of religious art were common forces that shaped the visual culture of Northern Europe. The intense focus on portraiture in England, for instance, corresponds closely to the advent of the English Reformation. More devotional forms of art were outlawed once the leadership of the English Church was transferred in 1531 from the Pope to Henry VIII.

The brilliance of the Augsburg-born painter Hans Holbein the Younger (*c* 1497–1543) was another contributing factor. Holbein travelled to England in 1526 with a letter of recommendation from Erasmus in his pocket, and soon became the English court's most celebrated painter. His revered works helped initiate a tradition of portraiture in England that remains alive today. One can see it unfold in the **NATIONAL PORTRAIT GALLERY** and the **ROYAL COLLECTION**, as well as **TATE BRITAIN**, the gallery that houses the country's best collection of British art from 1500 on.

Albrecht DÜRER
St Eustace, 1501
BRITISH MUSEUM

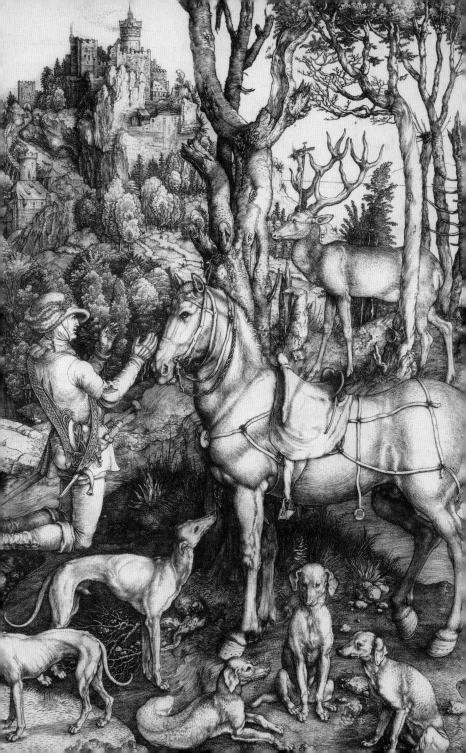

Robert CAMPIN
A Woman, c 1435
This illusionistic portrait is one of a pair by Campin, presumably of a husband and wife. In contrast to those produced in 15th-century Italy, which were normally in pure profile, portraits in Flanders were commonly composed in three-quarters view, with the sitter's face advancing towards the viewer at an angle.

Jan VAN EYCK
The Arnolfini Portrait, 1434
During the Renaissance, artists began once again to sign their work, for the first time since ancient Greece. Van Eyck wittily scribes his signature on the wall above the mirror like graffiti – 'Jan van Eyck was here 1434'. The painter himself might also be one of the figures reflected in the mirror.

The earliest notable Northern European art on view comes from the Low Countries during the 1430s, where there was a concentration of densely populated cities to rival Italy. There are few 14th-century panels from the region, but this does not mean there was no tradition of painting in Flanders at the time: while Italian Renaissance artists looked for inspiration in the panels and frescoes of artists such as Giotto, Northern Renaissance artists referred to an ancestry of manuscript painters (the **BRITISH LIBRARY** houses a magnificent selection of their works).

A portrait of a woman, dating to 1435, stands out sharply. The panel is by Campin, who is now attributed works previously given to an unknown artist, the Master of Flémalle. The piece is not just prominent because of the bright-white colour of the lady's headscarf. To a degree unmatched by any other paintings exhibited from the period, including those of the Florentine painter Masaccio, there is an almost photographic naturalism to the woman's face.

The work's fidelity to the real world can be partly explained by its use of oil. Because it had slower drying times than tempera, oil paint gave far greater opportunity for precision. The translucence of the oil that bound the paint – normally linseed – also allowed the pigment to be layered to create unprecedented depth and shade.

Van Eyck, just like Campin, contrasts the texture of a headscarf to that of a human face in a haunting portrait. Scholars have speculated that it is a self-portrait, and if this is true it marks an important point in art history, as no earlier self-portraits on panel are known. His *Arnolfini Portrait* (1434), which depicts Tuscan merchant Giovanni di Nicolao Arnolfini and his wife in a room of their home, is rightly considered one of the great masterpieces of 15th-century art. The care and attention the artist has taken is exceptional for a secular work of art, and demonstrates all his gifts, from the highly realistic perspective to the meticulous painting of details across the panel. His treatment of light is also notable. It floods in from the left-hand window, prefiguring later Dutch art, and Van Eyck treats all colours and textures carefully to represent its natural glow.

The painting is all the more extraordinary when one considers that Van Eyck, like other Flemish artists, honed perspective by trial and error, rather than by studying Classical methods. Indeed, this lack of interest in the antique world, and the emphasis on empiricism rather than a more conceptual approach, marks a major difference between early Northern and Italian Renaissance art.

Rogier van der Weyden (1400–64) was an apprentice to Campin and some of his portraits at the gallery, which are co-attributed to the artist's workshop, show a comparable ability to his teacher. The only piece undoubtedly by Van der Weyden's hand is *The Magdalen Reading* (c 1438),

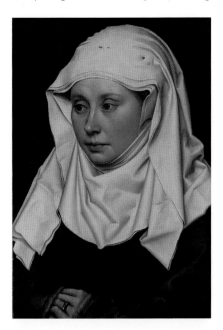

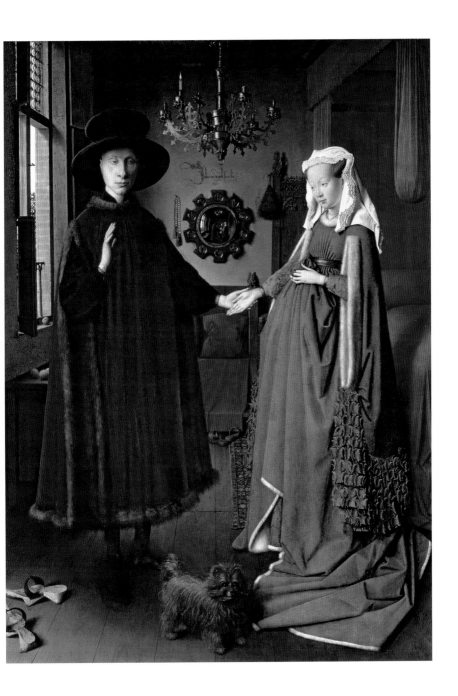

Hans HOLBEIN the Younger
The Ambassadors, 1533
Holbein's hand is at its most
sure in this famous work,
with a huge variety of
textures and details rendered
realistically across the panel.

The distorted skull in the
foreground, which is
corrected if seen from the
right, is a highly symbolic
gesture – a memento mori, a
reminder of mortality.

Lucas CRANACH the Elder
*Cupid complaining to
Venus*, c 1525
Cranach was a close friend of
Martin Luther, the priest
pivotal to the Reformation,
and many of his narrative

works can be seen as moral
allegories. This scene shows
Cupid stung by bees while
stealing honeycomb. (The
gallery believes the painting
was once part of Adolf
Hitler's private collection.)

a fragment cut from a larger work. The gentle
contours of Mary Magdalene's dress give the
painting a serenity characteristic of the artist.

The paintings by the immediate successors
of these three early Flemish artists are of a high
standard, although not quite as superb. The early
style of Dirk Bouts (c 1415–75) – strongly
influenced by Van der Weyden – is shown in

The Entombment, a very rare painting on linen
from the 1450s. Hans Memling (c 1430–94) is
well represented in the collection, including a
triptych (a piece in three panels) that shows Welsh
courtier Sir John Donne, who commissioned the
piece, kneeling with his family in front of the Virgin
and Child. The profound influence of early
Netherlandish art on other European painters

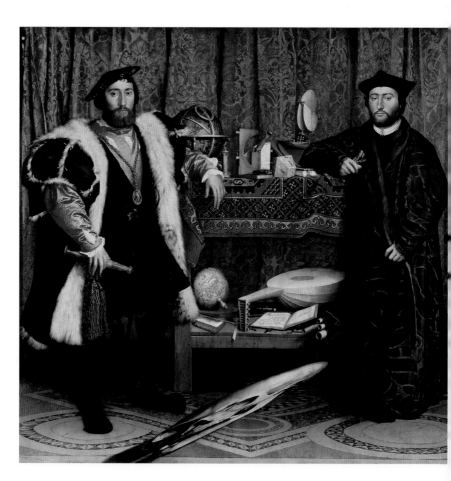

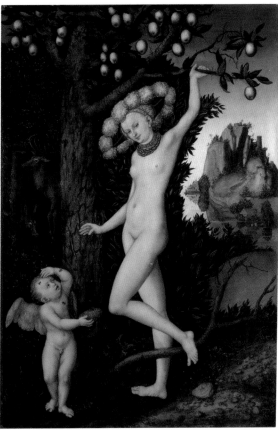

s illustrated by the work of the acclaimed Iberian Bartolomé Bermejo (c 1440–95), whose visionary scene *St Michael Triumphs over the Devil* (1468), which clads the saint in exquisite, bejewelled armour, deserves to be better known.

A small, double-sided oil panel by Dürer, from 1496, relatively early in his career, depicts St Jerome in an evocative landscape, clouds gathering in the background. Dürer was distinguished as a landscape artist, particularly in watercolour, where he raised the status of the medium. The other painting by the German master in the collection, a likeness of his father from the following year, proves his many talents extended to portraiture. He scrutinises his father's face with both empathy and accuracy, noting every detail from stubble and wrinkles to the bags under his watery eyes.

Dürer's concentration on physical individuality remains unmatched until one sees his fellow Bavarian Hans Holbein the Younger. The gallery owns three excellent works by the master, including one, dating to 1526–8, which inventively poses a lady with her pet squirrel and a passing bird. The painting that draws the most crowds, however, including art historians attempting to unravel its complex symbolism, is *The Ambassadors* (1533). The meaning of the work is not in the two diplomats' faces, but in their books and instruments, which are recreated with remarkable exactness. Scholars have related this masterpiece to the Reformation, speculating, for example, that the broken string of the lute, which lies next to a Lutheran hymnbook, may represent theological discord.

Another artist on display whose career is intertwined with the religious politics of the period is the painter and printmaker Lucas Cranach the Elder (1472–1553). The majority of his output was portraiture and several fine examples are presented, including a diptych of two of the protestant Electors of Saxony, for whom he was court painter. *Cupid complaining to Venus* (c 1525) epitomises another strand of his art: naive mythological paintings featuring naked female figures. These distinctive works divide opinion, especially when it comes to their odd rendering of the human body.

Landscape with a Footbridge (c 1518–20) is a painting by Albrecht Altdorfer (c 1480–1538) that is special for what it leaves out rather than what it includes. It is one of the very earliest works known in oil to depict a landscape without figures, and it revels in a real view of Altdorfer's native Danube

Hieronymus BOSCH
Christ Mocked (The Crowning with Thorns), *c* 1490–1500
Scarily sharp spikes replace thorns on Christ's crown, as four grotesque men prepare him for his execution. This is a typically harrowing image by Bosch, with each figure a different, potent expression of anti-Christian evil, though Jesus' unafraid gaze delivers some hope at least.

valley, rather than an imaginary idyll. Compare it to the histrionic landscape *The Death of Eurydice* (1552–71) by Niccolò dell'Abate (1509–1571), one of the founders of the Mannerist school of Fontainebleau in France.

The Netherlandish painter Hieronymus Bosch (*c* 1450–1516) has only one painting in the gallery, but what a work it is. *Christ Mocked (The Crowning with Thorns)* (*c* 1490–1500) is highly disturbing, as direct in its menace as the complex visions of heaven and hell for which Bosch is best known. It places Jesus in the centre of the canvas, looking out to the viewer while four inquisitors at the corners pen him in. The artist could paint perspective – just look at the three-dimensional leaf on the hat of the top-right figure, which pops out of the picture – but he chooses to keep the action on a single spatial plain to add an extra sense of claustrophobia.

The 16th century sees a range of other Northern artists developing Renaissance techniques in different directions. Marinus van

Reymerswaele (1490–1567) uses caricature in *Two Tax Gatherers* (*c* 1540), which shows a gift for satire perhaps influenced by another painter from Antwerp, Quentin Massys (1465–1530), whose oil copy of Leonardo's satirical drawing of a grotesque old woman is on display. Some pictures, such as *The Amazement of the Gods* (1590s) by the German Hans von Aachen (1552–1615) and *The Adoration of the Kings* (*c* 1595) by Flemish painter Bartholomaeus Spranger (1546–1611), seem to ape the Italian Mannerists in the way that their poses move away from a Classical *contrapposto*, where arms and legs are slightly off axis, to form more exaggerated twists.

In the cycle of four canvases, *The Four Elements* by Joachim Beuckelaer (*c* 1534–74), the lives of working-class traders are pushed to the forefront, although the joy is not in the people themselves, but in the produce they sell: succulent haunches of meat, huge marrows and lettuces, baskets of oily fish. These still-life market scenes are then related directly to the Bible by episodes that take place in the background; in *Fire*, Christ is shown seated through a door beyond a butcher's kitchen.

A painting by Dutchman Pieter Bruegel the Elder (1525–69), *The Adoration of the Kings* (1564), more closely connects the Bible story to everyday life. The conventions for this key Christian episode, such as the presence of angels and the regal posture of Mary and the baby Jesus, can be seen in a version by the Antwerp artist Jan Gossaert (*c* 1478–1532) of 1510–15. Bruegel's take is strikingly different. Rather than creating an ideal version of the episode in the Catholic tradition, he caricatures a village scene where the Virgin looks like an ordinary woman and Jesus acts as a child, scared and vulnerable. The commonplace does not run counter to religion in Bruegel's art – it reflects its universal truth.

Pieter BRUEGEL the Elder
The Adoration of the Kings,
1564
The figures that surround
Mary and baby Jesus in this
scene are slightly satirised by
Bruegel, but this is not in
order to disrespect the
religious subject matter. A
man wearing glasses in the
extreme right, for instance,
symbolises the blindness of
the common man to the
importance of Christ.

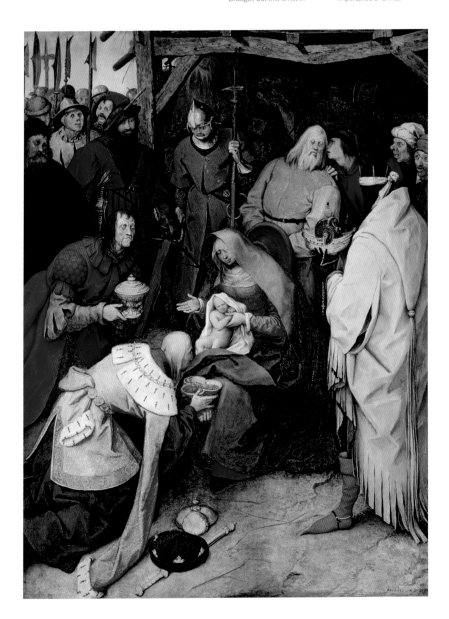

Simon BENING
*Genealogy of Dom Fernando
of Portugal*, 1530–4
BRITISH LIBRARY
This family tree is included in
a sumptuous volume painted
by Bening, which traced
Portugese royalty all the way
back to Biblical times. This
book was one of the last great
illuminated manuscripts. The
printing press soon took
precedence as a more
efficient method of
distributing both words and
images.

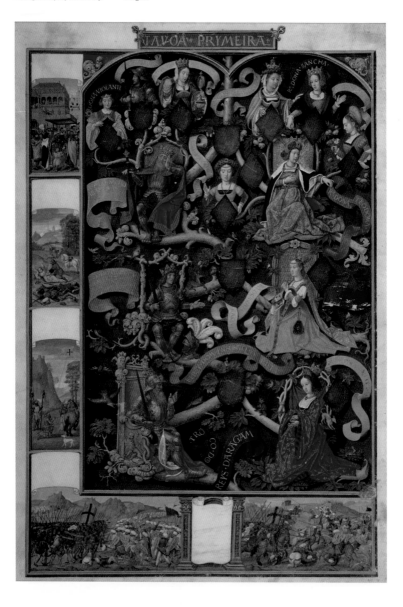

Nicholas HILLIARD
Queen Elizabeth I, 1575
TATE BRITAIN
Hilliard's portrait of the Tudor
queen is typical of the
likenesses she favoured:
shallow, opulent, without

shade or emotion. It is up to
various symbols to tell us
about the sitter. The phoenix
medallion on her breast
signifies her rise to power
and may also allude to her
virginity.

French and Flemish manuscript illuminators were some of the finest artists of the Renaissance. As well as works commissioned by the French nobleman John, Duke of Berry, the most important patron of early Renaissance manuscripts, the **BRITISH LIBRARY** holds book art by the pre-eminent painters Jean Fouquet (1420–81) and Simon Bening (1483–1561), including a beautiful genealogy by the later artist.

The **COURTAULD GALLERY** owns one of the period's earliest masterpieces on panel, *The Entombment Triptych* (c 1415) by Campin. Other highlights include a first-rate Cranach – *Adam and Eve* (1526) – and two panels by Bruegel. The Dutch painter's *Massacre of The Innocents* (1565–7), an aerial-view landscape that features a wide range of episodes, is one of many world-class works in the **ROYAL COLLECTION**. Another is *Noli me tangere* (c 1524), a rare religious work by Holbein. The collection presents portraits

by the painter, as well as works by his successors at the English court, including the fashionable Marcus Gheeraedts the Younger (c 1561–1635).

Both Holbein and Gheeraedts feature in the **NATIONAL PORTRAIT GALLERY**, which, with more than 1,400 portraits on display throughout the year, delivers a complete overview of British portraiture. Tudor portraits are also presented in venues as diverse as the **NATIONAL MARITIME MUSEUM**, **DULWICH PICTURE GALLERY**, **TATE BRITAIN**, the **MUSEUM OF LONDON** and the **HUNTERIAN MUSEUM**. The National Maritime Museum presents the majority of its fine art at Greenwich's **QUEEN'S HOUSE**, the earliest example of Renaissance architecture in England. It was completed in 1635 by architect Inigo Jones (1573–1652), who is immortalised in a skilful

portrait by William Dobson (1611–46) at **CHISWICK HOUSE**.

Nicholas Hilliard (c 1547–1619) emerges in these collections as one of the greatest portrait artists, especially in the genre of miniatures. He became a favourite of Elizabeth I from 1570, and one of his most well-known works (now at Tate Britain) represents the English icon in exquisite costume. The **VICTORIA AND ALBERT MUSEUM (V&A)** dedicates a gallery to miniatures, which includes an excellent work by François Clouet (c 1516–72), if not any by his father Jean (c 1485–1540/1), the principal French portraitist. The museum exhibits Northern sculpture alongside Italian, so one can note its particular characteristics, such as a greater use of wood. Limoges in France was celebrated for its enamel work on metal, and the **WALLACE COLLECTION** showcases beautiful examples.

Renaissance carving first came to London in the form of the gilt-bronze Italianate tomb of Henry VII and his queen in **WESTMINSTER ABBEY**. Henry VIII employed Florentine sculptor Pietro Torrigiano (1472–1528) to create this grand monument to his father. The **GOLDSMITHS' COMPANY** displays a stunningly carved silver cup used by Elizabeth I at her coronation.

As well as its superb Dürer collection, the **BRITISH MUSEUM**'s graphic art includes drawings by Cranach, Altdorfer and Bruegel, plus engravings by Van der Weyden, Holbein, Bosch and the master-printmakers Lucas van Leyden (1494–1533) from the Netherlands, and Martin Schongauer (c 1448–91), Dürer's predecessor in Germany. Works on paper are also held in the **UCL ART COLLECTIONS**, as well as in the Courtauld Gallery, which owns Bruegel's only etching.

The word 'baroque' was initially an adjective of abuse, derived from the Portuguese description of imperfect teeth and pearls (*barroco*). It was not until 1758 that it was written in relation to the arts, when French critic Denis Diderot used it to mean 'bizarre'. How this term of dismissal turned to one of praise, and how it became a catch-all title for 17th-century culture, is hard to fathom. There is an occasional 'bizarre' extravagance to the art but, visiting the pre-eminent collections of the **NATIONAL GALLERY**, other trends are also evident that complicate any simple definition, such as idealisation and a preoccupation with light.

Perhaps it is best to proceed with words in mind from *Romeo and Juliet* (1597) by the period's supreme dramatist, William Shakespeare: 'What's in a name? That which we call a rose / By any other name would smell as sweet.'

As the 16th-century turned and Shakespeare established himself in London, the Scottish King James I assumed the English throne and thereby set the stage for the creation of the United Kingdom. His son Charles I was also to prove influential, and not only for his execution in 1649, which precipitated the country's brief time as a republic. Charles was one of Europe's major art collectors, buying the work of High Renaissance Old Masters as well as contemporary artists including Flemish painters Peter Paul Rubens (1577–1640) and Anthony van Dyck (1599–1641).

The former established an international reputation to match that of Titian and, having received a knighthood, created for Charles a series of magnificent ceiling paintings at London's **BANQUETING HOUSE**, which can still be seen in situ today. The king's many masterpieces were dispersed after his execution, but those that were recovered after the restoration of the monarchy in 1660, when Charles II came to power, form the foundation of the **ROYAL COLLECTION**.

London caught up in architecture as well as art when a soaring new **ST PAUL'S CATHEDRAL** was commissioned in the Baroque style after the Great Fire decimated the city in 1666. Its architect, Christopher Wren (1632–1723), was a founder of the **ROYAL SOCIETY**, the world's oldest scientific academy, which encouraged a new spirit of enquiry and discovery. In the Age of Enlightenment that was to follow, science and art were close partners; their connections are often explored in venues such as the **SCIENCE MUSEUM**, **NATURAL HISTORY MUSEUM** and **WELLCOME COLLECTION**.

Numerous new academies dedicated to art were founded in Italy during the 17th century. Rome, in particular, remained an essential destination for every painter, as the revived Catholic Church commissioned painting, sculpture and architecture across the city. Counter-Reformation art in Italy, as well as in Spain, had a distinctly dramatic, emotional character, in an effort to heighten religious experience. Elsewhere, aristocrats aspired to the French court style of Louis XIV, whose Palace of Versailles became a byword for opulence, while the rich Dutch Republic, dominant in trade and tolerant of difference, allowed artists freedom to innovate on their own terms.

Peter Paul RUBENS
The Whitehall Ceiling: The Apotheosis of James I,
1632–4
BANQUETING HOUSE

Michelangelo Merisi da
CARAVAGGIO
*Salome receives the Head
of John the Baptist*,
1607–10
Caravaggio's use of shadows
gives vivid intensity to the
gestures of his biblical
characters. In this canvas,
finished in Naples in the
artist's final years, chiaroscuro
is exploited even more
radically, eradicating colour to
create a mood of dark tragedy
as a vengeful Herodias holds
up St John's head.

As a struggling young painter, Michelangelo
Merisi da Caravaggio (1571–1610) peddled
still lifes and half-length figures from the streets of
Rome, and *Boy Bitten by a Lizard* (c 1595–1600)
combines both forms in a scene of high drama.
A boy is captured realistically at the moment of
convulsion, his finger bitten by a lizard that jumps
out from a still life of flowers and fruit. The robust
foreshortening and high-contrast chiaroscuro
at play are used to more emphatic effect in the
religious scenes for which the master shot to fame,
such as *The Supper at Emmaus* (1601) and
Salome receives the Head of John the Baptist
(1607–10), his two other works on display.

Caravaggio's models were working people,
and one can see that he kept their actual clothes
and faces in his pictures in an effort to make his
religious scenes relevant for the contemporary
viewer. For Bologna-born Annibale Carracci (1560–
1609), turning the disciples into commoners was
taking realism too far; instead, his paintings on view
return to idealisation. There is a modern sensibility
in the dramatic use of light in *The Dead Christ
Mourned* (1604), although in many ways the work
is a studied refinement of High Renaissance
values: Titian, in the bright drapery, Raphael, in the

Nicolas POUSSIN
The Adoration of the Golden Calf, 1633–4
Poussin's combination of discipline and dazzle is key to his renown. In this exciting scene, which illustrates the Israelites' pagan worship of an idol in the absence of Moses on Mount Sinai, the busy action is unified by an even distribution of blue, red and orange across the canvas.

harmonious composition, and Mantegna, in the Classicism of Jesus' body.

The collections present other artists active in Rome who mirrored Carracci's method, including German painter Adam Elsheimer (1578–1610) and the Bolognese artists Guido Reni (1575–1642) and Domenichino (1581–1641). *The Coronation of the Virgin* (1607) demonstrates Reni's exceptional compositional ability. A later artist of the Bolognese school, Guercino (1591–1666), combines Carracci's softness of line and colour with some of Caravaggio's chiaroscuro. The styles of Carracci and Caravaggio offered European painters a way out from the dead-end of Mannerism, which had abandoned accurate representation.

The Rome-based French master Nicolas Poussin (1594–1665) allies a careful study of nature and Classicism, characteristic of the art

academies that were being set up by Carracci and his followers, with a sensuality inspired by Titian. The most alluring of the gallery's large group of his works capture figures in dance, their skin a memorable, peach-like hue. *The Adoration of the Golden Calf* (1633–4) takes its design of drunken dancers from *A Bacchanalian Revel before a Term* (1632–3), but has a greater depth of field and more pronounced colour contrasts. In *The Triumph of Pan* (1636), nymphs, satyrs and goats intertwine in myriad extravagant positions; unlike in Mannerism, however, the figures are all in rational proportion.

Rubens' *Samson and Delilah* (1609–10) echoes Caravaggio in its light and shade, as well as Michelangelo in its musculature. By the time of *Minerva protects Pax from Mars* (1629–30), the Flemish artist has a style fully his own, characterised by loose brush strokes, rich colours,

REMBRANDT van Rijn
Self Portrait at the Age of 63, 1669
Rembrandt produced over a hundred self-portraits in painting and print. This example was painted in his last year, by which time his son and wife had passed away, and he was bankrupt. It is characteristically honest, the paint applied thickly with a palette knife to create extra pathos.

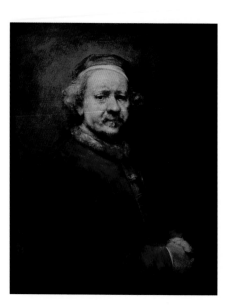

energetic arrangements and eroticised women. In his wonderful late work *The Rape of the Sabine Women* (1635–40), Rubens' application of paint has become so fluent and intuitive that it almost resembles one of the artist's oil sketches on show. Three portrait pictures demonstrate another genre in which Rubens excelled, and there are also several by his studio, likened to a factory due to its productivity.

A room celebrates Van Dyck, one of Rubens' former pupils. The artist appears keen to flatter all his noble sitters, even in double portraits, making thin teenagers like the Lords John and Bernard Stuart (*c* 1638) look confident, and plain women such as Lady Thimbelby and Viscountess Andover (1637) stylish. In contrast, Frans Hals (1581–1666), who worked in Haarlem in the Netherlands, tended to paint ordinary citizens, often in large groups. Even when depicting a person of greater status, such as the master calligrapher Jean de la Chambre (1636), Hals' quick brushwork captures the sitter's personality with spontaneity rather than studiousness.

This lively technique can be compared again with *Portrait of Aechje Claesdr* (1634) by Rembrandt (1606–69), the Amsterdam-based painter nearly 30 years Hals' junior. The handling is also unconventional but, instead of an impression of speed, there is one of time spent in frank and deeply felt observation. This style is particularly emotive in his two self-portraits on view, aged 34 (1640) and 63, in his last year (1669). No previous artist scrutinised himself so often, and few have since so unflinchingly. Rembrandt's impressive narrative works, such as *Belshazzar's Feast* (1636–8), are indebted to Caravaggio. The Italian artist's example loomed large in both the Netherlands and Spain, as both countries enjoyed their respective golden ages of art.

A significant figure in Spanish art is Domenikos Theotokopoulos, known as El Greco (1541–1614), or 'The Greek', because of his Cretan birth. In *Christ driving the Traders from the Temple* (*c* 1600), the best of three works by the painter, the figures are so contorted that they evoke some kind of holy rapture. Although influenced by Venetian Mannerism, the painting's composition

Diego **VELÁZQUEZ**
The Rokeby Venus,
1647–51
The female nude was very
rare in Spanish art, because
of objections by the Church
and its censor, the
Inquisition. Velázquez evokes
the beauty of Venus with his
creamy handling of paint, but
also her vanity, as her
indistinct reflection stares out
from the mirror.

and colour (dull-grey flesh punctuated by bright drapery) have a violent, visionary individuality that anticipates the Baroque.

Saint Francis in Meditation (1635–9) by Francisco de Zurbarán (1598–1664) mixes mysticism with the Caravaggesque realism practised by his compatriot, Jusepe de Ribera (1591–1652), also on display. Francis' face is obscured in darkness while the skull in his hands is bathed in a ray of eerie light. Zurbarán was succeeded in Seville by Bartolomé Esteban Murillo

(1617–82), whose *The Infant Saint John with the Lamb* (1660–5) promotes a more sentimental piety.

Diego Velázquez (1599–1660), the century's most celebrated Spanish artist, appears inspired by courtliness rather than Catholicism. *Christ in the House of Martha and Mary* (1618) is in the vein of Flemish painters like Beuckelaer, while *Christ Contemplated by the Christian Soul* (1628–9) emulates the Bolognese style. His brushwork comes to life in his court portraits on view that include two of Philip IV, his primary patron, and his

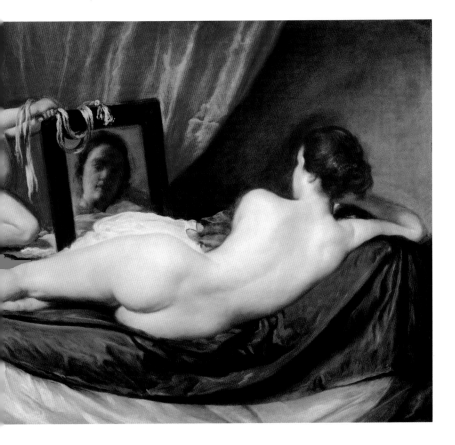

CLAUDE
Landscape with the Marriage of Isaac and Rebecca, 1648
Claude Gellée, known as Claude or Claude Lorrain, brought Classical beauty to the nascent genre of landscape. This radiant work uses trees to frame and balance the action, and mixes biblical Arcadia with contemporary life, with Greek ruins flanked by a modern watermill in the background.

magnetic likeness of Archbishop Fernando de Valdés (1640–5). The gallery's most acclaimed Velázquez is *The Rokeby Venus* (1647–51), the only surviving female nude by the artist.

The influence of Pieter Bruegel's aerial landscapes can be seen, for example, in *The Adoration of the Kings* (1598) by his son Jan Brueghel the Elder (1568–1625), as well as in Rubens' resplendent autumn scene *A View of Het Steen in the Early Morning* (1636). There are also some notable works in the genre by the unconventional Neapolitan painter Salvator Rosa (1615–73), whose interest in the occult is demonstrated in the nocturnal vision *Witches at their Incantations* (c 1646).

The most highly sought-after landscape painter on view was Claude (1604–82). His large canvases like *Landscape with the Marriage of Isaac and Rebecca* (1648) have a serenity and sense of order more typical of Italian religious art. Claude would sketch the real Roman landscape, alongside his fellow French expatriate Poussin, but the final paintings are imagined antique idylls, featuring Classical architecture and figures from myth and religion. The diffusion of sunlight, particularly on horizons, gives the images a glow that landscape painters have long-strived to replicate.

Pictures by the prolific Dutch artist Jan van Goyen (1596–1656) turn away from the past, favouring contemporary land and sea views in

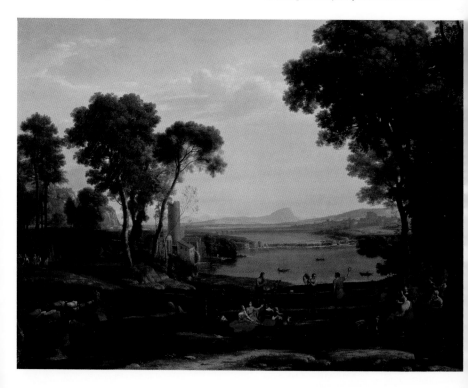

Johannes VERMEER
A Young Woman standing at a Virginal, *c* 1670–2
The play of light becomes the subject for the Delft-based master – the way it reflects different areas of plaster, shapes the woman's skirt, sparkles the gold frame. Another force at play is symbolism. What, if anything, do the elements of the scene signify about the woman?

muted, harmonious tones. *A River Scene, with a Hut on an Island* (1640–5) glorifies the sky – it dominates over three-quarters of the pictorial space.

Other Northern landscape artists hone their own styles: Simon de Vlieger (1601–53) focuses on marine paintings; Aert van der Neer (1603–77) specialises in winter and moonlight scenes; Jacob van Ruisdael (1628–82) creates more dramatic works with a varied palette, often painting panoramas; and Aelbert Cuyp (1620–91) ravishes Claude-like light over his native Dutch countryside in *River Landscape with Horseman and Peasants* (1658–60), his largest surviving painting.

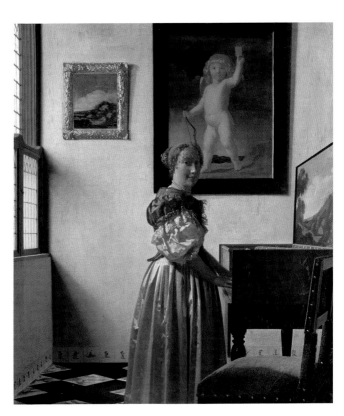

There was a mass market for still lifes as well as landscapes among the burgeoning professional classes of Northern Europe. The still-life genre is exemplified by decorative pieces like *Flowers in a Vase* (1685) by renowned Düsseldorf-based Rachel Ruysch (1664–1750), as well as 'vanitas' works that – in the manner of Holbein – arrange objects, such as skulls, to reflect on human vanities. Paintings by Dutchman Jan Steen (1626–79) and Flemish artist David Teniers the Younger (1610–90) represent another new type of art, known as 'genre' scenes: episodes from working-class domestic life. Their accessible subject matter and cautionary moral messages struck a chord with the middle classes.

Artists in the Netherlands, such as Gerard ter Borch (1617–81) and Pieter de Hooch (1629–84), turn their attention to the bourgeoisie in a selection of works, for example the latter's *A Woman Drinking with Two Men* (1658), a delicately painted interior scene. *A Young Woman standing at a Virginal* (*c* 1670–2), one of two late interiors by the celebrated Johannes Vermeer (1632–75), has an extremely sensitive use of light that heightens a simple scene into one of ethereal beauty.

Anthony VAN DYCK
*Charles I with M. de St
Antoine*, 1633
THE ROYAL COLLECTION
As painter to the Stuart court,
the Flemish artist Van Dyck
painted Charles I in several
monumental equestrian

portraits, of which this fluent
work is the finest. The low
vantage point gives the
diminutive English monarch
a more imposing
appearance, and the
beautiful horse adds to his
nobility.

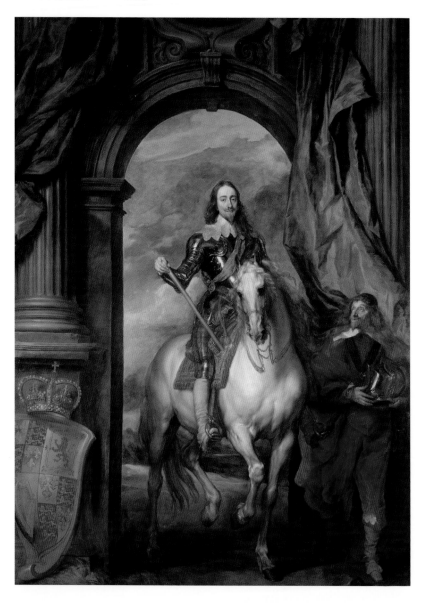

Giovanni Lorenzo BERNINI
Neptune and Triton,
1622–3
V&A
Neptune and Triton were
Classical gods of the sea,
father and son respectively.
This magnificent work – the
only large-scale sculpture by
Bernini outside Italy –
replaces Classical
composure for a Baroque
sense of action. Neptune's
hair and cloak blow in the
wind, while Triton emerges
from the waves.

The 17th-century collections of the **VICTORIA AND ALBERT MUSEUM (V&A)** are so diverse, particularly in decorative art, that they make the case that Baroque was a global style, influencing craftsmen from China to Mexico. The most famous sculptor, however, was Italian: Giovanni Lorenzo Bernini (1598–1680), well known for his works of art and architecture around Rome. His monumental statue *Neptune and Triton* (1622–3) has an overt theatricality that epitomises the period.

The museum holds both a painting and tapestry by French artist Charles Le Brun (1619–90), an important figure who commissioned dramatic decoration for Louis XIV's palaces. He is celebrated by a bust in the **WALLACE COLLECTION**, whose Baroque highlights include Rubens' glorious *The Rainbow Landscape* (1635) and *The Laughing Cavalier* (1624) by Hals.

The **ROYAL COLLECTION** possesses important examples of Dutch Golden Age art, including a sublime Vermeer, as well as canvases by Italian and Flemish names from Caravaggio to Jan Brueghel. The palaces also hold more than 20 portraits by Van Dyck, including his masterpiece *Charles I with M. de St Antoine* (1633), plus plenty by the subsequent English court painter Peter Lely (1618–80) and a rare self-portrait by the Italian Artemisia Gentileschi (1593–1653), who followed in the footsteps of two early female painters, Lavinia Fontana (1552–1614) and Sofonisba Anguissola (1532–1625), both unfortunately not represented in London's public galleries. Artemisia also helped her father Orazio (1563–1639) complete ceiling paintings for **QUEEN'S HOUSE**, and these are now installed in **MARLBOROUGH HOUSE**.

APSLEY HOUSE hangs the collection of the English military hero the Duke of Wellington, whose acquisitions included four world-class works by Velázquez. The Iveagh Bequest at **KENWOOD HOUSE** is definitely worth a visit for the bucolic surroundings of Hampstead Heath as well as its art, which includes Hals and Vermeer, among other later and earlier masters. **MANSION HOUSE** also holds notable 17th-century Dutch art.

DULWICH PICTURE GALLERY's many attractions include Rembrandt's *A Girl at a Window* (1645) and Poussin's *The Triumph of David* (1628–31). Rubens is the focus of the **COURTAULD GALLERY**'s Baroque collection. Highlights from the **BRITISH MUSEUM**'s works on paper include the Flemish artist's portrait drawing of Isabella Brant (*c* 1621) and Rembrandt's painterly etchings and drypoints – original prints, rather than reproductions, which met with more acclaim in his lifetime than his canvases.

Wren's **OLD ROYAL NAVAL COLLEGE** is a paean to England's maritime might, with magnificent ceiling paintings by James Thornhill (1675–1734), and the nearby **NATIONAL MARITIME MUSEUM** holds works by Willem van der Velde (1611–93), the Dutch draughtsman who kick-started British marine art. The museum, like the **NATIONAL PORTRAIT GALLERY** and **TATE BRITAIN**, also features portraits of figures so central to 17th-century London life as Oliver Cromwell, the leader of Britain's brief republic, and the diarist Samuel Pepys, who is captured by German-born court painter Godfrey Kneller (1646–1723). His portraits are also on view at venues including the **ROYAL HOSPITAL CHELSEA**, alongside works by Van Dyck and Lely.

While the term Baroque suffers by virtue of its breadth, Rococo is more pinpointed in its particularity. It refers to a specific style of French art and design from the first half of the 18th century, characterised by light, playful and sensual forms.

Although it influenced the arts of other countries, Rococo had its origin and definitive expression in Paris, and specifically the royal court. By the turn of the 18th century, Louis XIV – the self-proclaimed Sun King who had been one of the continent's major patrons of art for more than five decades – showed signs of tiring of the grand Italianate Baroque decoration that predominated in his palaces. In 1699 he urged his new architect and interior designer Jules Hardouin-Mansart (1646–1708) to emphasise youth and grace over solemnity.

This looser approach started to shape some late-Louis XIV decoration, before becoming the central theme to the art commissioned during the reign of his son, Louis XV, who came to the throne in 1715. The king and his mistress, Madame de Pompadour, favoured the effervescent form of interior pioneered by Nicolas Pineau (1684–1754) and Juste Aurèle Meissonier (1695–1750). These artists subordinated the architectural to the ornamental, covering every surface with extravagant, asymmetrical curving forms reminiscent of flora and the spray of fountains, as if the garden outside had come indoors. The word Rococo has an associated derivation, coming from rocaille, the shell-shaped rock forms popular in garden grottos.

The freedom and frivolity of this decoration was mirrored in paintings and sculpture. In France's Royal Academy, a clique of artists argued for art that excited the senses rather than the mind. The group was known as the Rubenists, due to their admiration for the Flemish painter's passionate use of colour, and they became more influential than the Poussinists whose intellectual design methods had dominated the Academy since its inception in 1648.

The first definitively Rococo painter was Jean-Antoine Watteau (1684–1721), the Valenciennes-born artist-craftsman whose painting *Pilgrimage to the Isle of Cythera* was accepted for display by the Academy in 1717. It portrayed a *fête galante*, an aristocratic party, and heralded a whole genre of paintings that celebrated the idle pursuits of the elite. Later in the century, François Boucher (1703–70) and Jean-Honoré Fragonard (1732–1806) became the most important French painters, pushing the style in even more luxuriant directions.

The latter's *The Swing* (1767) is the most famous masterpiece of Rococo art at the **WALLACE COLLECTION** in London's Hertford House. The mansion was once the home of Richard Wallace and his descendants, and is now a national museum exhibiting the family's acquisitions of European art, including London's finest group of 18th-century French paintings. The mansion's interior is a tribute to the glamour of pre-revolutionary France, displaying luxury objects once owned by the last line of French royalty. The museum has fewer works of Italian and German Rococo, which can be covered in depth by visits to see the **ROYAL COLLECTION**, and to the **NATIONAL GALLERY, VICTORIA AND ALBERT MUSEUM (V&A)** and **COURTAULD GALLERY**.

Jean-Honoré FRAGONARD
The Swing, 1767
WALLACE COLLECTION

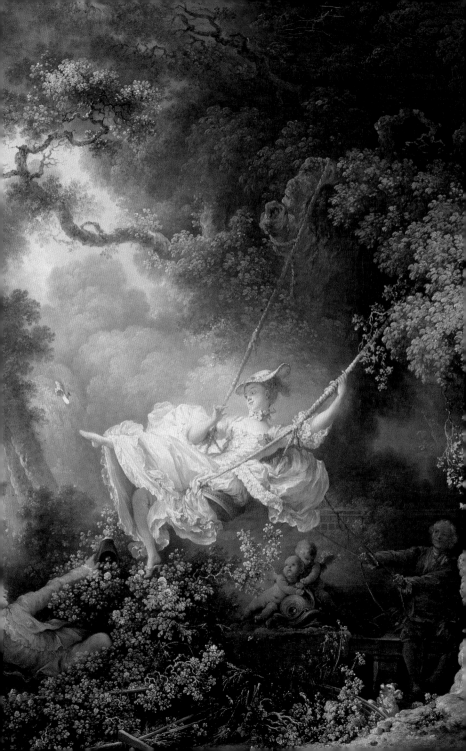

Jean-Antoine WATTEAU
Les Champs Élisées,
1718–19
The elegant figures in
Watteau's *fête galantes* have
a faux informality. They seem
at ease but, through their
arrangement, the French
artist hints at subtexts. In this
example, the boisterous
lovers in the background
contrast the placid, platonic
group in the foreground,
where a sculpture of Venus is
asleep.

The Wallace Collection offers something unique
for the London art lover. Paintings and
sculptures are arranged in spaces alongside lavish
objects and interior decoration, recreating the
experience of total immersion in art that French
aristocrats once enjoyed.

There is no set chronology to the displays,
but if you want to follow a Rococo trail around the
mansion, start on the ground floor Billiard Room.
It features fine works by André-Charles Boulle
(1642–1732), furniture-maker extraordinaire for
Louis XIV and specialist in the inlay of wood and
metal illustration, known as marquetry. The pieces
demonstrate the gradual movement towards the
Rococo style at the end of the king's reign.
A cabinet dating from 1665–70 is typically

Baroque in its imposing form and bold, naturalistic
marquetry, which depicts still lives of flowers and
insects. A toilet mirror of 1713, in contrast, features
refined, thin swirls of decoration, in brass and turtle
shell, gently undulating across the entire wooden
surface.

Watteau is introduced in this room with two
wide canvases, including *Fête in a Park* (1718–20)
which is a larger, revised version of *Les Champs
Élisées* (1718–19), an intimate work on display with
other characteristically diminutive *fête galantes* in
the upstairs Small Drawing Room; the space's
frame-by-frame arrangement of works by Watteau
and his followers, Jean-Baptiste Pater (1695–
1736) and Nicolas Lancret (1690–1743), is one
of the highlights of the museum. As well as their

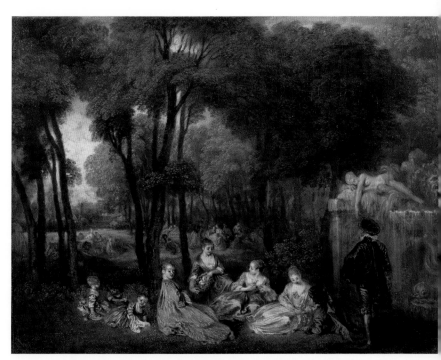

Alexandre FORTIER
Astronomical clock, *c* 1750
Made for Jean Paris de
Monmartel, royal banker and
godfather to Madame de
Pompadour, this remarkable
clock takes the Rococo style
to new heights of splendour.
The combination of
flamboyant gilding, patinated
putti and multiple dials gives
a sense of super-abundance.

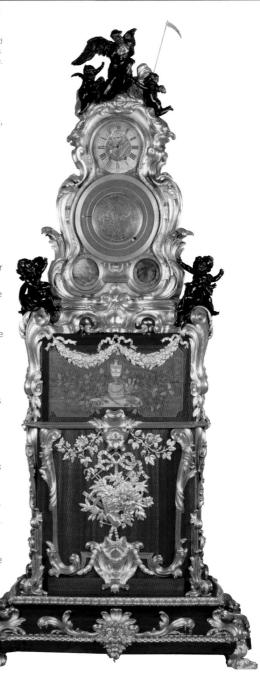

subject matter – young, wealthy, pleasure-seeking
men and women fawning here-and-there at leisure,
more often than not in the ground of a park or
garden – the *fête galantes* are characterised by
richly painted costume, inspired by Venetian art,
and looseness in the treatment of trees, plants and
stone work.

The Back State Room on the ground floor is
one of the mansion's most majestic spaces,
showcasing the high-Rococo style esteemed by
Louis XV and Madame de Pompadour. Rampant
curls of gold unfurl across the room's walls,
curtains and objets d'art, unifying the space in their
opulence. The paintings are of less importance
than the objects, which include Louis XV's favourite
chest of draws (1739), by Antoine-Robert
Gaudreaus (1682–1746), and an extraordinary
astronomical clock (*c* 1750) designed by Alexandre
Fortier (*c* 1700–70).

The royal love of porcelain is revealed by some
outstanding works from Sèvres where, with Louis
XV and Madame de Pompadour's support, a
factory was established that remains famous to this
day. Perhaps the most distinguished example is an
ornate inkstand, adorned with miniature globes,
which was given by Louis XV to his daughter. The
French appear to have gilded their ceramics at
every opportunity; upstairs next to the *fête galantes*
are 18th-century examples of Chinese celadon
mounted in gilt-bronze.

The Rococo style is also at its most spectacular
in the grand staircase that leads up to the first floor.
It features a gilded iron balustrade (1719–20) that
once graced the premises of the Royal Bank of
France in Paris. Four full-size works by Madame de
Pompadour's favourite painter, Boucher, hang on
the walls, and include *The Setting of the Sun*
(1752). In composition, these mythological
paintings owe much to the example of
Rubens, with action orientated along
different diagonals to create a sense of
movement. But Boucher's vision of the
world is one of poise and sensuality rather

François BOUCHER
The Setting of the Sun,
1752
This work and *The Rising of the Sun* were the basis of tapestries commissioned for

Louis XV's bedroom. Louis XV inherited his father's association with the sun god Apollo, shown here returning to the sea at night after bringing light to the day.

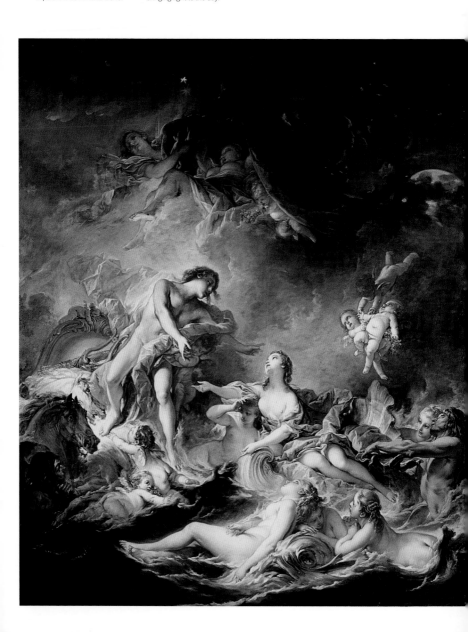

Thomas GAINSBOROUGH
Miss Elizabeth Haverfield,
early 1780s
This lovely portrait by the
English artist has the feeling
of spontaneity that
characterises his mature

work. Very rough and rapid
strokes create the landscape,
making it appear almost
abstract, but the girl's dress
is painted delicately, and her
face has charm and dignity.

han tumultuous drama. The swirling tides form
comfortable chaise longues for naked figures who
swoon as if in love.

This erotic mood permeates the pastoral
scenes Boucher pioneered, such as *An Autumn
Pastoral* (1749) on the first-floor landing, which
shows a peasant feeding grapes to an elegant
lady, as a sleepy boy looks on voyeuristically.
The master of this type
of sexualised scene,
however, seems to be
Fragonard. *The Swing*
(1767), on view
upstairs in the Oval
Drawing Room,
features the popular
motif of a woman on
a swing, which
symbolised the
fickleness of female
flirtation and love.
Fragonard makes the
metaphor steamier by
placing the young lady's
lover behind a bush.
He thrusts out his arm
towards her opening
pink dress, as her
shoe falls off her foot,
signifying her loss
of virginity.

The artist was adept at paintwork as well
as provocative symbolism: note the lovely handling
of the leaves, frills and late-afternoon light. The
same applies to Boucher, as one can see from his
radiant portrait of *Madame de Pompadour* (1759)
in the same room. Her dress is recreated in
exquisite detail, to the point where one can
almost feel the silk and lace.

Two female portraits in the Great Gallery, *Miss
Elizabeth Haverfield* (early 1780s) and *Mrs Mary
Robinson (Perdita)* (1781), represent the English

painter Thomas Gainsborough (1727–88).
Both show the influence of Watteau in their free
brushwork, but it is used here for a different end:
to vividly capture an impression of the sitter's
character, as if in a passing moment, for the
viewer. The 'sensibility' of individuals – the nature
of their perceptions and sensations of others and
the world – was a popular topic in Europe, analysed
by philosophers such
as John Locke and
David Hume. The
portraits on view by
Jean-Baptiste Greuze
(1725–1805) take
sensibility in a sickly
sweet, sentimental
direction.

One can compare
Gainsborough's work to
12 portraits, on view in
a variety of rooms, by
his great rival Joshua
Reynolds (1723–92).
Their more self-
conscious style is
characteristic of the
studied Neoclassicism
that took over English
art. It was a spirit also
seen in late 18th-
century French art, as
testified by works in the Study, a space dedicated to
Marie Antoinette, the last queen of France. Her
elaborate drop-front desk (1780), designed by
Jean-Henri Riesener (1734–1806), is gilded with
mounts showing Classical male figures. And in
1789, on the eve of revolution, her favourite artist
Elisabeth-Louise Vigée Le Brun (1755–1842) poses
Madame Perregaux with a Classical balustrade
rather than a rose garden, in a lively but less
excessive style than Boucher and other
predecessors.

CANALETTO
The Bacino di San Marco on Ascension Day, *c* 1733–4
THE ROYAL COLLECTION
Canaletto demonstrates all his technical abilities with this representation of 'The Wedding of the Sea', an Ascension Day ceremony that commemorated Venice's marine power. The painter was renowned for his accuracy, completing many of his canvases outdoors rather than in the studio.

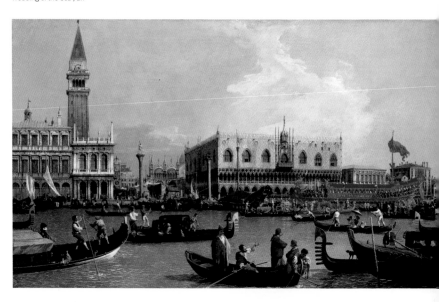

The Wallace Collection's selection of landscapes by Canaletto (1697–1768) are dwarfed by those of the **ROYAL COLLECTION,** which has the largest quantity of his work in the world. The Italian's clear, highly detailed vistas of Venice, such as *The Bacino di San Marco on Ascension Day* (*c* 1733–4), appealed to English aristocrats on their Grand Tours, as well as English topographical artists, such as Paul Sandby (1731–1809), also well represented in the Royal Collection, and Samuel Scott (1702–72), whose marine paintings are at the **NATIONAL MARITIME MUSEUM**.

Canaletto borrowed his light palette from French Rococo, while his successor in Venice, Francesco Guardi (1712–93), adopted its free handling of paint. One can compare their landscapes at the **NATIONAL GALLERY**, in a room close to pieces by Guardi's brother-in-law, Giovanni Battista Tiepolo (1696–1770), the greatest Italian Rococo painter. The Venetian was famous for his vivacious frescoes in palaces across Europe. *An Allegory with Venus and Time* (*c* 1754–8) on view was intended to decorate a ceiling in his home city

French Rococo highlights at the gallery include the final picture (1763–4) of Madame de Pompadour, painted by François-Hubert Drouais (1727–75), and three charming genre scenes by Jean-Siméon Chardin (1699–1779), who had a more restrained style – alas, the painter's superlative still lifes are not held in the collection.

The gallery has a great group of Gainsboroughs, including his early masterpiece *M and Mrs Andrews* (1750) and some evocative landscapes. One can appreciate his influence at the **NATIONAL PORTRAIT GALLERY, KENWOOD HOUSE**, the **ROYAL ACADEMY OF ARTS (RA)**, where the painter was a member, and **DULWICH PICTURE GALLERY**, which also exhibits works by Watteau, Canaletto and Tiepolo. The English artist's graphite and chalk works are particularly picturesque; the **COURTAULD GALLERY** holds a notable collection alongside several of his

Giovanni Battista TIEPOLO
An Allegory with Venus and Time, *c* 1754–8
NATIONAL GALLERY
Tiepolo painted mythological subjects with a bravura inspired by the High Renaissance masters. This oval piece, intended for a ceiling, is typical of the Italian's work in the way it mixes vigour with a lightness of palette and subject. The figure of Time cradles a baby boy, passed from Venus.

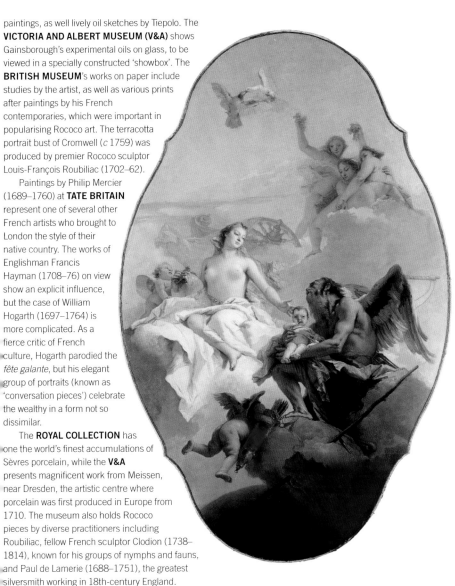

paintings, as well lively oil sketches by Tiepolo. The **VICTORIA AND ALBERT MUSEUM (V&A)** shows Gainsborough's experimental oils on glass, to be viewed in a specially constructed 'showbox'. The **BRITISH MUSEUM**'s works on paper include studies by the artist, as well as various prints after paintings by his French contemporaries, which were important in popularising Rococo art. The terracotta portrait bust of Cromwell (*c* 1759) was produced by premier Rococo sculptor Louis-François Roubiliac (1702–62).

Paintings by Philip Mercier (1689–1760) at **TATE BRITAIN** represent one of several other French artists who brought to London the style of their native country. The works of Englishman Francis Hayman (1708–76) on view show an explicit influence, but the case of William Hogarth (1697–1764) is more complicated. As a fierce critic of French culture, Hogarth parodied the *fête galante*, but his elegant group of portraits (known as 'conversation pieces') celebrate the wealthy in a form not so dissimilar.

The **ROYAL COLLECTION** has one of the world's finest accumulations of Sèvres porcelain, while the **V&A** presents magnificent work from Meissen, near Dresden, the artistic centre where porcelain was first produced in Europe from 1710. The museum also holds Rococo pieces by diverse practitioners including Roubiliac, fellow French sculptor Clodion (1738–1814), known for his groups of nymphs and fauns, and Paul de Lamerie (1688–1751), the greatest silversmith working in 18th-century England.

British tastemakers never quite fell for the frivolities of 18th-century French art. Their hearts lay elsewhere: in Italy, specifically Rome, Florence and Venice. A Grand Tour of the country was obligatory for every young British aristocrat, exposing them to the refinements of antiquity and the Renaissance. On his return from the peninsula, the wealthy Lord Burlington gathered around him artists and designers keen to recreate the Italian Classical style in London. *The Four Books of Architecture* by Renaissance architect Andrea Palladio (1508–80) was their guide and explained how one could achieve the proportion and harmony present in Classical buildings.

Burlington employed Scotsman Colen Campbell (1676–1729) to remodel his London home, Burlington House, now home to the **ROYAL ACADEMY OF ARTS (RA)** and five other learned societies (the institution's initial premises were **SOMERSET HOUSE**). The painter and architect William Kent (1684–1748) decorated the interiors, including spaces on the first floor that now make up the RA's Fine Rooms. The Academy has restored Kent's sumptuous schemes and uses the rooms to display its art collection.

Another notable Burlington-Kent collaboration was **CHISWICK HOUSE**, inspired by Palladio's famous Villa Capra near Vicenza. The gardens aimed at an idealised version of nature reminiscent of a painting by Claude. The landscape's Classicism, however, is worn lightly, and allows for natural variety and surprise. Its combination of order and informality has had an important influence on England's garden tradition.

Neoclassicism, or Neo-Palladianism, soon became an essential element in the city's Georgian architecture, especially in public buildings such as the **NATIONAL GALLERY**, which inside presents paintings, both from Britain and France, that are crucially connected to the Classical revival.

The collections of the **RA**, **TATE BRITAIN** and **SIR JOHN SOANE'S MUSEUM** are also significant on the same subject. The former was established in 1768 under the patronage of George III in 1768, in a bid to give artists greater prestige in the country's cultural life. Members and non-members would send in works for an annual exhibition, equivalent to the Salon at the Paris Academy. Critics used the shows to take the temperature of the country's art scene, making and breaking careers in the process. The Summer Exhibition, as it is known, continues to this day, as does the RA's art school.

The Academy's first president, Joshua Reynolds, preached the importance of painting Classical and religious stories – these works were known as 'history pictures', along with paintings of events from the recent past. He declared that every work, even portraits, should borrow from the 'grand style' of the Renaissance and imitate the ancients.

Reynolds' friend Angelica Kauffman (1741–1807) took the task especially to heart. When commissioned to decorate the ceilings at the RA, she created four self-portraits to demonstrate the characteristics of a good Neoclassical work: invention, colour, composition and design. The latter goes as far as to show Kauffman in some kind of Classical temple, robed in antique costume and sketching the Belvedere torso, the Athenian sculpture considered the ideal representation of Classical beauty.

Angelica KAUFFMAN
Design, (detail) 1778–80
ROYAL ACADEMY OF ARTS

Joshua REYNOLDS
Lady Cockburn and her
Three Eldest Sons, 1773
As well as evoking the
Classical era, Reynolds
relates this portrait to the
post-Renaissance European
canon. The composition
mirrors Van Dyck's *Charity*
(1627–8), and the oldest
boy's posture is taken from
The Rokeby Venus (1647–
51) by Velázquez. Both
paintings are also in the
National Gallery.

Reynolds may have considered history painting the noblest art form, but his portraits of the great and the good paid the bills. His picture of Banastre Tarleton (1782), a colonel in the American War of Independence, has all the self-conscious grandeur of a historical scene. The sitter poses heroically with his foot on a cannon gun as smoke billows, horses buck and the flag of the British Legion buffets in the wind.

Reynolds' portrait of Lady Cockburn (1773) is consciously Classical. She is clothed in lavish robes and set in front of a Classical column, with her three sons swooning around her like putti in an Italian Renaissance painting. Cockburn would have loved these antique associations. The theorist Johann Joachim Winckelmann famously praised the 'noble simplicity and calm grandeur' of Classical art; these characteristics struck a chord with the self-image of every contemporary aristocrat.

The painter's other three portraits on view focus more on the independent characters of each sitter. This ability to differentiate his approach depending on his subject served Reynolds well, although he never painted for the royal court, unlike Johann Zoffany (1733–1810) and Thomas Lawrence (1769–1830). The gallery only holds one work by the former, but three by the latter, including a full-length portrait of a seated Queen Charlotte (1789).

Lawrence's light, stylish touch to skin and dress gives the likeness undoubted beauty, even though the monarch's best years were by that point behind her.

The painter George Stubbs (1724–1806) seems to revere the animal form more than the human. The horses in the conversation piece *The Milbanke and Melbourne Families* (c 1769) are more realistic than the people around them. His most acclaimed work is *Whistlejacket* (c 1762), a portrait of a sought-after breed of Arab stallion. Stubbs treats the horse with the kind of heightened naturalism the Greeks reserved for naked athletes, with every muscle and detail lovingly recreated. The horse is projected on a plain background, an unusual move that gives its form even more focus. Animals were more often set in landscapes, to add to the beauty of the natural world; Gainsborough's tranquil picture *The Watering Place* (1777) is a good example on display.

The animal in *An Experiment on a Bird in the Air Pump* (1768) by Joseph Wright of Derby (1734–97) is not treated with such veneration. It shows a scientist demonstrating an air pump to a group of men, women and children around a table, and a cockatoo is in a flask, deprived of air as the pump is operated. The objects and people are painted realistically, but there is high theatre in the reactions of the group and the chiaroscuro, with the

George STUBBS
Whistlejacket, c 1762
Stubbs' seminal portrait captures one of the Marquess of Rockingham's prize horses. The artist's eye is attentive to the physiology of the stallion's powerful body, but it also reveals his temperament. The horse twists his head in disdain at the viewer while he rears upwards.

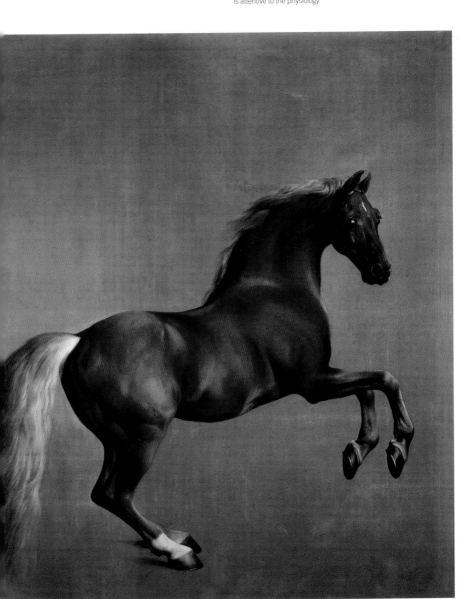

William HOGARTH
Marriage A-la-Mode: 2, The Tête à Tête, c 1743
In this satirical scene by Hogarth, a husband returns from a brothel at breakfast time, while his wife yawns following her own party. The

Neoclassical decor also speaks of the couple's situation. Cupid plays in ruins in a picture above the mantelpiece, while a bust's nose is broken, symbolising impotence.

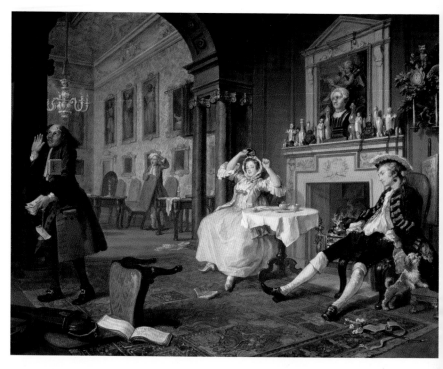

only light coming from a table lamp and the moon in the window. Artists like Wright treated industry and science with the same artistic intensity as Caravaggio once treated Bible stories.

The Graham Children (1742) is Hogarth's finest portrait of children. The painter criticised French art's frivolities, but the picture's airy mood and loose brush strokes ally him with the Rococo style, and his treatise *The Analysis of Beauty* (1753) was to argue for the importance of the serpentine line, a curving form so prevalent in French art.

But Hogarth does not mix his messages when it comes to Classicism: he was resolutely against the Italianate takeover of London, and in particular the hypocrisy of the Neo-Palladian lifestyle. In his

series *Marriage A-la-Mode* (c 1743), Neoclassical interiors are the backdrop as a marriage of convenience degenerates into disaster – the style is equated with moral corruption, rather than nobility. These six paintings were models for etchings, as Hogarth specialised in satirical graphic art during his career, as well as several other genres. His patriotic outlook sets him as the first painter of the English School as, until his work, foreign-born artists dominated the country's art scene.

The Italian artist Pietro Longhi (c 1700–85) painted groups of unnamed people in interiors. The five pieces on view seem a cross between the Dutch genre scene and British conversation piece. They are gentle pictures, with a mild sense of splendour and only occasional metaphor or irony.

Jean-Auguste-Dominique INGRES
Madame Moitessier, 1856
The French artist derived the pose of his sitter for this portrait, hand touching cheek, from an ancient Roman fresco that had been unearthed at Herculaneum, Italy. Moitessier's plump, seemingly boneless fingers are typical of the artistic license the painter took with the female body.

One can conclude that post-Rococo French art also favoured restraint, looking at the works by two of France's most famous painters, Jacques-Louis David (1748–1825) and Jean-Auguste-Dominique Ingres (1780–1867).

French Enlightenment thinkers like Jean-Jacques Rousseau railed against artificiality and courtly affectation and, following his studies at the French Academy in Rome, David found a solution: an austere manner inspired by the soberest side of Athenian and Roman art. After 1789, the artist's work glorified the values of the French Revolution, which, for many, chimed with the liberties seen centuries earlier in the Roman Republic and the Greek city-states.

David's likeness of Jacobus Blauw (1795) was painted six years after the Revolution. He paints his sitter, a Dutch minister in Paris, with the same clarity as his more famous portraits of French Republican martyrs. The background is entirely plain and there are no unnecessary objects or fripperies, just Blaux, boldly modelled, holding a quill as a sincere public servant. We are reminded of the Napoleonic wars that followed in the 19th century by four grand battle scenes by Emile-Jean-Horace Vernet (1789–1863), grandson of Claude-Joseph Vernet (1714–89) whose acclaimed landscapes are also on show.

While David embraced Classicism for its rectitude, his pupil Ingres had a more smooth style, perfected by careful preparatory studies. His representations of women are a radical take on Raphael's curvaceous Madonnas. In *Angelica saved by Ruggiero (*1819–39), a later, smaller version of a painting now in the Louvre, Paris, Angelica is so voluptuous that her neck and arms appear to have no bones. Madame Moitessier, who sat for one of the artist's very finest portraits (1856), met Ingres' very particular idea of Classical beauty. The artist spent 12 years on the remarkable picture, agonising over every detail.

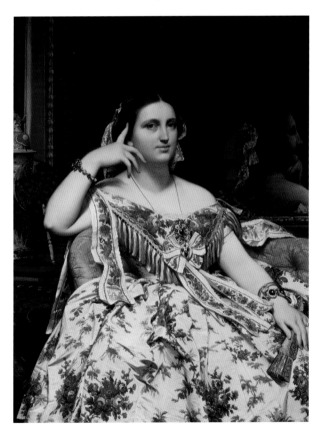

James **BARRY**
Crowning the Victors at Olympia, (detail) from *The Progress of Human Knowledge and Culture*, *c* 1777–84
RSA

Barry was given complete artistic freedom, if little money, for his commission to paint the Great Room in the RSA. He chose the noble seven-year labour of

tracing the development of Greek civilisation across its walls. This section shows celebrations after the Olympic Games.

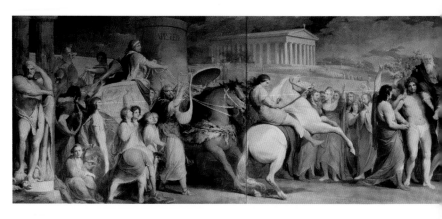

The **VICTORIA AND ALBERT MUSEUM (V&A)** spotlights sculpture that drew inspiration from antiquity. *Theseus and the Minotaur* (1782) is one of the most important mythological works by Italy's pre-eminent Neoclassicist, Antonio Canova (1757–1822). Portrait busts made a major comeback; the V&A and the **WALLACE COLLECTION** hold pieces by the French proponent Jean-Antoine Houdon (1741–1828). Englishman Josiah Wedgwood (1730–95) also emulates Greek and Roman art with his ceramics.

Painters at the **RA** include Reynolds and the most famous English-speaking artist after him, Benjamin West (1738–1820). Highlights on paper include Stubbs' original drawings for his publication *Anatomy of a Horse* (1766), for which he dissected specimens, plus Palladio-inspired architectural studies; the **ROYAL INSTITUTE OF BRITISH ARCHITECTS (RIBA)** also has a fine collection, on view in its library as well as at the V&A. A beautiful study by Ingres is held at the **BRITISH MUSEUM**, as well as the **COURTAULD GALLERY**, which has restored a major late work by Reynolds, *Cupid and Psyche* (*c* 1789).

West, Reynolds and James Barry (1741–1806) are held by **TATE BRITAIN** as examples of the period's finest history painters. John Singleton

Copley (1738–1815) is another – his monumental *Defeat of the Floating Batteries at Gibraltar* (1783–91) is on display at the **GUILDHALL ART GALLERY**. Barry's career-defining work is his sequence of wall paintings, *The Progress of Human Knowledge and Culture* (*c* 1777–84), which are on display at the **ROYAL SOCIETY FOR THE ENCOURAGEMENT OF ARTS, MANUFACTURES AND COMMERCE (RSA)**.

The Tate also has pieces by Hogarth, Stubbs, Zoffany, Lawrence and Joesph Wright of Derby, as well as portraitists such as Allan Ramsay (1713–84), George Romney (1734–1802) and Henry Raeburn (1756–1823), whose art can also be seen in the **NATIONAL PORTRAIT GALLERY**. **DULWICH PICTURE GALLERY** dedicates two rooms to British portraiture, while Raeburn is one of the most famous figures in the **FLEMING COLLECTION** of Scottish art.

Zoffany's finest conversation pieces were those commissioned by George III and Queen Charlotte which now form part of the **ROYAL COLLECTION**. Their son, the Prince Regent, gave his name to the 'Regency style', which mixed Neoclassicism with other modes; his interiors for **BUCKINGHAM PALACE** can be compared to those by Kent at **KENSINGTON PALACE**. The impact on the

Antonio CANOVA
Theseus and the Minotaur,
1782
V&A
Canova departs from the
drama of Baroque sculpture
by composing the Greek hero
Theseus calmly sitting astride
his adversary. The man's
ideal body has all of the
harmony of Classic period
sculpture, but it was not a
copy – the Italian artist
entirely invented the scene.

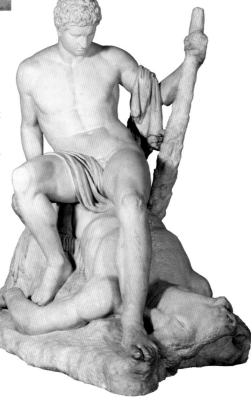

drawing rooms of the middle classes can be seen
at the **GEFFRYE MUSEUM**.

SIR JOHN SOANE'S MUSEUM reflects the
tastes of its founder, one of London's most
influential Neoclassical architects. John Flaxman
(1755–1826) is the cornerstone of its Neoclassical
art collection (although the **FLAXMAN GALLERY** at
University College London (UCL) has the best of
this important sculptor), alongside Hogarth and
Reynolds. Both prolific painters feature in less well-
known locations: for example, Reynolds in the
Iveagh Bequest at **KENWOOD HOUSE**, and at
SPENCER HOUSE and **RANGER'S HOUSE**;
Hogarth at **SOUTHSIDE HOUSE** and the
CARTOON MUSEUM. The two are alongside each
other at the **NATIONAL MARITIME MUSEUM**,
LINCOLN'S INN, **MARBLE HILL HOUSE** and **ST
BARTHOLOMEW'S HOSPITAL MUSEUM**, plus
the **FOUNDLING MUSEUM**, once a hospital for
abandoned children to which Hogarth
encouraged artists to donate works.
Composer George Handel gave fundraising
performances; his art collection is at the
HANDEL HOUSE MUSEUM. Some of Samuel
Johnson's can be seen at **DR JOHNSON'S
HOUSE**, while the acquisitions of Horace Walpole,
another key critic, are at **STRAWBERRY HILL**.

'What a mockery this / Of history, the past and that to come! Now do I feel how all men are deceived,' wrote the English poet William Wordsworth of his disillusionment with the French Revolution. The events of 1789 had led to mob violence and the mass executions of the Reign of Terror. How could any idealist retain any hope?

Closer to home, Wordsworth and his contemporaries had only to visit Manchester to witness another betrayal. The inventions of the Enlightenment, from the steam engine to the spinning jenny, had led to appalling social realities for the city. It was one of the most industrialised settlements in the world, with a sprawl of mills, foundries and other factories fed by coal and the labour of hundreds of thousands of new workers who had relocated from the countryside. The conditions were so poor that, for the American writer Mark Twain, the 'transition between Manchester and Death would be unnoticeable', and for French thinker Alexis de Tocqueville, 'civilised man turned into a savage'. Karl Marx concluded that the exploitation of the proletariat would inevitably lead to revolution.

Other visionaries returned to nature for salvation, in particular poets such as Wordsworth and Samuel Taylor Coleridge. Their joint publication *Lyrical Ballads* (1798) changed the course of literature, inspiring the English Romantic movement. And in the same way Wordsworth rejoiced in the landscape of his native Lake District, the painter John Constable (1776–1837) found beauty and truth in the landscape of his home in Suffolk.

Constable and Joseph Mallord William Turner (1775–1851), who is discussed in detail in the next chapter, were the two most accomplished painters in a golden age of British landscape art. One sees the full sweep of the tradition at **TATE BRITAIN**, but by visiting the **NATIONAL GALLERY** one can better compare British artists' approach to that of other European painters of the first half of the 19th century, particularly German and French Romantics.

Although there was no common method, most Romantic artists avoided Neoclassical purity of line and colour for compositions that were rich and complex. There was another stark contrast with Neoclassicism: instead of faith in the canon of the ancients, artists privileged their own feelings. For some, like Turner, it was beside the point whether the viewer understood what was painted. This emphasis on the artist's individual sensibility is an aspect of Romanticism that endures today.

No London artist, perhaps no Romantic artist, was so individual as the Lambeth-based mystic, poet, painter and printmaker William Blake (1757–1827). Blake had strange visions, believed in free love, preferred Gothic to Greek art and venerated the imagination as 'the world of eternity. It is the divine bosom into which we shall all go after the death of the vegetated body.' The Tate and the **BRITISH MUSEUM** hold the best selections of his seminal works on paper, including illustrations for his own books of poetry, such as *Europe: A Prophecy* (1794).

William BLAKE
The Ancient of Days,
frontispiece to *Europe: A Prophecy*, 1794
BRITISH MUSEUM

Before enjoying the outstanding group of works by Constable, take in two pictures by one of his heroes, Richard Wilson (1714–82), a founding father of British landscape art. 'He looked at nature entirely for himself,' claimed Constable, although the works show how much Wilson learned from Claude, as the Frenchman's end-of-day light glows over a Welsh countryside.

Wilson's nostalgic paintings marked a departure with more topographical landscapes common in Britain at the time. Constable also surrendered accuracy for emotional expression.

His earliest piece on view, *Weymouth Bay* (1816–17), was created on the Dorset coast where he went for his honeymoon. It is a work of youthful enthusiasm, its sky and sea created roughly with thick jabs of paint. The beach itself is, rather radically, just bare, primed canvas.

This lively method became typical of the artist's oil sketches, which include *Salisbury Cathedral and Leadenhall from the River Avon* (1820). These were made in the open air before being taken back to studio as source material for measured works such as *Stratford Mill* (1820). Like his masterpiece

John CONSTABLE
The Hay Wain, 1821
Constable's practice was
transformed by his decision
to start painting six-foot
canvases, such as this
famous work of a horse-
drawn cart passing through
the River Stour. The size of
the works put the painter's
vision of nature, in affinity
with the working man, on an
awe-inspiring scale.

The Hay Wain (1821), *Stratford Mill* shows the
River Stour in harmony with local, working people,
as if nature is at its most complete when at one with
man. There is a rich variety to the artist's brush
strokes and colour tones, particularly in the wooded
area and the river. Constable's paintwork becomes
even more stirring in his late works, such as
Salisbury Cathedral from the Meadows (1831),
on long-term loan to the gallery.

Constable had greater success in France
during his lifetime than in Britain. He received a
gold medal alongside fellow English landscapists
Anthony Vandyke Copley Fielding (1787–1855)
and Richard Parkes Bonington (1802–28) at the
Paris Academy's 1824 Salon. Bonington, who died
tragically young, is represented in the collection by
a small but brilliant oil sketch, as is Paul Huet
(1803–69), the French landscape painter with
whom he formed a strong friendship.

It is interesting to compare these artists with
Caspar David Friedrich (1774–1840), the most
famous German landscape painter of the 19th
century. *Winter Landscape* (1811) is the gallery's
only holding of his work, but it is characteristic in
the way that the composition has two pictorial
planes – a razor-sharp foreground and a vague,
misty background. Thirty years before this canvas
was painted, the philosopher Immanuel Kant, so
influential in German thought, had concluded that
a noumenal realm transcended human reason and

Caspar David FRIEDRICH
Winter Landscape, 1811
A crippled man throws down
his crutches to prey at a
crucifix as a Gothic church
emerges from the mist. The
German artist ensures that
nature is at the centre of the
work's religious meaning, in
the form of a resilient
evergreen that echoes the
exact shape of the church
spire.

experience. Friedrich forces us to gaze into this mist and speculate on the beyond.

Friedrich trained in Copenhagen and was important in the dissemination of Danish art, which had its own golden age during the first half of the century. The gallery features a pleasant piece by Christen Købke (1810–48), *The Northern Drawbridge to the Citadel in Copenhagen* (1837), which is far more quiet and careful than pieces by Constable and Turner. Other less famous if interesting European artists on view from this time include Johann Heinrich Ferdinand Olivier (1785–1841) and Julius Schnorr von Carolsfeld (1794–1872). Both Germans were members of the Nazerene Brotherhood, a group admired by the Pre-Raphaelites for their strict moral purpose. Carolsfeld's *Ruth in Boaz's Field* (1828) is typical in the way it tells an Old Testament story with crisp clarity rather than grandeur.

Two late works by Eugène Delacroix (1798–1863), the foremost French Romantic painter, take a very different tack. There are no precise lines in *Christ on the Cross* (1853) and *Ovid among the Scythians* (1859). Figures are roughed-out so they seem more like apparitions than flesh-and-blood realities, and spatial relationships between them are ambiguous. Both pictures have peculiar palettes – note the blue hills in *Ovid among the Scythians* – which create the sense that the artist's vision is important above all. He may have died only a few years earlier than his great rival Ingres, but Delacroix seems like he was painting in a different century.

A Shipwreck (1817–18) by Delacroix's pupil Jean-Louis-André-Théodore Géricault (1791–1824), at the gallery on long-term loan, seems associated with Géricault's masterpiece *The Raft of the Medusa* (1818–19), at the Louvre, Paris, which shows the crew of an abandoned ship set adrift – a tragic, true-life tale. *A Shipwreck* is a close-up on a naked sailor as he emerges washed up from the sea, leaning away from the viewer, back bent, exhausted on a rock. Even ripped with muscles à la Michelangelo, he is a figure of suffering rather than of Classical heroism. The artist makes a similar move in *A Horse frightened by Lightning* (c 1813–4), a work that makes an interesting comparison with Stubbs' equine portrait *Whistlejacket* (1762). Géricault's horse is in psychological distress, kept still by fear, in an eerie environment at night.

Honoré-Victorin Daumier (1808–79) was a pioneer of lithography, a printmaking technique invented at the turn of the 18th century that preserved the fluent touch of the artist. *Don Quixote and Sancho Panza* (c 1855), although an oil, has a feel of a print, with the famous protagonists not much more than silhouettes.

The leading Spanish painter Francisco de Goya (1746–1828) is also inspired by literature in *A Scene from 'The Forcibly Bewitched'* (1798), which represents a macabre episode from a play by Antonio de Zamora. This is the only one of the five works by Goya on display that has the darker, visionary edge that associates him with the Romantics. Three are accomplished portraits, including a likeness of the Duke of Wellington (1812–14) that puts a gentle, unassuming face to the English war hero.

But if there is no Goya masterpiece, one can more than make do with the finest known painting by the Frenchman Paul Delaroche (1797–1856), *The Execution of Lady Jane Grey* (1833). The canvas caused a sensation when it was displayed in Paris, the guillotine still fresh in the memory. Its meticulous realism and Romantic version of the past set new standards for the painting of history.

Eugène DELACROIX
Christ on the Cross, 1853
The French artist breaks sharply from Neoclassicism in this dream-like representation of the Crucifixion. The brushwork is so nervy and idiosyncratic that all figures are painted out of proportion and with indistinct features. Christ's face, normally a conduit for emotional expression, is in shade.

John **MARTIN**
The Great Day of His Wrath,
1851–3
TATE BRITAIN
The artist consulted the Book
of Revelation for his three
epic landscapes on the Last
Judgement, which reveal
God's power over both nature
and man. This work in the
series illustrates the
earthquake where the 'moon
became as blood … and
every mountain and island
were moved out of their
places'.

If *The Hay Wain* at the National Gallery has peaked your interest in Constable, the **ROYAL ACADEMY OF ARTS (RA)** has a superb selection of works, including some rare oil sketches of seascapes and another of his famous six-foot canvases, *The Leaping Horse* (1825). The **VICTORIA AND ALBERT MUSEUM (V&A)** and **TATE BRITAIN** also hold a wide variety of canvases, drawings and prints, including some of the artist's moving views of London's Hampstead Heath, where he found refuge from the city. If you visit the heath itself, one can see *Hampstead Heath with Pond and Bathers* (1821) in the Iveagh Bequest at **KENWOOD HOUSE**, close to where it was originally painted.

The Tate is the best place to see Constable in the context of other Romantic landscape painters, who often had very different approaches. John Sel Cotman (1782–1842), influenced by the late work of Thomas Girtin (1775–1802), specialised in watercolours, learning how to manipulate the medium so that it had as many possibilities as oil. Samuel Palmer (1805–81) painted hallucinatory images from his Kent village of Shoreham that owe

much to the mysticism of Blake.

The more graphic compositions of Philip James De Loutherbourg (1740–1812) and John Martin (1789–1854), like Géricault, confront the natural world's power and threat. Martin produced his life's masterpiece, a triptych of epic landscapes inspired by the apocalypse of the Last Judgement, a year before his death. These artists' works fit with the idea of 'the sublime': magnificence combined with terror, capable of inflaming human passions and pleasure much more than mere beauty. This concept was elucidated by the theorist Edmund Burke and found an advocate outside of landscape art in Henry Fuseli (1741–1825), rofessor of Painting at the RA for many years. His ark canvases on view at the Tate and the cademy recreate myths in a grand style, but with hint of malevolence, as if they were nightmares.

Goya indulges even blacker thoughts in his two eries of prints included in the collection of the RITISH MUSEUM, *The Fantasies* (1799) and he *Disasters of War* (1810–20). The latter is a sturbing catalogue of the most barbaric acts and onsequences of war, a landmark shift away from eroic depictions. The museum also holds early xperiments in lithography, as well as etchings of

imaginary prisons by Giovanni Battista Piranesi (1720–78) that inspired American writer Edgar Allan Poe. The Tate owns three landscapes by one of Poe's compatriots, Samuel Colman (1780–1845), part of America's Romantic movement known as the Hudson River School.

The **WALLACE COLLECTION** includes the finest group of Delaroche's work outside France (10 oils and two watercolours), a wide selection of Boningtons and a few pieces by both Delacroix and Géricault. The **COURTAULD GALLERY** has Britain's only full-length portrait by Goya. **KEATS HOUSE** explores the short life of one of the most talented Romantic poets, while the **BRITISH LIBRARY** holds objects of interest such as Blake's notebook, in which he wrote and sketched over 30 years.

Francisco de GOYA
An heroic feat! With dead men! from *The Disasters of War*, 1810–20
BRITISH MUSEUM
This scene of dismembered bodies hanging from a tree is one of the most horrific

plates in a print series by Goya that focuses on the atrocities of Spain's conflict with France. It is one of the earliest anti-war works and, because of its attitude, was not published for 50 years after its production.

ARTIST IN FOCUS:
JMW TURNER

Despite the critical attention he has received since his death, the wing dedicated to his output at **TATE BRITAIN**, the contemporary art prize in his name at the same institution, and the polls topped as the country's most popular artist and producer of its favourite work, the **NATIONAL GALLERY**'s *The Fighting Temeraire* (1839), Joseph Mallord William Turner (1775–1851) continues to challenge our expectations.

Contradictions start with his character: the critic John Ruskin, the landscape painter's most vociferous admirer, whose *Modern Painters* (1843–60) argued for his superiority, found him both eccentric and shrewd, selfish and well-mannered, 'good-natured evidently, bad-tempered evidently'.

Brought up in a barber's shop in Covent Garden's Maiden Lane, a narrow street so named because of its active prostitutes, Turner appears a Londoner through and through: talking in a Cockney accent, taking trips up and down the Thames in order to commit to paper the turn of light and tide, and, in canvases such as *The Burning of the House of Lords and Commons, 16th October 1834* (1835), capturing some of the city's most momentous events. But then one is reminded how keenly this patriot left London for tours of the Continent. He visited Italy 17 times, set up

a studio in Rome, and produced magical views of Venice, like *The Dogano, San Giorgio, Citella, from the Steps of the Europa* (1842), which caused one critic to claim the city 'was surely built to be painted by … Turner'.

In his best-known works, skies and seas are abstract mists of bright colour – predominantly primaries, such as cobalt blue, scarlet red, and chrome and cadmium yellows, which overlay and intercede with white. However, we learn that Turner was a topographer at heart, concerned to take down the truth in what he saw, preparing for watercolours with countless preparatory sketches. And he was an avid maker of prints, where emphasis on line would replace that on palette.

His subjects turn from the sublime, such as shipwrecks and storms, to the picturesque; from the glory of English victory to the horrors of war; from modern ideals to those of the ancient world. Visitors to the Tate ready to claim him as a forerunner to the work of Impressionist Claude Monet (1840–1926) or Abstract Expressionist Mark Rothko (1903–70) may be disappointed to learn that Turner's hero was 17th-century landscape painter Claude, and that he was obsessed with his place in the Old Master tradition.

These ambiguities are the reason we continue to look at the artist's work so closely. For a winner of the Turner Prize, sculptor Anish Kapoor (1954–) their mystery allows for a more personal relationship with the viewer than in previous art: 'They don't throw the question of interpretation and meaning at you. They leave the question open and look for a response. It's an internal project, that's its real beauty … and we all have to look at Turner as one of the places where that kind of relationship begins.'

John LINNELL
Joseph Mallord Willilam Turner, 1838
NATIONAL PORTRAIT GALLERY

JMW TURNER
The Fighting Temeraire,
(detail) 1839
NATIONAL GALLERY

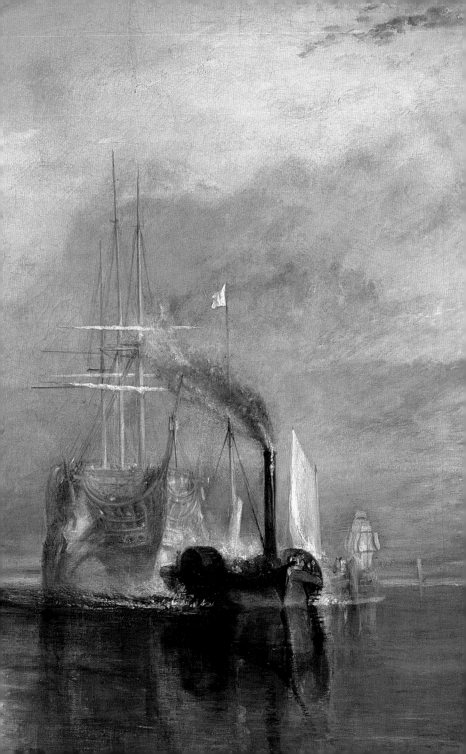

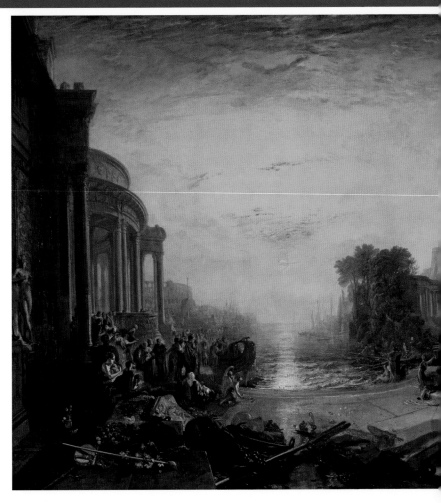

On his death, Turner left all of the works he still owned to the nation. The bequest comprises nearly 300 oil paintings and around 30,000 sketches and watercolours, including the contents of about 300 sketchbooks. Its breadth and depth means that its guardians at Tate Britain can rotate their displays frequently, in 10 spaces dedicated to the artist that form a separate section of the gallery. There are major temporary exhibitions from time to time connecting the painter with other artists, and some of his works are always placed in the Tate's main chronological displays.

Following experience as an architectural draughtsman, Turner found a job working as an assistant scene-painter at Oxford Street's Pantheon Opera House. It was destroyed by fire in 1792 and the Tate holds Turner's watercolour of its ruins. A more accomplished example of his early aesthetic is *Fishermen at Sea* (1796), his first oil exhibited by the **ROYAL ACADEMY OF ARTS (RA)**, where he studied before becoming a full member in 1802. It is an atmospheric noctural scene not dissimilar in style to De Loutherbourg, with none of the colour experiments we associate with Turner's later work.

In the last years of the century he toured England and Wales extensively, and the Tate holds

lovely works on paper, such as *View towards Snowdon from above Traeth Bach* (1798), which show the young man's wonder with the countryside he encountered, as well as the influence of landscape artist Wilson. A sketchbook from a few years later includes compositions made by the pier at Calais (*c* 1802), when Turner travelled to France for the first time. In an impressive oil from the decade, *The Battle of Trafalgar, as Seen from the Mizen Starboard Shrouds of the Victory* (1806–8), Turner eschews accuracy for cannon-smoked chaos, as the ships and their sails jut at angles towards the viewer.

Claude's heavenly use of light consumed Turner for his entire career; his last few exhibits at the RA before his death related to the artist. Two of the finest of Turner's many paraphrases of the Frenchman are *The Decline of the Carthaginian Empire* (*c* 1817), a reinterpretation of Claude's seminal harbour views, and *Palestrina: Composition* (1828), intended as a pendant piece for the Old Master's *Jacob with Laban and his Daughters* (1676), which is now at **DULWICH PICTURE GALLERY**.

Other artists quoted include Raphael, Michelangelo and, with the unfinished *The Death of Actaeon* (*c* 1837), Titian. Turner's ego seems such that he also needed to show he was a match

The Decline of the Carthaginian Empire,
c 1817
This poetic work by Turner is one of the pinnacles of his early career, received with universal praise. It is an ode to the Classical paintings of Claude, the 17th-century landscapist who invented the harbour scene, but the rich use of colour is all Turner's own.

Norham Castle: Sunrise,
c 1845
Turner visited Northumberland's Norham Castle as a younger man, creating drawings, watercolours and prints that later informed this atmospheric unfinished canvas. Translucent areas of colour express the forms of the landscape, such as the castle, which is painted as a thin glaze of blue.

Snow Storm: Steam-Boat off a Harbour's Mouth, 1842
This late painting is the most complex and compelling of several scenes by Turner of disasters at sea. There is no horizon line to orientate the action. The boat instead seems the centre of a cyclone, with waves, wind and steam unified in a spiral that closes in around it.

for every other living artist. There are responses in the collection to works by artists as diverse as Géricault and the Scottish genre painter David Wilkie (1785–1841). The Tate also affords a great comparison between Turner and his great rival in RA exhibitions, Constable.

A decisive decade seems to be the 1820s when, following trips to the Mediterranean, the artist shifts to a brighter palette and a more restless technique, with a wide variety of touches and gradations. Turner began to build up paint layers from lighter grounds for extra luminosity. Although they appear spontaneous, his chromatic blends and contrasts tended to be planned. Turner was inspired by colour theories, as codified by thinkers like Johann Wolfgang von Goethe.

Ruskin considered the decade 1835–45 'the crowning period of Turner's genius', although critics at the time thought it one of decline. The water is muddied by the fact that it has become standard to represent the painter by his unfinished work, which tends to pose him as proto-Impressionist. Ruskin's favourites included Turner's Italian oil sketches on view, like *From the Top of the Rigi* (1844), which are almost fully abstract essays on colour. *Sun Setting over a Lake* (*c* 1840) may have a sun represented by an impudent blotch of yellow paint, and the radiant *Norham Castle: Sunrise* (*c* 1845) the outline of grazing horses, but would Turner have wanted us to give these incomplete canvases the same attention as his finished works?

A canvas he exhibited in 1842, *Snow Storm: Steam-Boat off a Harbour's Mouth*, gives us a clue, if not the answer. It is only slightly more figurative than his unfinished works, a vortex of waves and sky with a phantom of a boat in the centre. Ridiculed by the press, Turner countered that he had been lashed to the mast while painting in order 'to show what such a scene was like'. However abstract it seems to us, for the artist it was a representation of what he saw.

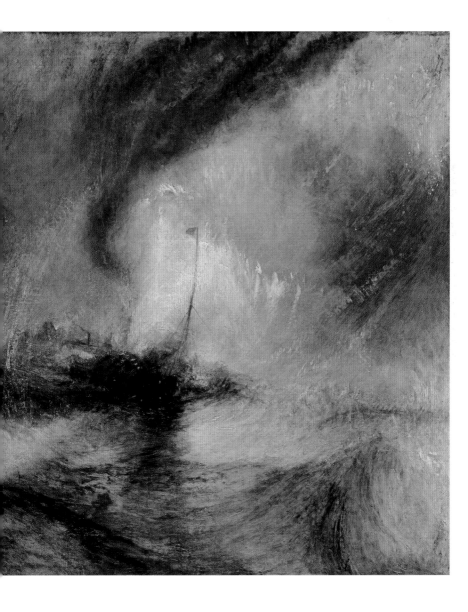

The Battle of Trafalgar, 21 October 1805, 1822–4
NATIONAL MARITIME MUSEUM
The artist's largest canvas was a commission from George IV, intended to make a pair with an earlier battle scene by De Loutherbourg. Rather than reportage, the artist combines in one view several incidents that took place at different times, an innovative approach that met with fierce criticism.

One of the **NATIONAL GALLERY**'s prized possessions is *The Fighting Temeraire,* a eulogy to a heroic ship from the Battle of Trafalgar, towed by a tugboat 30 years later as the sun sets on Britain's naval power. In contrast, Turner rejoices in new technology in *Rain, Steam and Speed: The Great Western Railway* (1844), a dynamic work that anticipates Futurism. Two of Turner's canvases hang between those of Claude, as the artist requested in his will.

Turner studied at the **RA** and became its Professor of Perspective. The artist would famously send in unfinished works to exhibitions and then, in a display of genius, complete them in the gallery before the show opened. The RA's archives contain anecdotes on his shownmanship, as well as prints from his series *Liber studiorum* (1806–19). Turner was involved closely in its creation, etching designs himself. The Tate holds copies, plus preliminary works connected to the series, while the **BRITISH MUSEUM** presents a virtually complete collection of prints after Turner and some outstanding watercolours. The **COURTAULD GALLERY** owns works on paper, as does the **VICTORIA AND ALBERT MUSEUM (V&A)**, which also displays some excellent canvases in context with other landscape painters.

One painting worth seeking out is *The Battle of Trafalgar, 21 October 1805* (1822–4) at the **NATIONAL MARITIME MUSEUM,** Turner's only royal commission. Previously private collections like the **WALLACE COLLECTION, SIR JOHN SOANE'S MUSEUM** and the Iveagh Bequest at **KENWOOD HOUSE** also present pieces. There are over 20 likenesses of the artist held at the **NATIONAL PORTRAIT GALLERY**, including a teenage self-portrait in miniature. Those interested in his life can visit **SANDYCOMBE LODGE**, the Twickenham retreat he designed and built himself.

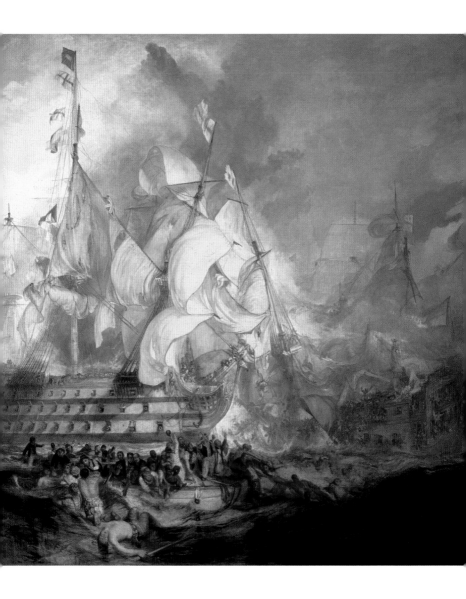

THE PRE-RAPHAELITES

The novelist Justin McCarthy wrote in 1876 about how far the Pre-Raphaelites had infiltrated English society over three decades: 'We have now in London Pre-Raphaelite painters, Pre-Raphaelite poets, Pre-Raphaelite novelists, Pre-Raphaelite young ladies; Pre-Raphaelite hair, eyes, complexion, dress, decorations, window curtains, chairs, tables, knives, forks and coal-scuttles.'

Would the seven young men who founded the Pre-Raphaelite Brotherhood in September 1848 have winced if they knew then how conventional their style would become? One of their idealistic number, the writer William Michael Rossetti, would recall their main aim 'to sympathise with what is direct and serious and heartfelt in previous art, to the exclusion of what is conventional and self-parading and learned by rote'.

William's brother, Dante Gabriel Rossetti (1828–82), was one of the most gifted brethren, along with William Holman Hunt (1827–1910) and John Everett Millais (1829–96). All three painters had studied at the **ROYAL ACADEMY OF ARTS (RA)** (Millais, remarkably, since the age of 11) and were frustrated at the 'grand style' the RA inculcated in its artists. The other members were painter James Collinson (1825–81), the critic Frederick Georges Stephens and sculptor Thomas Woolner (1825–92).

Their will to see things through fresh eyes returned them to painters who practised before High Renaissance artists such as Raphael, the idol of the art establishment. Rossetti's *Ecce Ancilla Domini* (1849–50), for example, mimics the flatter style of late Medieval art. Critics ridiculed Rossetti, while Millais received worse: accusations of blasphemy for his realistic depiction of the Holy

Family in his *Christ in the House of His Parents* (1849–50). Millais also sought truth in the detailed replication of nature, but his meticulous botany in the now-famous *Ophelia* (1851–2) was dismissed by *The Times* as 'a weedy ditch' which 'robs the drowning struggle of that lovelorn maiden of all pathos and beauty'.

The Brotherhood soon disbanded in the early 1850s, but the artists continued to work, if in different directions. The Pre-Raphaelite style broadened as it was picked up by followers, chief among them Edward Burne-Jones (1833–98) who, with his collaborator, the designer William Morris (1834–96), was initially mentored by Rossetti. Like every good avant-garde movement, vilification turned slowly to critical success, collectors, commissions, imitators – as McCarthy describes – and, in the case of Millais and Burne-Jones, knighthoods.

The movement's most iconic representations remain those of the Pre-Raphaelites 'stunners' (as they were known): women with full lips, flowing hair, bushy eyebrows and large, pensive eyes. But the painters' very male fixation on their female muses brought scandal. Effie Gray divorced John Ruskin, a vocal supporter of the movement, to marry Millais. Rossetti's wife Lizzie Siddal, the model for *Ophelia*, committed suicide, perhaps in connection with her husband's interest in other women, including Morris' wife Jane. These and other stories have overshadowed the artistic importance of the Pre-Raphaelites, who influenced movements including European Symbolism. The collection of **TATE BRITAIN** redresses the balance, as do other significant works in lesser-known locations across London.

Dante Gabriel ROSSETTI
Ecce Ancilla Domini,
1849–50
TATE BRITAIN

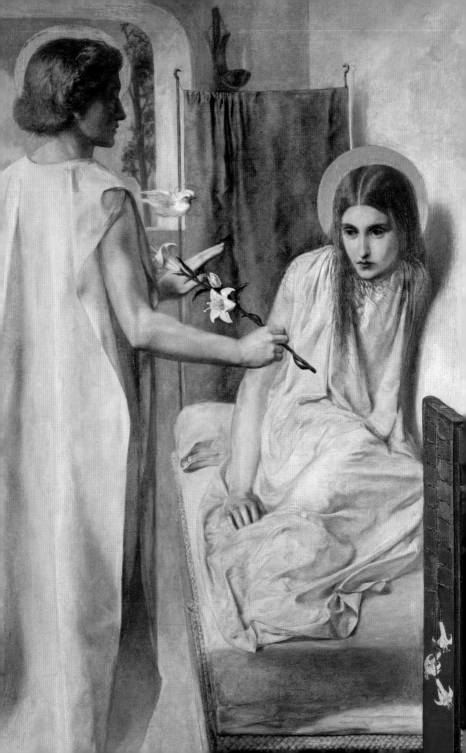

John Everett MILLAIS
Ophelia, 1851–2
Millais presents the drowning of Hamlet's beloved from the play by Shakespeare. The artist laboured for four months on a riverbank in order to copy the background accurately. For the foreground, his model Lizzie Siddal posed for days in a cold bath, becoming ill in the process.

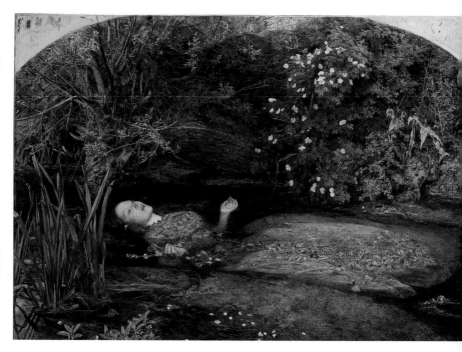

Rossetti's first major oil, *The Girlhood of Mary Virgin* from 1849, is marked with the initials PRB, an acronym the Brotherhood inscribed on their early works. There is little hint of the radicalism of Rossetti's nearby *Ecce Ancilla Domini*, nor *Christ in the House of His Parents* by Millais, both displayed to such controversy the next year. Millais represented the Holy Family as ordinary people – far too ordinary for writer Charles Dickens, who denounced the painter's Jesus as 'a hideous, wry-necked, blubbering, red-headed boy, in a bed-gown'.

But Millais' intention was to praise his subjects, and his realism is combined with earnest symbolism in a very Pre-Raphaelite effort to create a new, more honest typology for religious painting. He applies this approach to the literary canon in *Ophelia,* where he paints a tragic death from Shakespeare's *Hamlet* in highly naturalistic detail. The bard also inspires Millais' *Mariana* (1851), plus works like *Puck* (1845–7), one of two sculptures by Woolner, and Hunt's *Claudio and Isabella* (1850).

The latter's *Our English Coasts* (1852), like *Ophelia,* reproduces nature in vivid colour and painstaking precision. Hunt switches focus for *The Awakening Conscience* (1853), which shows a lady rising from the lap of a man. Moral quandaries were evidently a mainstay for the painters, who preached Victorian ethics even if they did not practise them. *'Take your Son, Sir'* (1851–92) is one of the most intriguing images of this type, by Rossetti's former teacher Ford Madox Brown (1821–93). Collinson abandons the cause, creating genre scenes such as *Home Again* (1856), but Arthur Hughes (1832–

Edward BURNE-JONES
King Cophetua and the
Beggar Maid, 1884
The poet Tennyson made
famous this Medieval tale of
love between monarch and
maid. The painter chose the
subject because of its
Socialist overtones, having
been converted to the cause
by Morris. The work was
exhibited to acclaim in Paris
in 1889, inspiring French
Symbolist artists and writers.

1915) picks up the baton, producing works in an
even more piercing Pre-Raphaelite palette, such
as *April Love* (1855–6).

Chatterton (1856) by Henry Wallis (1830–
1916) depicts the serene corpse of the melancholy
poet who took his own life at 17. Like Chatterton,
and Rossetti, Burne-Jones had an obsession with
the Medieval world, expressed in works like *King
Cophetua and the Beggar Maid* (1884). Rossetti
described Burne-Jones' works as 'marvels of finish
and imaginative detail', but in their decorative
beauty and more Classical style they reject the early
Pre-Raphaelite agenda. *The Golden Stairs* (1880)
epitomises Aestheticism, the late 19th-century urge
for mood over narrative. In *La Belle Iseult* (1858),
William Morris paints his wife-to-be Jane in a room
with an attention to pattern that prefigures his
interior designs.

Jane is also the model for *Proserpine* (1874),
which, with *Beata Beatrix* (1864–70), illustrates
Rossetti's late preoccupation with the female form.
Frederic Leighton and John William Waterhouse
(1849–1917) merge Pre-Raphaelitism with their
reinvented Classical idealism; compare
Waterhouse's *The Lady of Shalott* (1888), inspired
by a poem by Alfred Tennyson, with Millais'
Ophelia. The gallery spotlights the sculpture revival
known as 'The New Sculpture', led by Leighton and
Alfred Gilbert (1854–1934). One should also catch
works by Richard Dadd (1817–86) and George
Frederic Watts (1817–1904), two underrated,
visionary Victorians.

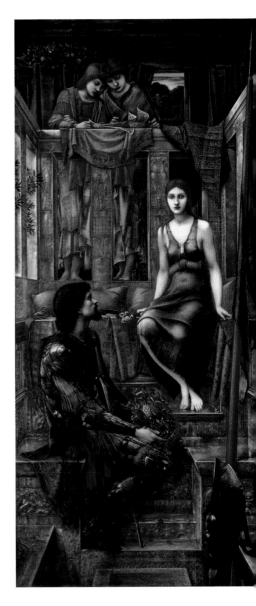

William Holman HUNT
The Eve of St Agnes, 1848
GUILDHALL ART GALLERY
The artist recreates a
dramatic scene from Keats'
fine poem, the title of which
is the legendary night (21

January) when young women
see their future husbands in
a dream. Porphyro comes to
Madeline in reality, and they
elope while the castle's
revellers are fast asleep.

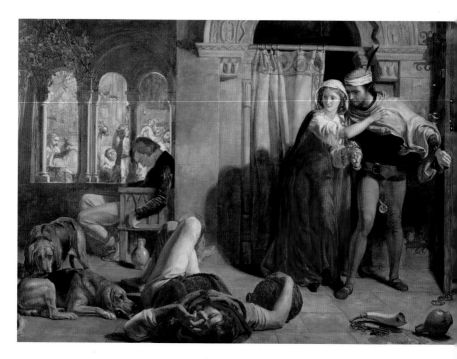

A great group of Pre-Raphaelite paintings can be discovered at the City of London's **GUILDHALL ART GALLERY**. These include *The Eve of St Agnes* (1848) by Hunt, which holds a pivotal position in the history of the Brotherhood, as it was Rossetti's great admiration for the painting that led to the two artists' friendship. Rossetti's late career is well represented by the lyrical *La Ghirlandata* (1873), while several fine pieces by Millais are on view, including *The Woodman's Daughter* (1850–1). One can also see *Our Saviour Subject to his Parents at Nazareth* (1847–56) by John Rogers Herbert (1810–90), considered the inspiration for Millais' *Christ in the House of His Parents*.

The multi-talented William Morris is known best for bringing a Medieval-inspired, handcrafted, indigenous aesthetic – known as Arts & Crafts – to interior design and objects, in reaction to modern industrial production. An early commission is the Green Dining Room for the **VICTORIA AND ALBERT MUSEUM (V&A)**, designed with Burne-Jones, a partner in Morris's company along with others including Rossetti. The museum holds Pre-Raphaelite paintings and works by Morris & Co in every media, including carpets and wallpapers that feature Celtic-style knots of flora, plus tapestries made in collaboration with Burne-Jones that rank among the most beautiful Pre-Raphaelite pieces.

Morris was born in Walthamstow, which hosts the **WILLIAM MORRIS GALLERY**, whose collection includes stained glass designed by the Pre-Raphaelite circle. The group's renewal of this ecclesiastical art form can be seen in situ in Chelsea's **HOLY TRINITY SLOANE SQUARE**

Edward **BURNE-JONES,**
John Henry **DEARLE** and
William **MORRIS**
Angeli Ministrantes, 1894
V&A
The weavers of this tapestry,
produced in the workshops
of Morris & Co, translated
with great skill Burne-Jones'
designs of two dignified
angels that, in combination
with the floral patterns by
Dearle (1860–1932) for the
background and borders,
remind us of Medieval
illuminated manuscripts.

church. Morris designed his own beautiful home,
the **RED HOUSE,** at Bexleyheath; it is a must for
Arts & Crafts lovers. One can visit his
Hammersmith abode, **KELMSCOTT HOUSE,** as
well as the **EMERY WALKER HOUSE,** home to the
eponymous Arts & Crafts designer. The **GEFFRYE
MUSEUM** has collections of the output of Liberty &
Co, the most prominent retailer of related domestic
products.

Leighton is represented by two large frescoes at
the V&A, landscapes at the **NATIONAL GALLERY**
and sculptures and sketches at the **RA,** where he
was President. **LEIGHTON HOUSE MUSEUM,** his
former opulent home and
studio, has as its star
attraction an Arab Hall
covered in Islamic tiles. The
house displays highlights from
the Cecil French Bequest, a
Pre-Raphaelite art collection
left to the borough, which
should find a permanent
home in the future at nearby
FULHAM PALACE.

Leighton's own collection
has been dispersed, but
returns on occasion for
temporary exhibitions. Some
walls are lined with peacock-
blue tiles by William De
Morgan (1839–1917), whose
ceramics can be explored at
the **DE MORGAN
FOUNDATION** alongside
paintings by his wife Evelyn
(1855–1919).

The **BRITISH MUSEUM**
holds interesting works on
paper, such as Rossetti's
Camelot-inspired watercolour
Arthur's Tomb (1855), once
owned by Ruskin. Many
Victorian artists are captured

in the new medium of photography at the
NATIONAL PORTRAIT GALLERY, as well as
in more traditional materials, such as pencil and
paper in Rossetti's portraits of his brother William,
Maddox Brown and Woolner. The latter put
portraits to the forefront of his practice, and a range
of his busts and profile reliefs are held at the
gallery.

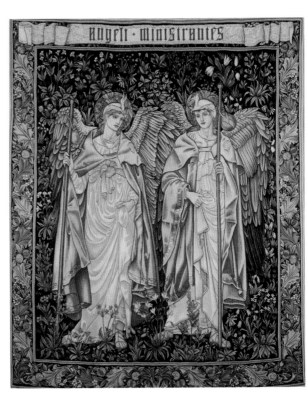

MODERN ART

IMPRESSIONISM &
THE BIRTH OF MODERN ART

When should we celebrate the birthday of modern art? Some historians would throw a party on 15 May, as on that date in Paris in 1863 opened the Salon des Refusés, a one-off exhibition of works that the French Academy had refused for its official Salon.

The Salon des Refusés included two types of artist: incompetents, who failed in their efforts to meet the selection committee's criteria, and innovators, whose art consciously departed from the conservative academic norm. The public tended to confuse the two, coming in large crowds to pour their scorn. Édouard Manet (1832–83) created the most controversy with his radical *The Luncheon on the Grass*, which was met with praise and hostility in equal measure.

The experience taught Manet and like-minded contemporaries that they could receive attention by displaying art away from the Academy. This practical independence precipitated a revolution in art, as artists seized control of distribution as well as production. The poet Jules Laforgue later concluded: 'No more official beauty … The public, unaided, will learn to see for itself and will be attracted naturally to those painters whom they find modern and vital.'

In 1874, a group of painters including Monet and Pierre-Auguste Renoir (1841–1919) staged their own show in a Paris studio, changing the course of art history in the process. The artists were dubbed 'the Impressionists' by critics, after the title of one of Monet's works, and because the paintings seemed hasty and unfinished to the discerning eyes of the time. The forms on the canvases were blurred and indefinite, created with short, broken brush strokes in unblended colour.

In Monet's case, the term Impressionism was apt, as he wished to reproduce his first, naive impressions of a scene, which he thought more authentic than a studied, academic-style reproduction. He even advised another painter to 'try to forget what objects you have before you, a tree, a house, a field, or whatever'. This distrust of knowledge and will to move beyond rules, beyond reason, even beyond thought, would characterise many future art movements and signified a momentous break with the traditions of the Renaissance and Enlightenment.

Charles Baudelaire, a poet and companion of Manet's, had first articulated 'modernity' in an essay, *The Painter of Modern Life* (1863), as 'the transient, the fleeting, the contingent'. Monet and his contemporaries had created the perfect visual language to match, helping to make Paris the capital of modern art in the process. The success of the Impressionists freed future generations of artists from academic constraints.

British collectors took time to catch on, but acquisitions by the English industrialist Samuel Courtauld, purchased during the 1920s, include some exemplary Impressionist and Post-Impressionist pieces, such as Renoir's *The Theatre Box* (1874), which featured in that first, groundbreaking Impressionist exhibition. One of the cultural delights of London is a visit to the **COURTAULD GALLERY** to see these paintings, which are supplemented with a large tranche of works on long-term loan. More masterpieces, as well as a greater art-historical context, can be enjoyed at the **NATIONAL GALLERY**.

Pierre-Auguste RENOIR
The Theatre Box, 1874
COURTAULD GALLERY

Claude MONET
Autumn Effect at Argenteuil, 1873
This enchanting landscape demonstrates some of Monet's innovative techniques. The ripple of the river is suggested by short, horizontal strokes, which become smaller as they lead the eye into the distance; the artist scratches out paint from the right-hand tree to illustrate its diffusion of light.

Three galleries are dedicated to Impressionism and Post-Impressionism, on the first floor overlooking the courtyard of Somerset House. The gallery's world-class works on paper rotate in room 12 and are also on view by appointment.

The household name of Impressionism, Monet, is introduced by the landscape *Autumn Effect at Argenteuil* (1873), a view of a spot on the River Seine, near the small town close to Paris where he lived. Warm brown trees with yellow highlights are contrasted wonderfully with the cool blues and whites of the sky. The effect is doubled by the reflection of the river, and unified by the use of pink tones across the centre. The subject seems less the scene itself, more the act of seeing – for both the artist and the viewer, who takes time to adjust to Monet's vision of the world, painted, in Laforgue's words, 'in the heat of sensory intoxication'.

In a later landscape, *Antibes* (1888), one follows Monet to the Mediterranean, where he sought new effects of light. His use of a single tree to frame his image of the sea hints at his love of Japanese prints. From afar the tree seems to be created from a blended green tone; up close, one can note that it is made from separate blue, green and red marks.

Paint tubes had been invented in 1841, which made plein-air painting far easier – previously pigs' bladders were the primary way of transporting pigment. By working outside, Monet was following English painters such as Constable and Millais, as well as a group of leading French landscape painters, such as Jean-Baptiste-Camille Corot (1796–1875), who gathered around the village of

Edgar DEGAS
Two Dancers on A Stage,
c 1874
Degas' composition in this
picture owes much to
photography. Rather than
positioning the ballerinas in
the centre, as usual, he
paints them at an odd,
informal angle. The floor
takes up much of the image
and another figure of a
dancer is sliced off by the
frame at the left.

Barbizon. An Impressionist who made direct
contact with the Barbizon School was Eugène
Boudin (1824–98), in whose studio Monet
apprenticed as a young man. One can feel every
movement of the brush in his effervescent sketch
of figures on the beach at Trouville (1875). A late
coastal scene at nearby Deauville (1893)
emphasises the scenery of wide sand and sky.

Alfred Sisley (1839–99) thins his paint in *Snow
at Louveciennes* (*c* 1874), so that the primed
canvas shows through at points, while his *Boats on
the Seine* (*c* 1877) makes thicker, wilder marks –
one can understand how eyes so used to a smooth
finish were puzzled by this technique
at the time. Berthe Morisot (1841–
95) was the first woman to regularly
exhibit with the Impressionists. She
had rare skills in both landscape and
portraiture, and her work is
represented in the gallery by a
likeness (1872–5) of her sister
Edma, whose costume is treated
with confident marks and
highlights of colour.

The Theatre Box by Renoir
depicts an elegant couple, the young
lady staring outwards to meet the
viewer's gaze, the young man
looking through his binoculars
towards other members of the
audience. The theatre is revealed as
a social stage for fashionable society,
where men look and women are
looked at. The painting can be seen
as part of the Impressionist project
to create new subjects for their new
type of art. Baudelaire had urged
artists to turn to the contemporary
life of Paris, like his archetype of the
flâneur, or dandy, who would sit at
bars and cafes on the boulevards,
distracted by what he saw around
him.

Parisian Edgar Degas (1834–1917) liked to
look at the city's females, and in particular the
dancers who took to the stage at night. His *Two
Dancers on A Stage* (*c* 1874) captures ballerinas
as they move across the stage, while his statuette
Dancer Looking at the Sole of her Right Foot
(*c* 1895, cast 1919–20) focuses on a nude woman
behind the curtain, preparing for her performance.
Degas only exhibited his sculpture once during his
lifetime; its rough handling was unorthodox for
19th-century France.

From the late 1870s, Degas abandoned oil for
the immediacy of pastels; *After the Bath – Woman*

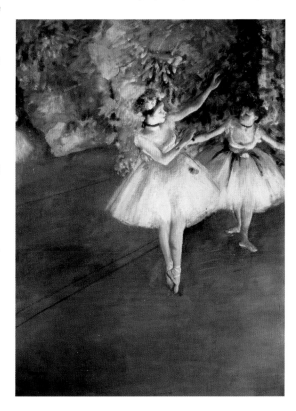

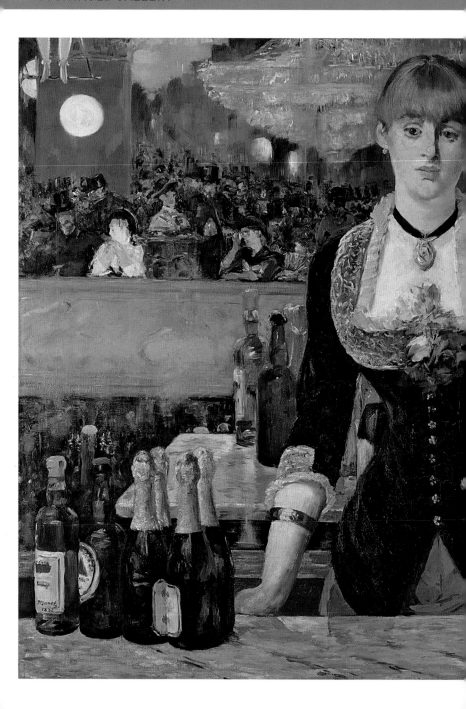

Édouard MANET
A Bar at the Folies-Bergère, 1882
Manet's painting of the famous Paris musical hall was his last major work. The reflection in the background mirror is mysteriously incorrect, in the way it shows the lady leaning forward in conversation with a man. It appears to be a moment from a different time, or an image in the barmaid's imagination.

Drying Herself (c 1895) is, in the artist's words, 'as if you looked through a keyhole'.

Degas preferred to work in his studio than on the spot. One learns that Manet – despite his central position in the movement – also chose his own path. *Banks of the Seine at Argenteuil* (1874) tells us that he painted outdoors with Monet in a not dissimilar style (the two figures are Monet's wife and son). But he kept a firmer structure than his companion, and never abandoned his use of black. The Courtauld has a copy of *Luncheon on the Grass*, probably painted after the 1863 version and lacking its realist finish. Instead of a reverence for the *fête galantes* of Watteau and, earlier, Giorgione, it takes a playful attitude, mixing and matching the Classical and the contemporary. Irony is replaced with anxiety in his masterpiece *A Bar at the Folies-Bergère* (1882), where a barmaid at the infamous Paris haunt stares out in private sadness.

Henri de Toulouse-Lautrec (1864–1901) gained fame for works that had all the atmosphere of the Parisian night. *Tete-a-tete Supper* (c 1899) pictures promiscuous Lucy Jourdan in a restaurant's private room. Sickly green tones and a flattened perspective help give the painting a hallucinatory feel. But Lautrec was a master of printmaking above all, and the lithograph *Bust of Mademoiselle Marcelle Lender* (1895) is created in the more graphic aesthetic seen on his posters in the city's streets.

The brief but bright career of Georges Seurat (1859–91) is represented by a substantial group of small oils. By the 1880s, there was reaction against the casual nature of Impressionist art. Seurat wanted to address the same concerns – light, landscape and contemporary life – but with greater gravity. *Bridge at Courbevoie* (1886–7) exemplifies his approach, termed Divisionalism or Pointillism. In his studio he would methodically paint his scene in tiny, uniform strokes or dots. Like computer pixels, when seen from afar they fuse in the eye into a comprehensible representation. The effect is as luminous as early Impressionist landscapes, but

Paul CÉZANNE
The Card Players, *c* 1892–5
'I love above all else,' confessed Cézanne, 'the appearance of people who have grown old without breaking old customs.' His scenes of card players, far from being fixated on the transient moment, like early Impressionism, evoke the sense of time passing slowly, in silent, patient concentration.

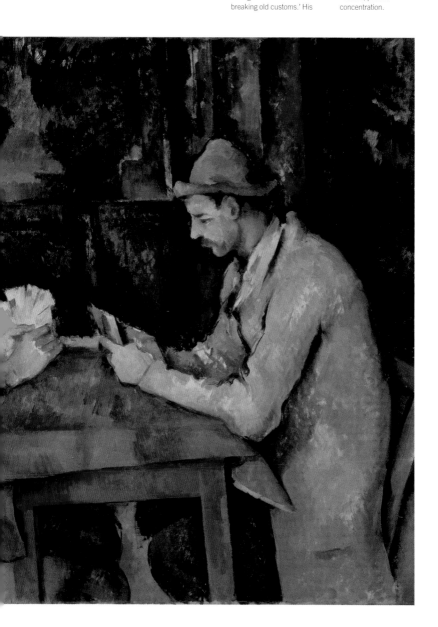

Paul GAUGUIN
Nevermore, 1897
Gauguin abandoned his bourgeois lifestyle in Paris to live in Polynesia. This reclining nude combines an attention to pattern and colour with a sense of paranoia. The woman seems uneasy at the presence of the two figures. A portentous raven looks on, a reference, like the title, to a poem by Edgar Allan Poe.

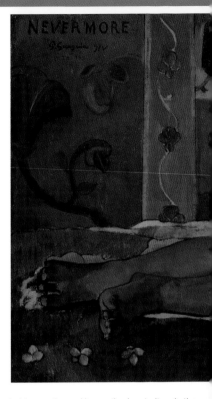

has a reassuring structural effect. The collection holds two Divisionist pieces on paper by Paul Signac (1863–1935), who, with Seurat and others, set up the annual Salon des Independants as a rival to the Academy exhibition.

The landscapes of Camille Pissaro (1830–1903), such as *Festival at L'Hermitage* (1876–8), look at working-class rural life. Many other artists also wished to escape the metropolis and its middle-class values for the countryside. The Courtauld holds the greatest group of works in Britain by Paul Cézanne (1839–1906), who from 1877 toiled in isolation in Aix-en-Provence, in an effort to find in his art, like Seurat, a timelessness that Impressionism lacked but that was achieved by the Old Masters. *Still Life with Plaster Cupid* (*c* 1894) is a composite of the different viewpoints from which the artist studied the scene over a prolonged period. He painstakingly recorded his exact perceptions, slowly reworking the outlines of the forms until they had a weight and tactility true

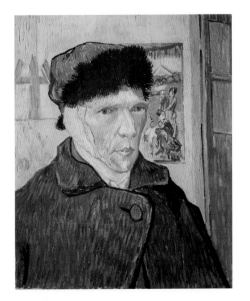

to his experience. He practised portraiture in the same considered manner, including a series of pictures of card players, one of which is owned by the Courtauld (1892–5), as well as landscape. The Courtauld shows five excellent examples of the latter, which, dating from between 1875 and 1896, disclose very gradual developments in his method.

Paul Gauguin (1848–1903) produced *Haymaking* (1889) at a village called Le Pouldu, as Pont-Aven, his normal Brittany base and the most famous countryside retreat for painters, was choc-a-bloc with artists; Gauguin strived for, in his words, the 'savage, primitive quality' of peasant life, most authentic when most removed. Gauguin did not copy nature, but instead used it to express his imagination, influenced by Symbolist writers such as poet Stéphane Mallarmé. *Haymaking* is a case in point, in the way that both perspective and modulated, naturalistic colour are rejected, the result being close to stained glass, or perhaps Japanese prints, both of which were an inspiration

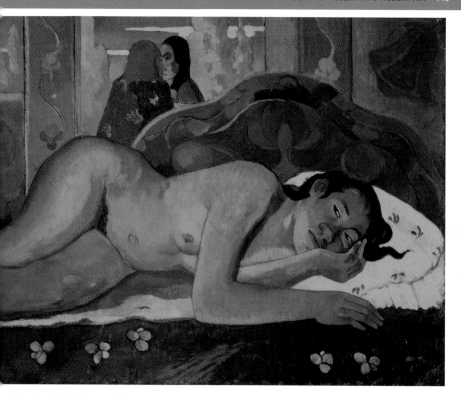

or Gauguin during his career. The two other paintings by the artist – *A Dream* and *Nevermore* (both 1897) – were produced in Tahiti, after he renounced Western life for the South Seas. Gauguin's naive Post-Impressionist manner was at first known as Cloisonnism (because of its resemblance to the enamel technique), before being seen as a strand of Symbolism called Synthetism due to its complex synthesis of the external world, internal fantasy and the aesthetic considerations on the canvas.

It is said that it was after a violent argument with Gauguin that Vincent van Gogh (1853–90) cut off his earlobe in an act of self-mutilation. In a self-portrait from 1889, the Dutch artist turns his thin face in order to better show the wound. The work is a vivid, candid analysis of his mental state, and illustrates the intensity with which Van Gogh lived and practised his art. For a man trained as a theologian, painting was a religion, and his fierce individual brush strokes – which produced peerless

landscapes aflame with colour, such as *Peach Trees in Blossom* (also 1889) on view – were those of a fervent believer searching for redemption in a state of permanent anxiety. The following year Van Gogh took his own life.

Vincent VAN GOGH
Self-portrait with Bandaged Ear, 1889
This self-portrait was painted after the Dutch artist severed his own ear in an attack of anxiety. His easel in the left background stands blank, perhaps symbolic of a void in his mental state, in contrast to a Japanese print on the right, which was normally an inspiration to the artist.

SEE ALSO

Georges SEURAT
Bathers at Asnières, 1884
NATIONAL GALLERY
Large-scale size and simple,
regular shapes give Seurat's
everyday scene of young
men bathing a monumental

feel. In 1886, the French
artist invented his Divisionist
technique, whereby images
were formed with contrasting
dots of colour; he then
reworked areas of this
canvas.

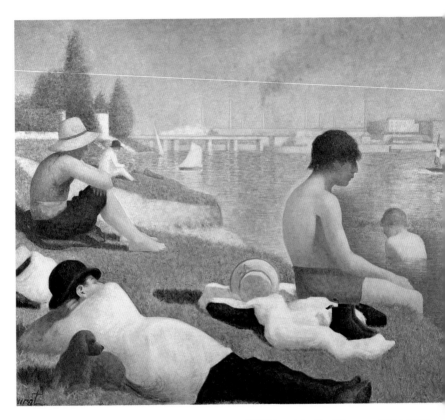

The **NATIONAL GALLERY** has the largest
Impressionist and Post-Impressionist collection
in the city, with memorable canvases on display
from all the major artists. Impressionism took
shape when Monet and Renoir painted together in
the summer of 1869, and *Bathers at La
Grenouillère* by Monet is testament to the free
handling of paint they developed. *The Execution of
Maximilian* (c 1867–8) by Manet is an overt
criticism of the French military. Post-Impressionist
highlights include Seurat's large-scale *Bathers at
Asnières* (1884), Van Gogh's iconic still life
Sunflowers (1888) and the jungle scene *Surprised!*

(1891) by painter Henri Rousseau (1844–1910),
whose naive style was championed by Picasso
(1881–1973).

The gallery features the Barbizon School,
including Corot, Théodore Rousseau (1812–67)
and Charles-François Daubigny (1817–78). Their
interest in painting in the open air, sensitivity to
light, photographic-style composition and freedom
from artificiality proved inspirational to artists like
Monet. The Impressionists inherited their concern
for real life from Realists such as Jean-François
Millet (1814–75) and Gustave Courbet (1819–77).
Courbet wished to 'create a living art' that was real

Auguste RODIN
The Kiss, 1901–4
TATE MODERN
Rodin thought his idealised vision of sexual love was formulaic, but it won the heart of the public. The couple is based on an adulterous pair from Dante's *Inferno*, whose passion was inflamed when reading the story of Lancelot and Guinevere. The book is still clutched in the man's left hand.

to himself and his times; in *Young Ladies on the Bank of the Seine* (before 1857), city girls laze provocatively by the river. Millet gained admirers with works like *The Winnower* (1847–8) that concentrated on the rural poor. The leading Russian Realist, Ilya Repin (1844–1930), is represented by a study of an old man.

But Monet and his contemporaries also shared Aestheticism's emphasis on visual pleasure. At **TATE BRITAIN**, one can appreciate a leading Aesthetic painter, James Abbott McNeill Whistler (1834–1903). His *Nocturnes* are dreamlike landscapes of the Thames at night, restricted in colour range and simple in design, under the influence of Japanese art. The gallery holds many works by Walter Sickert (1860–1942) who championed Impressionism in Britain, setting up the **New English Art Club** in 1885 in dissatisfaction with the **ROYAL ACADEMY OF ARTS (RA)**. One member, American John Singer Sargent (1856–1925), is revealed as the period's most successful portrait painter. The leading American Impressionist in landscape, Winslow Homer (1836–1910), is unfortunately absent from London's major collections, but the Tate and the **FLEMING COLLECTION** include paintings by

the Glasgow Boys, like John Lavery (1856–1941), who adopted the French style in Scotland.

TATE MODERN's international displays start at 1900, which means the Tate's 19th-century European art tends to be shown in its Liverpool and St Ives branches, or loaned to other galleries. Auguste Rodin (1840–1917) first made casts of *The Kiss* in the 1880s, but a late version (1901–4) has the right date for display in Tate Modern. It is remains the best known sculpture in Britain by the groundbreaking French artist, although at the **VICTORIA AND ALBERT MUSEUM (V&A)** one can enjoy a group selected and given by the man himself. Finished in a rough, impressionistic style, these experimental pieces avoid stock subjects in an aim to connect with the human condition. The museum also owns poster art by Lautrec and paintings donated by Victorian banker Alexander Constantine Ionides, an early collector of the French Realists in England, while the **BRITISH MUSEUM** includes works on paper by artists such as Degas, Gauguin and Van Gogh.

A NEW CENTURY: 1900–14

Artists in the 19th century rebelled against naturalism, but those who came to prominence in the next were even bolder, turning on representation itself. Painters including Turner, Monet and Cézanne had redefined what it meant to see and then reproduce the world. With the work of the Russian artists Wassily Kandinsky (1866–1944) and Kasimir Malevich (1878–1935), the modern era consciously moved from figuration to abstraction, where painted forms correlated purely to ideas and sensations rather than objects.

Whether these ideas and sensations were universal or the personal expressions of the artist, or a combination of both, was the subject of debate and difference during the century. For the titan of 20th-century art, Pablo Picasso, this dilemma forgot that the object could never be eradicated. 'There is no abstract art,' the Spanish artist claimed. 'You must always start with something. Afterward you can remove all traces of reality. There's no danger then, anyway, because the idea of the object will have left an indelible mark.'

Cubism, the great artistic project pioneered in Paris by Picasso and Georges Braque (1882–1963), tested the representational limits of painting and sculpture without going entirely beyond them. In its most extreme phase, the still life is methodically deconstructed to a point where a table of objects appear as just a flat, monochrome matrix of angular shapes. But the world is always there, revealed by the title and some canny visual clues.

Having taken a wrecking ball to representation, the artists were in a position to build it up anew, embracing collage techniques in works such as Picasso's *Bottle of Vieux Marc, Glass, Guitar and Newspaper* (1913). For Picasso in particular, the years of Cubism were the seeds for abundant harvests later in his career, as if having gone to the very edges of figuration so early had freed him of any preconceptions about how art should be practised.

As the century turned, Cubism and other art movements such as Fauvism, led by Henri Matisse (1869–1954), served to strengthen the position of Paris as the most important centre for modern art. But the collections of **TATE MODERN** reveal that other cities across the continent remained fertile, such as Munich, which became a focal point for German Expressionism; Milan, the main hub of Italian Futurism; and London, where the Bloomsbury Group and Vorticism briefly blossomed under the influence of experiments abroad.

Housed in a converted power station by the Thames, Tate Modern contains the country's finest international 20th- and 21st-century art (British art from these centuries is also on view in **TATE BRITAIN**). Tate Modern shows work thematically, rather than chronologically, which allows for some fascinating comparisons between artists of different periods, although this can frustrate a visitor after a more traditional art history lesson. Your second stop in the city should be the **COURTAULD GALLERY**, which has outstanding displays of Expressionism.

Pablo PICASSO
Bottle of Vieux Marc, Glass, Guitar and Newspaper, (detail) 1913
TATE MODERN

Henri MATISSE
Portrait of Greta Moll, 1908
Although Matisse's style seems spontaneous, the French Fauve painter laboured on this portrait, asking his subject to sit for 10 three-hour sessions. His final act was to broaden the shape of Moll's arms to give her more grandeur, copying an example in the Louvre by Renaissance artist Veronese.

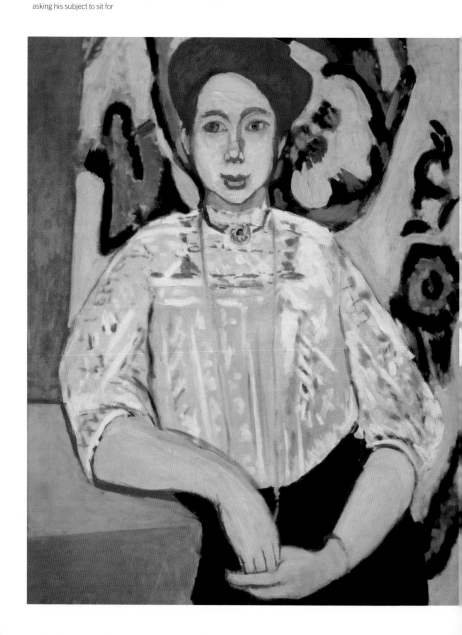

Ernst Ludwig KIRCHNER
Bathers at Moritzburg,
1909/26
Before Kirchner moved to
Berlin, where he produced
the nightlife scenes for which
he is best known, the
Expressionist artist painted

regularly in the countryside
outside Dresden. This is the
largest of several works he
painted of both sexes bathing
nude together, a communal
pursuit popular in Germany
at the time.

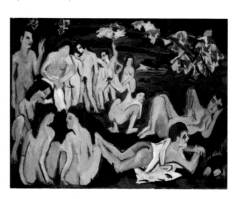

Tate holds two portraits that the leading Fauvist artists, Matisse and his friend André Derain (1880–1954), painted of each other in the summer of 1905. Both artists show the influence of Van Gogh in their marks of thick, incandescent colour, but their draughtsmanship is rougher and palette more arbitrary, particularly in Matisse's likeness of Derain.

Later that year, both painters caused a shock when their anti-naturalistic canvases went on view alongside others by like-minded artists including Maurice de Vlaminck (1876–1958), Georges Rouault (1871–1958) and Raoul Dufy (1877–1953), all of whom are also in the collection. One critic labelled them Les Fauves (The Wild Beasts), so feral their approach appeared. One of the finest works in this style at Tate Modern is Derain's *The Pool of London* (1906), where bold colour clashes vivify a scene on the River Thames.

One can notice a shift in Matisse's painting from 1907. *Standing Nude* of that year shows an interest in structural problems, as well as perhaps African art, with the shape of a woman's body rendered in angular, black lines. In his first commissioned portrait, made of Greta Moll (1908), on long-term loan from the National Gallery, the painter develops a more decorative approach with carefully contrasted, pale colours and the introduction of a flowered fabric into the pictorial space.

Matisse was working in the tradition of those artists, like Gauguin and the Norwegian Edvard Munch (1863–1944), who correlated their art to their own intuitions. The restless brush strokes and odd palette of greens and orange-reds in Munch's *The Sick Child* (1907), for instance, speak of both his anxiety and the illness of the subject. Paintings by Pierre Bonnard (1867–1947) and Édouard Vuillard (1868–1940), two members of the group Les Nabis (from the Hebrew word for prophet), also developed from this Symbolist tradition. Both artists are remembered for their interiors of women, set in the bathroom by Bonnard, the drawing room by Vuillard.

Bathers at Moritzburg (1909/26), the one work at Tate Modern by Ernst Ludwig Kirchner (1880–1938), imagines the flesh of nude bathers in a searing yellow far unlike skin. Kirchner and Karl Schmidt-Rottluff (1884–1976) were two members of Die Brücke (The Bridge), a group whose foundation in 1905 marked the first flowering of German Expressionism. 'He who renders his inner convictions … with spontaneity and sincerity is one of us,' Kirchner stated in the group's manifesto. *Bathers at Moritzburg* is painted in a direct, two-dimensional style that became the hallmark of Die Brücke; one can also see it starkly in Schmidt-Rottluff's *Two Women* (1912). The painters acknowledged their debt to African and Oceanic sculpture, and folk art, for this graphic quality, which, fused with Fauvist colour, helped them overcome painterly associations.

Cossacks (1910–11) is an important prewar canvas by the Moscow-born painter Kandinsky, who settled in Germany and became one of the principal artists in Der Blaue Reiter (The Blue Rider), an association of Munich-based artists formed in 1911. Kandinsky's art shared Die Brücke's interest in inner experience, but went further, wishing for art to become independent from the material world in order to better connect with

Wassily KANDINSKY
Cossacks, 1910–11
The viewer's eye constantly moves between the disparate images in this work by Kandinsky: the eponymous Russian cavalry in orange-red hats on the right, a bird hovering above, a fortress in the background. These vague representational elements were soon to disappear from his art.

emotion. The date of Kandinsky's first fully abstract work is a matter of debate (there is some evidence that it was as early as 1910). *Cossacks* appears transitional, as traces of objects remain in his colourful, semi-figurative shapes and squiggles.

Picasso's melancholy canvas *Girl in a Chemise* dates to a point where the artist had just moved from his Blue Period (1901–4) to his Rose Period (1904–6), both titled after their monochromatic method. *Bust of a Woman* (1909), in contrast, echoes the discoveries the artist made by painting his seminal *Demoiselles d'Avignon* in 1907 (now in the Museum of Modern Art (MoMA), New York, although a study is held at the **BRITISH MUSEUM**), especially the revelation that African masks could offer a way to rethink representation. *Bust of a Woman* constructs a female nude with black and brown geometric areas (known as

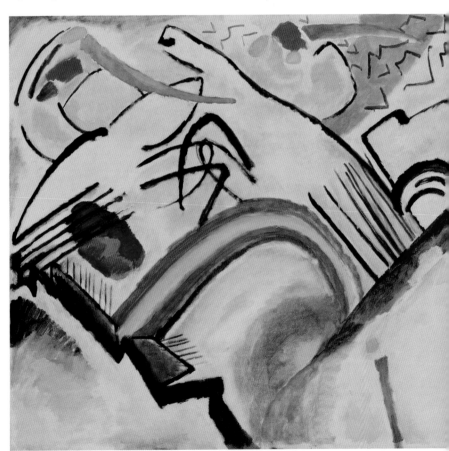

Georges BRAQUE
Clarinet and Bottle of Rum on a Mantelpiece, 1911
Music is the subject of this playful Cubist piece by Braque. It is represented in the clarinet that points out horizontally, the stencilled word *Valse* (Waltz) and the treble and bass clef shapes. One can also sense rhythm in the lines that shift at different angles and intervals.

facets') that directly reflect the masks' paired-down, wooden shapes. It appears a formal exercise, quite unlike the emotional African-inspired works of the Expressionists.

Cézanne's multi-perspectivism was another influence, although Picasso did not share the French artist's interest in his human subjects. *Seated Nude* (1909–10) is like the project of a mathematician who wants to ensure all his geometric elements tessellate perfectly. Braque's *Glass on a Table* (1909–10) arranges the facets in a less ordered fashion, so the foreground and background merge together. In his *Clarinet and Bottle of Rum on a Mantelpiece* (1911), the facets have fractured further into lines rather than concrete shapes. Only modulations in its sober grey tones give a sense of depth.

Bottle of Vieux Marc, Glass, Guitar and Newspaper (1913) by Picasso is the earliest collage work at the gallery. A scrap of newspaper represents itself in a bold move by the artist that dissolves the division between the artwork and the outside world. Collage inspired a fruitful new direction in Picasso's paintings. The shapes in canvas *Bowl of Fruit,*

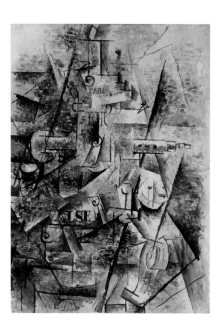

Bottle and Violin (1914) resemble cut-and-pasted pieces of paper, all different in tone and texture.

This synthesis of disparate elements led similar work to be termed Synthetic Cubism. It was adopted by followers of Picasso like the Madrid-born Juan Gris (1887–1927), in *Bottle of Rum and Newspaper* (1913–4), for example. Orphic Cubism, pioneered by French artist Robert Delaunay (1885–1941) and his wife Sonia (1885–1979), concentrated on chroma rather than collage techniques. Robert's *Windows Open Simultaneously (First Part, Third Motif)* (1912) constructs a view of the Eiffel Tower by the interplay of kaleidoscopic patches of colour.

Tate Modern reveals that Picasso's sculpture followed a similar path to his work in two dimensions. One can compare *Head of a Woman (Fernande)* (1909), whose flat, geometric elements relate to Analytical Cubism, with the later collage-style sculpture *Still Life* (1914). The gallery holds a

Umberto **BOCCIONI**
Unique Forms of Continuity in Space, 1913
The Italian artist exalts speed and flux in his famous sculptural figure: a Futurist superman, heroic but also inhuman. The statue's muscles bulge and blur in order to suggest motion. Boccioni studied photographs of people in movement to better create this effect.

good collection of Cubist statues by the Lithuanian Jacques Lipchitz (1891–1973), as well as four works by the Romanian master Constantin Brancusi (1876–1957), whose eloquent early piece *Maiastra* (1911) is an abstracted, elongated form of a bird, cast in gleaming bronze.

The sculpture *Unique Forms of Continuity in Space* (1913) by Umberto Boccioni (1882–1916) is one of the most celebrated works of Italian Futurism. The Futurists deified the dynamism of the mechanical age, making an idol out of the recent invention of the automobile. The group heralded a new beauty, 'the beauty of speed' that the motorcar afforded, and paintings such as *Abstract Speed: The Car has Passed* (1913) by Giacomo Balla (1871–1958) tried to express it in visual art. Boccioni's sculpture concentrates on the intensity of human movement, borrowing the visual language of Cubism in the process.

Futurism influenced avant-garde artists across the world, including the Russian painters Michel Larionov (1881–1964) and Natalya Goncharova (1881–1962). Tate Modern presents compositions by the pair, which in their conglomerations of linear forms attempt to represent the dynamism of light rays (they termed their experiments Rayonism). *Large Horse* (1914) by French sculptor Raymond Duchamp-Villon (1876–1918), brother of the more famous Marcel

Duchamp (1884–1968), captures instead the powerful motion of an animal.

A wide range of portraits by Augustus John (1878–1961) represents a painter hailed as Britain's finest at the start of the century, although his sister Gwen (1876–1939) is shown as a comparable talent. In 1910, Roger Fry curated an exhibition that introduced London to Seurat, Van Gogh, Gauguin and Cézanne. Fry's *River with Poplars* (c 1912) follows Cézanne's methods, while his friends, Duncan Grant (1885–1978) and Vanessa Bell (1879–1961), borrow continental techniques in their respective works such as the primitivist *Head of Eve* (1913) and *Abstract Painting* (c 1914), where Bell dares to paint only seven bright quadrilaterals. The three painters belonged to a bohemian collective called the Bloomsbury Group, named after the central London district in which they gathered.

Sickert's *Ennui* (c 1914) is the highpoint of the works that were produced by the Camden Town Group, who tended towards Realist interiors and city scenes. The London Group was an amalgamation of the Camden painters and the Vorticists, an avant-garde movement in the Futurist mould that exalted the idea of the vortex – a form suggested in the painting *Workshop* (c 1914–15) by the group's leader Wyndham Lewis (1882–1957). Vorticist painters at Tate Modern include

Vanessa BELL
Abstract Painting, c 1914
This painting by the Bloomsbury Group artist Bell is one of the very earliest works of pure abstraction at Tate Modern, and demonstrates that, on the eve of the First World War, some of the most radical experiments on the Continent were being absorbed and reinterpreted by English artists.

Christopher Nevinson (1889–1946), as well as David Bomberg (1890–1957), whose canvases *In the Hold* (c 1913–4) and *The Mud Bath* (1914) are among the movement's greatest achievements. The gallery also charts the emergence of three London-based sculptors: Jacob Epstein (1880–1959), whose *The Rock Drill* (1913–14) was the first representation of a robot; Eric Gill (1882–1940), a controversial artist known for his type design and relief works like *Ecstasy* (1910–11),

which features a copulating couple; and Henri Gaudier-Brzeska (1891–1915), a highly talented French sculptor cut down in his prime by the war that engulfed Europe.

Oskar **KOKOSCHKA**
Poster for the Vienna
Kunstschau, 1908
V&A
Klimt and other acclaimed
Austrian artists collaborated
on the first Vienna
Kunstschau, an exhibition

that intended to promote the
capital as a centre of
European art. Kokoschka
exhibited and designed this
poster, conceived in an
Expressionist style that, by
1908, had superseded Art
Nouveau.

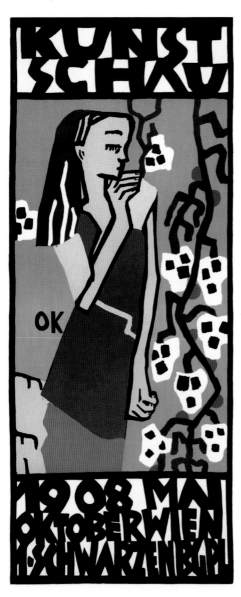

The **NATIONAL GALLERY** lends much of its 20th-century art on a long-term basis to Tate, although one can still enjoy a few gems at the venue, including canvases by Vuillard, French Symbolist painter Odilon Redon (1840–1916) and much-admired Austrian artist Gustav Klimt (1862–1918), who led the famous collective the Vienna Secession.

Alas, there are no works from Klimt's later, most experimental period, nor any by his brilliant protégé, Egon Schiele (1880–1918), but the **VICTORIA AND ALBERT MUSEUM (V&A)** owns a wonderful 1908 poster by the Secession artist Oskar Kokoschka (1886–1980). It demonstrates how Expressionism's pared-down aesthetic was a perfect fit with graphic art; the V&A and the **BRITISH MUSEUM** hold high-impact woodcuts and lithographs by key artists such as Kirchner, Erich Heckel (1883–1970) and Franz Marc (1880–1916), and Munch and Kathe Kollwitz (1867–1945) from an older generation.

The V&A is also the best place to study Art Nouveau, the turn-of-the-century manner full of flowing curves that preceded Expressionism, from the poster art of Czech Alphonse Mucha (1860–1939) to the erotic black-and-white illustrations of Englishman Aubrey Beardsley (1872–98). Notable Art Nouveau interiors include **LITTLE HOLLAND HOUSE** in Sutton, which was the former home of the designer Frank Dickinson (1874–1961), as well as the **Criterion Brasserie** and the food hall at **Harrods**.

London's Bloomsbury Group set up the Omega Workshops that, like Klimt and Kokoschka's Wiener Werkstätte (Vienna Workshops), bridged gaps between art and design. Omega textiles, ceramics and furniture are held at the **COURTAULD GALLERY**, together with canvases by the group's painters. Thanks to long-term loans from private collections, the Courtauld's walls are also

David **BOMBERG**
Racehorses, 1913
BEN URI GALLERY
As a young student at the
Slade in 1912, Bomberg saw
an exhibition of Italian
Futurist works in London.

The experience brought an
epiphany and precipitated a
series of drawings of which
this is the finest. Both horses
and their human riders are
deconstructed to a web of
thin, long rectangles.

adorned by exemplars of early 20th-century
European art that include Fauvist pieces by Derain,
Matisse, Dufy and a pre-Cubist Braque, and
Expressionist art by Kirchner, De Vlaminck,
Kandinsky, Paula Modersohn-Becker (1876–
1907), Gabriele Münter (1877–1962), Max
Pechstein (1881–1955), Kees Van Dongen (1877–
1968) and Alexej von Jawlensky (1864–1941).

The **ESTORICK COLLECTION OF MODERN
ITALIAN ART** explores Italian Futurism in detail;
highlights include *Leaving the Theatre* by Carlo
Carrà (1881–1966) and *The Boulevard* by Gino
Severini (1883–1966) – both 1910–11. The
BRITISH LIBRARY keeps many of the avant-garde
movements' manifestos and journals, such as the
three most important Futurist publications,
unavailable together anywhere else, and *Blast*, the
Vorticist magazine whose bold typography departs
markedly from ornate Victorian design. The V&A's
NATIONAL ART LIBRARY examines the rise of

artists' books from this time, while the **TYPE
MUSEUM** and **DESIGN MUSEUM** hold other
specimens of groundbreaking graphics.

The **FLEMING COLLECTION** presents
paintings by a group known as the Scottish
Colourists, including John Duncan Fergusson
(1874–1961), who brought Fauvism's intensity
of palette to British art. The **WHITECHAPEL
GALLERY** introduced the public to the Whitechapel
Boys, local Jewish artists such as Epstein and
Bomberg who helped establish Modernism in
London; St John's Wood's **BEN URI GALLERY,
THE LONDON JEWISH MUSEUM OF ART** stages
regular exhibitions of their work. The **ARTS
COUNCIL COLLECTION**, a national loan collection
of modern art, holds good examples from the
period, as do the **NATIONAL PORTRAIT GALLERY**
and the Slade School of Fine Art, where many
British Modernists studied (its works are part of
the **UCL ART COLLECTIONS**).

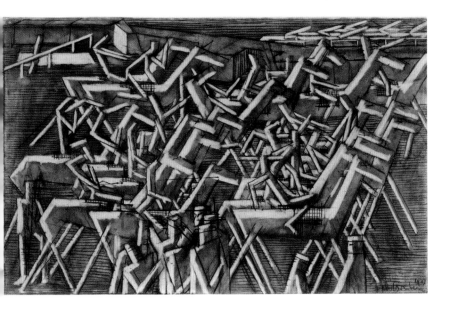

MODERN ART BETWEEN THE WARS

The golden generation of European painters and sculptors from the first years of the 20th century found themselves, with few exceptions, conscripted into the First World War (1914–18) and witness to destruction on an unprecedented scale. Most of the great artists of the past had encountered war indirectly. But the Great War made Kokoschka a cavalryman, Derain an artilleryman, and other artists machine-gunners, stretcher-bearers and medics. The Cubist painter Fernand Léger (1881–1955) wrote from the front that the war was 'the perfect orchestration of every means of killing, both old and new'. As well as Gaudier-Brzeska, exceptional talents such as Boccioni and Marc were among those who died during the conflict. The **IMPERIAL WAR MUSEUM**, **TATE MODERN** and **TATE BRITAIN** display fine examples of art by painters who captured the horrors in front of their eyes.

Before the conflict, Futurist-minded artists openly praised the industrial age; during and after the war, this position became less tenable, once artists had seen the systematic use of machines for murder. In London, Vorticism was an early casualty as associates moved away from the movement's aggressive aesthetic. In 1916, sculptor Jacob Epstein returned to the drill-wielding robot *Rock Drill* he had started before the war and, in disgust, cut off the drill and dismembered the figure. 'Lately the whole horror of war has come freshly upon me,' explained his fellow Whitechapel Boy Mark Gertler (1891–1939) in connection with his canvas *Merry-Go-Round* of the same year. One of the Tate's most affecting anti-war works, it shows rigid men and women on a revolving carousel, their mouths all open as if crying out in unison.

But technology remained an ideal for some European interwar artists. For Russian Constructivists, geometric forms inspired by engineering reflected the pure aspirations of the proletariat, recently emancipated by the Russian Revolution. The Bauhaus, a highly influential school established by Walter Gropius (1883–1969) in Weimar, Germany, proposed that technically orientated design could rebuild both Europe's infrastructure and visual culture.

Tate Modern shows particularly strong collections of Surrealist art, a movement that began in 1920s Paris and then spread widely so that, by the time of the Second World War, it had become influential as far as Mexico. Although Surrealist art tends to lack the formal experimentation of Cubism, its complex content – dipping in and out of the artist's unconscious – offers other rich rewards for the art lover.

Visitors can also follow the further development of important prewar artists such as Picasso and Matisse. The latter, once a trailblazer with Fauvism, settled into an art in the interwar years that was, in his phrase, 'like a good armchair', constructed to relax and soothe the mind with its beauty. Matisse's huge popularity by the 1940s caused American art critic Clement Greenberg to lament 'the debacle of the age of experiment'. But the Tate shows that subversive voices continued to speak out loud, not least the Dadaist *agent provocateur* Marcel Duchamp, who put two fingers up at good taste by submitting a urinal, *Fountain*, to a show in 1917.

Marcel DUCHAMP
Fountain, 1917,
1964 replica
TATE MODERN

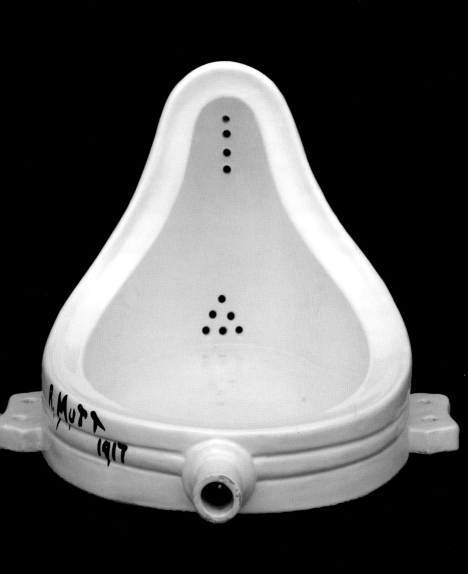

Kasimir MALEVICH
Dynamic Suprematism,
c 1915–16
The avant-garde Russian
painter Malevich created
constellations of simple
forms that had no reference
to the natural world. The
artist intended these
Minimalist pieces to be felt
with the same intensity as
Russian icons, although his
emphasis on 'pure feeling'
was secular rather than
religious.

The French capital continued to buzz with
artistic activity during and after the war. *Portrait
of a Girl* (*c* 1917) and *The Little Peasant* (*c* 1918)
by Amedeo Modigliani (1884–1920) perfect on
canvas the style of the Italian's prewar sculpture,
such as *Head* (*c* 1911–12). His elongated forms
take inspiration from African, Cambodian and
ancient Mediterranean art. *The Green Donkey*
(1911) is an early piece painted in Paris by the
visionary Belarussian artist Marc Chagall (1887–
1985), based on
nostalgic memories of
his native country.
The work's colourful,
folkloric imagery
remained
characteristic of the
artist, even when he
took a supernatural
turn in the 1920s
with prints like *The
Vision*. Other
interesting artists
from the School of
Paris on view include
Russian painter
Chaïm Soutine
(1893–1943) and
Balthus (1908–
2001), of Polish
descent.

By the time of *Dynamic Suprematism* (*c* 1915–
16), the Russian painter Kasimir Malevich had
rejected an early Cubist-Futuristic approach for
minimalist arrangements of geometric shapes on a
white background. 'To produce favourite objects
and little nooks of nature is just like a thief being
enraptured by his shackled legs,' he declared in his
manifesto. He named his art Suprematism, after
the 'supremacy of pure feeling' to which he thought
his practice connected.

El Lissitzky (1890–1941), in works like the print
series *Victory Over the Sun* (1923), adapted

Malevich's visual vocabulary to create designs in
tune with the utopian hopes of the Communist
state. Lissitzky was associated with Alexander
Rodchenko (1891–1956) and Vladimir Tatlin
(1885–1953) who created 'constructions' in
industrial materials that had either direct or
metaphorical social utility. Neither is in the Tate
collection, although there is a large collection of
works by Naum Gabo (1890–1977) who, like
Lissitsky, spread Constructivism in the West. Long-
term loans from the
David King
Collection represent
the Socialist
Realism that
superseded
Constructivism
once it fell out of
Stalin's favour.

Swinging
(1925) exemplifies
the geometric
Expressionism that
Kandinsky
developed during
his period as a
professor at the
Bauhaus. Tate
holds one painting
and a group of
works on paper by
Paul Klee (1879–1940), a Bauhaus teacher who
combined the pictorial poetry of Der Blaue Reiter
(of which he was once a member) with a
meticulous investigation into the principles of
composition. Hungarian László Moholy-Nagy
(1895–1946), in comparison, appears a complete
convert to Russian art's cool precision; *K VII*, from
1922, typifies the Constructivist techniques he
brought to the school the following year.

This austerity found an equivalent in De Stijl, a
cerebral Dutch art movement defined by Piet
Mondrian (1872–1944) and Theo van Doesburg

Max **BECKMANN**
Carnival, 1920
In this and other paintings from the early 1920s, the German artist Beckmann turned to metaphors of stage, circus and performance to examine what he saw as the theatre of life. His complex representations of the human condition were included in works considered 'degenerate' by the Nazis in 1937, forcing him into exile.

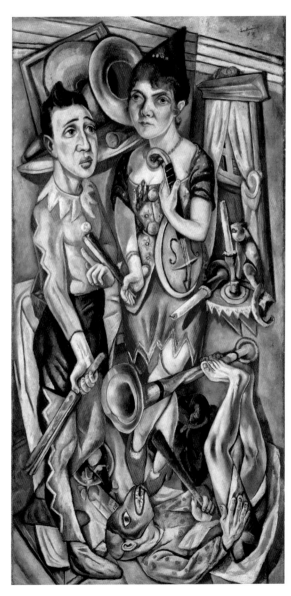

(1883–1931). One can follow Mondrian in the collection as he moves from Pointillism to Cubism to early attempts at geometric abstraction to a transcendent, mature style of the 1930s: asymmetrical grids of black vertical and horizontal lines on white, punctuated by rectangles of primary colour. Mondrian's journey towards Minimalism can be seen as a single-minded search to connect art with universal, quasi-spiritual elements. Van Doesburg had a similar focus, but split from Mondrian by developing diagonal lines in pieces like Tate's *Counter-Composition VI* (1925).

In a very different spirit to the Bauhaus, artists at Tate Modern loosely grouped under the movement Neue Sachlichkeit (New Objectivity) savagely satirised Germany society. *Carnival* (1920) by Max Beckmann (1884–1950) characterises the painter's fusion of comedy, tragedy and the grotesque; the Clown and the Fool represent the madness of the world. George Grosz (1893–1959) caricatures the bourgeoisie in two drawings, while Christian Schad (1894–1982) scrutinises himself and his lover in the unsettling photo-realistic *Self-Portrait* (1927).

Marcel Duchamp, Jean Arp (1886–1966), Kurt Schwitters (1887–1948) and Francis Picabia (1879–1953) introduce us to Dadaist art. The group exploded into life in 1916 in Zurich; Switzerland was a neutral country and haven for anti-establishment artists and writers, and its anarchist-nihilist approach can be seen as a direct reaction to the war. 'Dada' was a made-up word intended

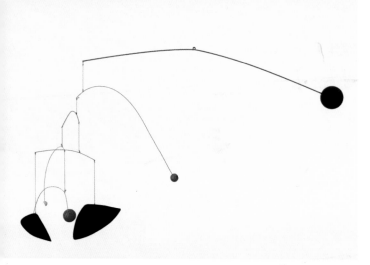

to have no meaning, and as such reflects well the art on view.

Arp created the composition for *Torn-Up Woodcut* (1920/54) by simply dropping scraps of paper from above, putting chance in control instead of his choice. Duchamp's totemic work *The Bride Stripped Bare by her Bachelors, Even* (1915–23), or *The Large Glass*, is exhibited in the form of a meticulous reconstruction by British artist Richard Hamilton (1922–). Oil, varnish, foil, wire and dust form images between two large, vertical sheets of glass, but the meaning of the images, and the piece as a whole, remains elusive. *Fountain* (1917/64) was the most notorious of Duchamp's 'readymades' – everyday objects the Frenchman posited as artworks. Art could now, it seemed, be anything the artist chose, and the value of a work was in the questions it raised, and not its material qualities.

Dada passed the baton in the mid-1920s to Surrealism, a multidisciplinary movement that drew on the theories of Sigmund Freud, who explained psychology with reference to the unconscious mind, which he argued was a mass of hidden desires. German painter Max Ernst (1891–1976) examines his repressed feelings as a son in *Pietà* or *Revolution by Night* (1923), which replaces a standard religious *Pietà* – in which Christ's dead body is cradled by Mary – with an image of the artist in the arms of his father.

The semi-representational forms in *Painting* (1927) by Joan Miró (1893–1983) were, for the Spaniard, automatically produced by his unconscious: 'As I paint, the picture begins to assert itself under my brush.' Frenchman André Masson (1896–1987) emerges as another pioneer of this approach, known as Automatism. Tate also has on loan from a private collection an early mobile, from about 1938, invented by the American sculptor Alexander Calder (1898–1976), from which abstract shapes are animated by the flow of air.

Other artists, much like Freud, emphasised the importance of dreams

Salvador DALÍ
Metamorphosis of Narcissus, 1937
The Spanish artist reinterprets the Greek myth of Narcissus, the youth who fatally fell in love with his reflection and was immortalised as a flower. The painting creates a startling double image where the man's form is replicated by a hand holding an egg, from which the flower shoots.

as a gateway to the unconscious. *The Reckless Sleeper* (1928) by Belgian René Magritte (1898–1967) depicts a sleeping man adjacent to six symbolic objects that appear in his dreams. *Metamorphosis of Narcissus* (1937) is a classic by the most famous Surrealist, Spanish artist Salvador Dalí (1904–89). He described such hallucinatory scenes, realistically rendered and full of deeply odd juxtapositions, as 'hand-painted dream photographs'. The unexpected combination of disparate elements was central to Dalí's practice, allowing disturbing connections that hinted at unconscious desires. *Lobster Telephone* (1936)

composites a ready-made telephone with a plaster lobster, both objects of sexual connotation for the artist. Italian painter Giorgio de Chirico (1888–1978) anticipates this method in *Uncertainty of the Poet* (1913), which sets a bunch of bananas next to a marble torso in a desolate, urban plaza.

While canvases on view by Léger continue Synthetic Cubism, Picasso abandons the style. Although close to the Surrealists, he never embraces their ideas fully, working independently, sometimes in several different modes at once. *Seated Woman in a Chemise* (1923) is painted in an Ingres-inspired Classicism; the semi-figurative

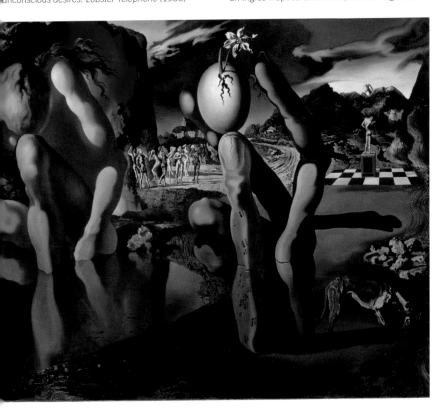

Henry MOORE
Recumbent Figure, 1938
This large reclining figure was one of the many the British sculptor produced during his career. Moore used native rock and wood for his sculptures, and the undulating form of this work seems to reflect the valleys of Oxfordshire from which its stone was quarried.

The Three Dancers (1925) features violently angular forms and harsh colours; *Nude Woman in a Red Armchair* (1932) is all erotically charged curves.

Mexican Diego Rivera (1886–1957) turns from Cubism in *Still Life* (1916) to a left-wing realist manner in *Mrs Helen Wills Moody* (1930), a huge preparatory piece for a fresco commissioned for the California stock exchange. *Cosmos and Disaster* of 1936 sees Rivera's collaborator, David Alfaro Siqueiros (1896–1974), mix black industrial paint with splinters of wood and grit to create an apocalyptic vision of a battlefield.

In the same year, Britain belatedly established its first Surrealist group and exhibition. Tate holds most of the associated artists, including Roland Penrose (1900–84), Edward Burra (1905–76), Leonora Carrington (1917–), Eileen Agar (1899–1991), Graham Sutherland (1903–80) and – the most influential – Paul Nash (1889–1946), whose *Landscape from a Dream* (1936–8) sets strange visual symbols in the context of the English landscape.

Two Primitivist-style sculpted faces, both entitled *Mask* (1928 and 1929), demonstrate the formative fascination that Henry Moore (1898–1986) had with Pre-Columbian art. *Recumbent Figure* (1938) is one of the English sculptor's first reclining females, and *Three Points* (1939–40) covers Surrealist ground, the three sharp forms creating an overwhelming sense of anxiety. His Second World War works on paper, ghostly representations of Londoners taking refuge from the Blitz in underground shelters, solidified his reputation as the country's finest artist.

Tate also covers in depth Ben Nicholson (1894–1982), as well as his father, the highly skilled painter and printmaker William Nicholson (1872–1949), whose best period was before the

Great War. Ben's reliefs and paintings from the mid-1930s are some of the finest expressions in England of the clean-lined Constructivist art expounded by Gabo, his associate. His sculptures are rivalled by the curved abstracts of Barbara Hepworth (1903–75). Both continued to blossom when, as a married couple, they moved to St Ives, Cornwall, in 1939, to escape wartime London: *1943–45 (St Ives, Cornwall)* demonstrates how Nicholson's art was reinvigorated by the idyllic Cornish environment.

Ben NICHOLSON
1943–45 (St Ives, Cornwall)
This harbour view exemplifies the landscape painting Nicholson embraced once he moved to St Ives during the Second World War. His 1930s excitement with pure geometric abstraction informs the composition, as does British victory, celebrated by a Union Jack in the foreground.

Amedeo MODIGLIANI
Female Nude, c 1916
COURTAULD GALLERY
Modigliani drew and painted
nudes throughout his career,
and these revered works,
more than his other
portraits, remind us of the
academic Classicism he
learnt as a younger man in
Italy. The most unusual
element in this work is the
long, geometric face,
inspired by pre-Classical
and non-Western art.

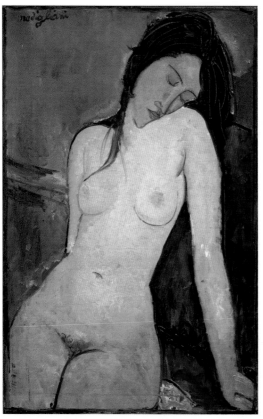

Constructivists Rodchenko and Alexandra Exter (1882–1949) are represented at the V&A, as are the Russian Socialist Realists. The giant front cloth by Picasso (1924), and back cloth by Goncharova (1926), were used by Ballets Russes, the legendary company of impresario Sergei Diaghilev. Bauhaus works include Moholy-Nagy's graphics and chairs by Marcel Breuer (1902–81). The school's simplification of form had a profound influence on architecture. Gropius and subsequent director Ludwig Mies van der Rohe (1886–1969), as well as Le Corbusier (1887–1965), were the pioneers of the stripped-down International Style.

The **LONDON TRANSPORT MUSEUM** shows how artists fleeing Nazi oppression, including Moholy-Nagy and Hans Schleger (1898–1976), helped to modernise the network's design. Emigrés Berthold Lubetkin (1901–90) and Ernö Goldfinger (1902–87) completed residential architecture in the International Style in Hampstead, respectively **HIGHPOINT** and **2 WILLOW ROAD**. The public can see inside the latter, which displays Modernist art. Other early modern architecture can be researched via the **ROYAL INSTITUTE OF BRITISH ARCHITECTS (RIBA)** and the **TWENTIETH CENTURY SOCIETY**; Lubetkin's penguin pool at **LONDON ZOO** is a favourite. If you visit Hampstead, stop at the **FREUD MUSEUM** to see the home and collection of the theorist synonymous with Surrealism. Nearby **FENTON HOUSE** displays works by William Nicholson, as well as older paintings.

The **VICTORIA AND ALBERT MUSEUM (V&A)** and **DESIGN MUSEUM** examine Art Deco, the glamorous interwar style whose geometric forms and exotic patterns developed from Cubism and Primitivism. The V&A includes pieces by French furniture designer Emile-Jacques Ruhlmann (1879–1933), English ceramicist Clarice Cliff (1899–72) and American architect Frank Lloyd Wright (1867–1959). One of the best Art Deco interiors open to the public (and the most fun) is **CLARIDGE'S BAR**.

A wartime female nude (c 1916) by Modigliani at the **COURTAULD GALLERY** is a crowd pleaser, as are interwar canvases by Kandinsky and

Paul NASH
Battle of Britain, 1941
IMPERIAL WAR MUSEUM
Britain's finest painters were commissioned to create art in response to the Second World War. Nash is known for his ominous war works, such as Tate's *Totes Meer (Dead Sea)* (1940–1), but this piece uses pretty plumes of smoke from fighter planes to emphasise freedom from Nazi occupation.

Nicholson. The **ESTORICK COLLECTION OF MODERN ITALIAN ART** features Modigliani and De Chirico. The **BRITISH MUSEUM** print collection holds etchings by admired American realist Edward Hopper (1882–1967) and Neue Sachlichkeit Expressionist Otto Dix (1891–1969), plus works by Mexican muralists Rivera, Siqueiros and José Clemente Orozco (1883–1949), including portraits by the former of his wife, the Surrealist painter Frida Kahlo (1907–54); her own art is not included in the city's public collections. Avant-garde curiosities at the **BRITISH LIBRARY** include a poetry collection by Vladimir Mayakovsky designed by El Lissitzky. The **BRITISH FILM INSTITUTE** is a centre for artist-films, such as *Un chien andalou* (1928), the Surrealist eye-slasher by Dalí and Luis Buñuel.

As well as Modernists, **TATE BRITAIN** displays quirky native painters such as Stanley Spencer

(1891–1959) and LS Lowry (1887–1976), respectively inspired by village life and the industrial North, as well as traditionalists such as William Coldstream (1908–87) of the Euston Road School. The collections of the **MUSEUM OF LONDON, NATIONAL PORTRAIT GALLERY** and the **ARTS COUNCIL COLLECTION** also have notable examples of interwar art, as does the **BEN URI GALLERY, THE LONDON JEWISH MUSEUM OF ART**, which holds *Apocalypse en Lilas, Capriccio*, painted in 1945 by Chagall in response to the Holocaust. In contrast, Nash celebrates aerial victory in *Battle of Britain* (1941), held at the **IMPERIAL WAR MUSEUM**. There is a range of other war-related collections: the **MINISTRY OF DEFENCE ART COLLECTION, NATIONAL ARMY MUSEUM** and **ROYAL AIR FORCE MUSEUM**.

POSTWAR ART: ABSTRACTION TO POP

In the modern era, as much as in the past, the cultural influence of any country has been closely connected with its economic and military confidence. The ascendency of the US as a pre-eminent post-Second World War superpower – only checked by an insular Soviet Union – coincided with the meteoric rise of New York as the capital of the international art scene.

European artists who arrived from across the Atlantic, many in fear of Nazi persecution, helped encourage experimentation, in particular Hans Hofmann (1880–1966) and Arshile Gorky (1905–48), immigrants who had roles in the development of Abstract Expressionism from the 1940s. New York was less factional than Paris and émigré artists as diverse as Mondrian, Beckmann and Dalí had admirers in common in the city during and after the war. But some of the New World's finest also defined themselves against the 'sterile conclusions of Western European art', in the words of North Dakota-born Abstract Expressionist Clyfford Still (1904–80).

TATE MODERN has a sufficiently broad collection of art to make comparisons across the two continents. A postwar work by Mark Rothko can find itself next to Monet's *Water-Lilies* (after 1916), a late painting by the French artist which, in its attempt to represent the play of light on a garden pond, becomes an almost abstract harmony of colour. Although Pop Art developed independently in the US and UK, one can note family resemblances between, for example, the iconic screen-print paintings of American Andy Warhol (1928–87) and the commercial-culture collages by Scottish artist Eduardo Paolozzi (1924–2005).

London's relationship with the international avant-garde after the war, explored at **TATE BRITAIN** as well as Tate Modern, makes for a fascinating story. In 1951, the five-month Festival of Britain on the south bank of the River Thames celebrated new, forward-thinking architecture and design, in an effort to promote postwar recovery. The newly formed **ARTS COUNCIL COLLECTION** commissioned works for the festival by modern minds such as Paolozzi, Hepworth and Ben Nicholson (his huge mural for the event is held by the Tate).

During the later 1950s and into the Swinging Sixties, sleek, concrete tower blocks in the International Style began to replace Victorian houses destroyed in the Blitz, and on the festival site sprung up the **SOUTHBANK CENTRE** arts complex, designed in a high-Modernist manner known as Brutalism and including the **HAYWARD GALLERY**. Conceived after the war as laboratory for new ideas, the **INSTITUTE OF CONTEMPORARY ARTS (ICA)** became a key location on the London scene. Meanwhile, Soho remained the decadent haunt of painters Lucian Freud (1922–) and Francis Bacon (1909–92) – dealt with in depth in the next chapter – whose psychologically taut forms of figurative art held out against the international trends of Abstraction and Pop.

There is no definitive point where postwar art ends and contemporary art begins, and one can argue that no division is necessary, as earlier trends – as well as artists – are still alive today. But for the practical purposes of this book, postwar art ends with Pop, before Conceptualism transformed art from objects to ideas.

Mark ROTHKO
Red on Maroon, (detail)
1959, from the *Seagram Murals*, 1958–9
TATE MODERN

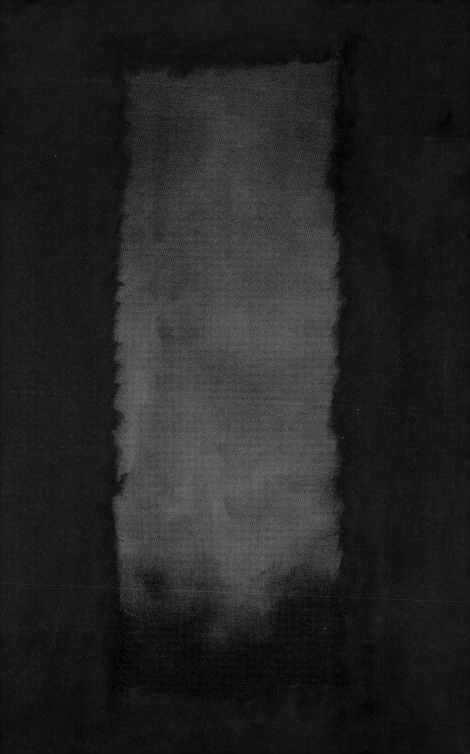

Jackson POLLOCK
Summertime: Number 9A,
1948
Pollock rhythmically poured paint in abstract webs from above, improvising as he went along, much like a jazz musician. After leaving its first layer to dry, he would have returned to this 5.4-metre-long canvas to apply secondary lines and areas of colour, possibly with a stick, trowel or knife.

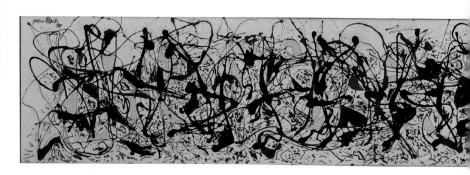

Naked Man with Knife (*c* 1938–40) is an early semi-figurative composition by Jackson Pollock (1912–56) that was derived from a work by Orozco, although the distorted body forms remind one of another of Pollock's heroes, Picasso. The violent physicality of this picture is then translated into process in *Summertime: Number 9A* (1948). A canvas has been laid out on a studio floor and Pollock – using his famous improvisational technique – has dripped abstract swirls of unmixed house paint back and forth across it.

In the words of critic Harold Rosenberg, 'the revelation is contained in the act' rather than by chance or design. In *The Visit* (1966–7), Pollock's fellow action painter Willem de Kooning (1904–97) brushes lurid colours with tangible aggression; the biomorphic shapes that result resemble the canvases of his friend Gorky, who is represented by *Waterfall* (1943). *Meryon* (1960–1) is a characteristic Franz Kline (1910–62), its wide, black, gestural strokes on white canvas influenced by both Japanese script and urban architecture.

Abstract Expressionism does not appear as a cohesive style; it was more a network of like-minded New York artists. *Sawhead* (1933) is a surreal prewar piece by the scene's most respected sculptor, David Smith (1906–65), inspired by the welded-metal creations of Picasso and Julio González (1876–1942). In *Agricola IX* (1952), Smith solders together eight agricultural

implements to create an expressive work akin to 3-D calligraphy.

In Rothko's mature paintings, two or three cloudy rectangles of translucent colour vibrate on large, thinly stained canvases. The effect starts as optical, before becoming emotional, as the richness of the colour overwhelms the viewer. 'I'm interested only in expressing basic human emotions – tragedy, ecstasy, doom,' the artist explained. The war, the Holocaust and Hiroshima had nailed the coffin of organised religion; Rothko's works offered an alternative spiritual experience. Jewels in the Tate collection include Rothko's sombre but stirring *Seagram Murals* (1958–9).

This seriousness of purpose – combined with a certain Beat Generation machismo – links most of the New York School on view, including Adolph Gottlieb (1903–74), Ad Reinhardt (1913–67) and, one of its chief theorists, Robert Motherwell (1915–91). In Still's *1953*, the fissure that ruptures the canvas of canyon-deep blue was, in the painter's words, 'a gesture of rejection of any authoritarian rationale or system of politico-dialectical dogma'. In *Adam* (1951–2) by Barnett Newman (1905–70), the three red vertical stripes ('zips') that run down an expanse of brown relate to man's creation by God.

Art Informel was Abstract Expressionism's European cousin, characterised by the 'informal' procedure used in pieces like *Busy Life* (1953) by

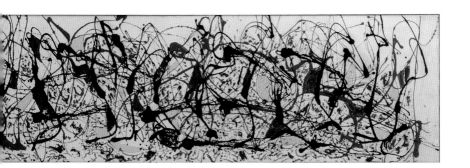

Jean Dubuffet (1901–85), where the French artist carves rudimentary figures in paint with a knife. *Hip, Hip, Hoorah!* (1949) by Dutch painter Karel Appel (1921–2006) has similarly rough imagery; Appel, Asger Jorn (1914–73) and Constant Nieuwenhuys (1920–2005) – members of the collective CoBrA – believed, in Appel's words, that 'the child in man is all that's strongest, most receptive, most open and unpredictable'.

Matisse embraces his inner child in *The Snail* (1953), his final masterpiece. Large, brightly painted, roughly scissor-cut pieces of paper are pasted to lyrical effect on white. Roberto Matta (1911–2002) and Yves Tanguy (1900–55) are two talented European Surrealist painters on view who moved to New York during the war, but sculptor Alberto Giacometti (1901–66) – whose mixed-media construction *Hour of the Traces* (1930) typifies his Surrealist interwar peroid – retreated to Geneva, then back to Paris. His friendship there with French existentialist Jean-Paul Sartre helped precipitate a new direction, in works like *Man Pointing* (1947): vertically stretched, pin-thin figures whose isolation in space summed up Sartre's thesis of human detachment.

In Britain, 1950s austerity precipitated pieces of grim, domestic realism such as *Mother Bathing Child* (1953) by Jack Smith (1928–) and *The Toilet* by John Bratby (1928–92), two of the artists termed Kitchen Sink painters. Frank Auerbach

Alberto GIACOMETTI
Man Pointing, 1947
This life-size bronze is one of the first human figures sculpted by Giacometti, marking a new direction in his work after the war. Its thinness of form adds rather than diminishes its presence, as does its rough, tactile texture, which also became characteristic of the Swiss artist's sculpture.

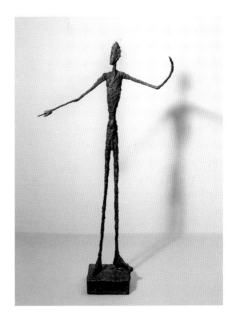

Anthony CARO
Early One Morning, 1962
In this seminal work of British sculpture, steel sheets and girders are painted bright red, wiping away all the nostalgia that had come before with the patinated appearance of metal. Its open structure, allowing multiple rather than single points of focus, encourages the spectator to walk around the work.

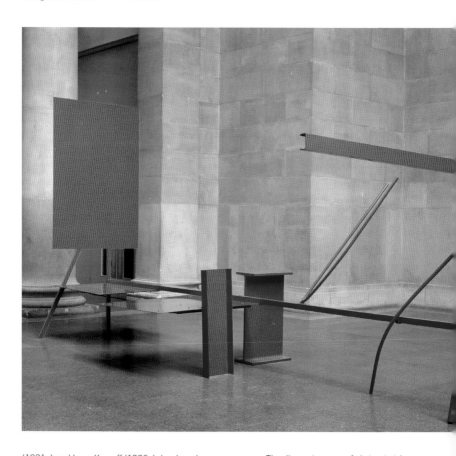

(1931–) and Leon Kossoff (1926–) developed claustrophobic canvases distinctive for their exceptionally thick oil paint, such as their respective *Oxford Street Building Site I* (1959–60) and *Man in a Wheelchair* (1959–62). *Girl with a White Dog* (1950–1) is a highpoint of Lucian Freud's early precise manner. By the end of the decade, Freud had embraced a more expressive technique, but the unease evident in *Girl with a White Dog* – and charged relationship between sitter and artist – persisted.

The disparate range of abstract styles across paintings by Terry Frost (1915–2003), Patrick Heron (1920–99), Roger Hilton (1911–75) and Peter Lanyon (1918–64) is testament to the force of the art explosion that occurred in St Ives after the war, sparked by the superb Cornish landscape and light. The geometric relief *Abstract in White, Black, Indian and Lilac* (1957) is an example of how Victor Pasmore (1908–98) continued Constructivism in London.

Eduardo **PAOLOZZI**
I was a Rich Man's Plaything, 1947, from *Ten Collages from BUNK*, 1947–52
An Ava Gardner-like siren, a fighter-bomber and Coca-Cola come together in

Paolozzi's magazine collage. The artist argued that postwar pop-culture iconography could create 'an art form more subtle and fulfilling than the orthodox choice of either the Tate Gallery or the Royal Academy'.

An open-form assembly of balanced, bright-red steel beams by Anthony Caro (1924–), *Early One Morning* (1962) heralded a lighter mood that came to British art during the 1960s, in contrast to the more serious-minded sculpture of Moore and Hepworth, and Kenneth Armitage (1916–2002) and Lynn Chadwick (1914–2003), who both rose to prominence in the previous decade. It has an affinity with David Smith's late works, such as *Cubi XIX* (1964), and the paintings of Kenneth Noland (1924–2010), both of whom Caro met in America. One can see the works of William Turnbull (1922–) and Phillip King (1934–) develop a similarly playful aesthetic.

Noland's paintings at Tate Modern – like those of his compatriots Helen Frankenthaler (1928–), Morris Louis (1912–62) and Jules Olitski (1922–) and, to a certain extent, his English contemporaries Robyn Denny (1930–), Richard Smith (1931–) and John Hoyland (1934–) – tend towards harder-edged, formalist colour experiments, with less of the overt emotionalism of their 1950s predecessors like Rothko (the critic Clement Greenberg called the style Post-Painterly Abstraction).

Study for Homage to the Square: Departing in Yellow (1964) is one of the best works by Bauhaus painter Josef Albers (1888–1976), who taught colour theories to Noland at the influential Black Mountain College in North Carolina.

Another Albers student, Robert Rauschenberg (1925–2008), resolutely rejects this rigorous approach with *Almanac* (1962); images from books and magazines have been screen-printed on canvas, before the application of painterly strokes of oil on top. *0 through 9* (1961) by Jasper Johns (1930–) uses the shape of simple numerals – superimposed on one another – to structure his composition. The two Americans' aesthetic was labelled Neo-Dada, due to their spirit of free association, although their interest in everyday images and symbols can be seen as part of Pop.

David HOCKNEY
A Bigger Splash, 1967
Hockney's paintings of Los Angeles pools sum up the sunnier outlook of art during the 1960s. This example also illustrates the influence of photography on the artist's practice, with its graphic form, Polaroid-like border and attempt to represent a passing instant.

An older pioneer was Joseph Cornell (1903–72) whose *Planet Set, Tête Etoilée, Giuditta Pasta (dédicace)* (1950) assembles found material in a glazed box.

The gallery holds a series of collages by Paolozzi that arrange ripped-out, trashy images from comics and magazines – pin-up girls, cartoon characters and consumer products. Known as *BUNK* (1947–52), they remain a foundation stone of British Pop Art, which celebrates, with varying degrees of irony, the low-brow culture of an increasingly consumer-minded, media-driven society. Richard Hamilton's painting *Swingeing London 67 (f)* (1968–9) is part of his series that reconstructs a newspaper photograph of rock star Mick Jagger handcuffed to the art dealer Robert Fraser after drugs charges.

Other luminaries in the Tate collection include Allen Jones (1937–), who caused controversy for sculptures like *Chair* (1969), where kinky female

Andy WARHOL
Marilyn Diptych, 1962
Four months after Marilyn Monroe's death, Warhol embarked on a series of screen-print paintings dedicated to the actress and sex symbol. The repetition of a single publicity image in this diptych suggests her ever-presence in the media, while the contrast between colour and black and white invokes her demise.

mannequins form furniture; Patrick Caulfield (1936–2005), who eschews visible brushwork for a synthetic style of brilliant colour and black outline; Peter Blake (1932–), a collector of pop-culture ephemera most famous for his cover of The Beatles' *Sergeant Pepper* album; and Joe Tilson (1928–), Derek Boshier (1937–) and Peter Phillips (1939–).

The paintings of Yorkshire-born artist David Hockney (1937–) become more carefree from the mid-1960s, following his move to California. *A Bigger Splash* (1967) celebrates a swimming-pool scene with effortless, colourful economy.

Are the artists of American Pop more critical of their culture? Roy Lichtenstein (1923–97) appropriates the aesthetic and content of a comic strip in *Whaam*! (1963); by offering up a picture of a fighter jet shooting another in such an impersonal style, the painting considers the sanitising effects of print media. With sculptures like his giant, mahogany electric plug (1970), Claes Oldenburg (1929–) draws out satirical and Surrealist associations from everyday objects. *Silo* (1963–4) by James Rosenquist (1933–) subverts the 'T-zone' ('taste zone') slogan from a Camel cigarette advert by adding a T-shaped enclosure to his image of girl smoking.

Andy Warhol superimposes found images from film and print on paint. The artist worships American capitalism: its banalities, such as a soup can (1968); its celebrities, most memorably Marilyn Monroe, whose image features in repetition in a major diptych (1962); and, in *Electric Chair* (1964), its more dark corners. The artist's hand was supplanted by the serendipities of the mechanised screen-print process, often completed by assistants in his studio, known as the Factory. Warhol famously claimed he wanted to be a machine.

Patrick **CAULFIELD**
Coloured Still Life, 1967
ALAN CRISTEA GALLERY
This silkscreen is produced
in a style consistent through
Caulfield's career. In his
alternative reality, ordinary
objects and interiors are
formed by heavy black
outlines filled with flat,
saturated colour. His
rigorous, stylised take on the
still life was influenced by
Cubism.

There is no single gallery in London that comes close to competing with the two Tates' displays of postwar painting and sculpture. Other quality works are, instead, spread out across a range of different locations, forming a treasure hunt for the interested art lover.

The commercial sector is a good place to start. Mayfair and St James's are areas synonymous with the sale of postwar art, in particular the galleries around Cork Street, behind the **ROYAL ACADEMY OF ARTS (RA)**, some of which, like the **REDFERN GALLERY**, were highly influential in the 1950s, if not so now. **WADDINGTON GALLERIES** presents British, European and American art, from Blake to Heron, Albers to Dubuffet, and Rauschenberg to Warhol. The **BERNARD JACOBSON GALLERY** holds a good postwar range, especially in American art, while the **ALAN CRISTEA GALLERY** sells limited-editions by many of the period's significant artists, including Hamilton and Caulfield, both of whose prints form an integral part of their output. The **GAGOSIAN GALLERY**, in Mayfair and Kings Cross, sells some blue-chip names including Picasso, Giacometti and Lichtenstein.

One can date the birth of British Pop to an evening in 1952 when Paolozzi projected his *BUNK* collages on a screen at the **ICA**, in a meeting of the Independent Group, whose number included Hamilton and Turnbull. Paolozzi's photo-montage film, *History of Nothing* (1960–2), gives an idea of what this alternative art-historical lecture must have

been like; the **BRITISH ARTISTS' FILM AND VIDEO STUDY COLLECTION** holds a copy, if it is not on show at either Tate. Paolozzi produced screen-prints from his collages, held at the **VICTORIA AND ALBERT MUSEUM (V&A)**, which, like the **BRITISH MUSEUM**, keeps graphic art by the key British postwar painters. The **NATIONAL PORTRAIT GALLERY** displays portraits both of and by the scene's stars, while the V&A's **NATIONAL ART LIBRARY** and the **BRITISH LIBRARY** hold their artists' books; the latter has art in other media, such as a late tapestry by Caulfield.

The **ESTORICK COLLECTION OF MODERN ITALIAN ART** features Giorgio Morandi (1890–1964), master of the modern still life, and the **COURTAULD GALLERY** holds the *Prometheus Triptych* (1950), an important late work by Kokoschka. The **WHITECHAPEL GALLERY** was the first public space to expose the Independent Group, Abstract Expressionists and European avant-garde to the mainstream. Alongside contemporary art exhibitions, it now rotates displays of collections not usually open to the public, such as the **BRITISH COUNCIL COLLECTION**, which includes important British paintings such as Freud's *Girl with Roses* (1947–8). The **ARTS COUNCIL COLLECTION** has a similar size and remit, although no permanent display site. The **ROYAL COLLEGE OF ART (RCA)** was the school of choice for Kitchen Sink and Pop artists, who are reflected in its holdings, together with earlier alumni, such as graphic artists Edward Bawden (1903–89) and Eric Ravilious (1903–42).

In a speech broadcast in 1949, departing President of the RA, painter Alfred Munnings (1878–1959), made a searing attack against Picasso. The institution's reputation as an enemy of modern art only began to recede from the 1970s. Caro, Hockney and company all became Academicians later in the century, and you can now see their contributions to the collection and annual Summer Exhibition.

Lucian **FREUD**
Girl with Roses, 1947–8
BRITISH COUNCIL COLLECTION
The British painter's large
portrait of his first wife Kitty
shows the same intensity of
interest in psychology as the
work of his famous
grandfather, Sigmund. There
is a pervasive mood of
anxiety, induced by her face
and posture, as well as the
rose's thorns and broken-
caned chair.

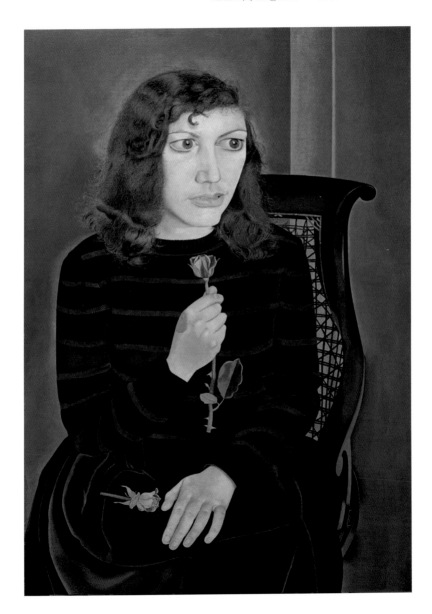

Francis Bacon's status seems to only get greater. Widely considered the best British painter of the 20th century, there have been few challengers to his crown in the 21st – only the canvases of his friend Lucian Freud occasionally reach the same heights. Although influenced by Surrealism and Expressionism, his work stands alone, beyond reduction to an art movement and beyond imitation, so successful is its synthesis of the objective and the personal. His images of the human form – disfigured, screaming, trapped – disturb us all, yet remain highly particular to his imagination.

Bacon's biography is a fascinating case study for any amateur psychologist. Drink, drugs, roulette and sadomasochism were some of his later vices, but the artist revealed that since his childhood he was 'accustomed to always living through forms of violence'. Born in 1909 to British parents in Dublin, the young Bacon suffered from a lack of love and a chronic asthma condition. His authoritarian father ordered the grooms on his horse-breeding farm to whip him in an effort to rid his teenage son of his effeminate ways, to little success: Bacon enjoyed homosexual affairs with the very same men who whipped him.

After being thrown out of home at the age of 16, Bacon had a revelation that was to affect his life and career: 'I remember looking at dog shit on the pavement and I suddenly realised, there it is – this is what life is like.' What sounds like stark pessimism was, in the artist's opinion, realism, or 'the brutality of fact'. But it would be nearly two decades before the self-taught artist translated this worldview into the representations for which he is now known.

The late 1920s saw Bacon come of age in Berlin and Paris, before settling in a studio in a South Kensington, London, from where he designed Modernist furniture and painted in a post-Cubist style. But the 1930s was an unproductive period, when Bacon would abandon art for long spells. After an unsuccessful exhibition in 1934, the painter destroyed many of his paintings.

His breakthrough work, *Three Studies for Figures at the Base of a Crucifixion,* would not be painted until 1944. This vivid triptych offended and exhilarated viewers in equal measure when it was displayed the following year. Its three sub-human forms were seen to stand for the degradation suffered during the Second World War. Bacon saw the Crucifixion as a symbol not of salvation but of man's inhumanity to man. The triad form, so ubiquitous in religious art, is used with high irony, and Christ is also absent, never to return in Bacon's postwar world.

The work is the most important by the artist in the nation's collection, and as such tends to be on permanent display in **TATE BRITAIN** or **TATE MODERN**. The Tate's group of paintings held is not as extensive as one might wish, but, so powerful is their impact, a few go much further than works by most other modern artists.

Ruskin SPEAR
Francis Bacon, 1984
NATIONAL PORTRAIT GALLERY

Francis BACON
Three Studies for Figures at the Base of a Crucifixion,
(detail) *c* 1944
TATE BRITAIN

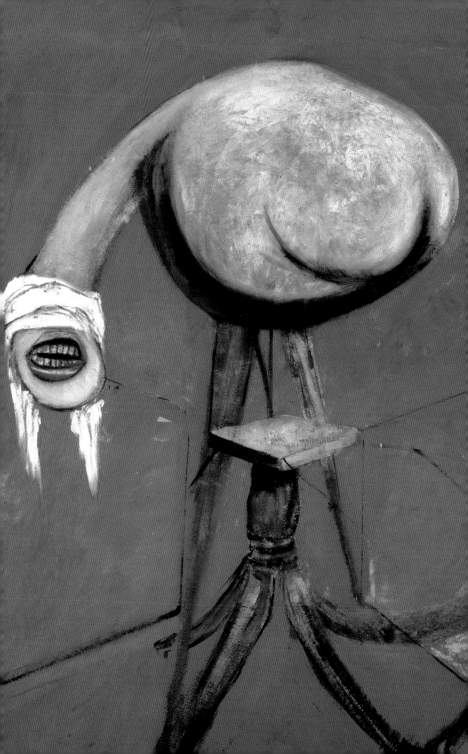

***Figure in a Landscape*,**
1945
This early painting, set
outdoors in London's Hyde
Park, has the same sense of
claustrophobia as Bacon's
later interiors. In an act that
anticipates the distortions he
would make to the images of
his lovers and friends, Eric
Hall's body has been
eviscerated by a black void.

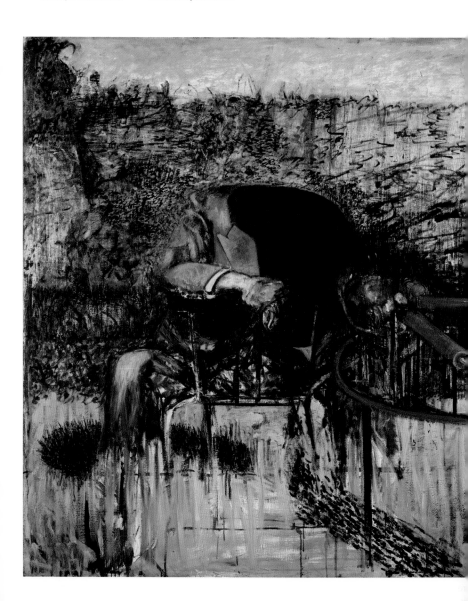

Portrait of Isabel Rawsthorne, 1966
Bacon turned to portraiture with new zeal during the 1960s. One of his muses was his friend and fellow artist Rawsthorne, who he captured more than a dozen times. Despite the fact her face has been radically disfigured, her imperious expression remains in the eyes and mouth.

Although one can find Bacon's paintings in **TATE MODERN**'s displays of international 20th-century art, Tate Britain normally dedicates a room to his output. The collection includes 14 canvases and 36 works on paper from the 600 or so surviving works by the artist. Bacon never lost the habit of destroying paintings; in fact, he said he tended to destroy better works, such was his disappointment when they would fail to meet their promise.

Figures in a Garden (*c* 1936) pictures a dog beside a strange form, whose cubic head is only made vaguely human by a single ear and a set of teeth. This rare, prewar piece was deemed 'insufficiently surreal' for Bacon to be included in the seminal Surrealist exhibition in London in 1936.

Bacon recalled that *Three Studies for Figures at the Base of a Crucifixion* was completed during 'a bad mood of drinking', and one needs a strong shot to steady the nerves after standing in front of it. Each of the canvases features a lumpy, long-necked grey creature on a flat, violent-orange background: one has its head down in mourning, another proudly shows its bloodstained teeth, the third howls with its mouth open. The painter identified the figures with the Eumenides of Greek mythology, the furies who personified vengeance.

The paintwork becomes even more rough and ready in *Figure in a Landscape* (1945), where an image of Bacon's lover Eric Hall, dozing on a seat in Hyde Park, is defaced by aggressive marks and smudges. Bacon derived his subjects from photographs, which he tore out of books and magazines – his chaotic studio was a foot-thick with them – and the microphone and mouth at the right was gleaned from reproductions of Nazi leaders. The time-lapse animal studies of English photographer Eadweard Muybridge (1830–1904) influenced *Study of a Dog* (1952), where paint is smeared to evoke movement.

Study for a Portrait (1952) shows a man in a suit in a full scream. The scratched-out paint has a horrible immediacy, like fingernails on a blackboard. The artist took the image of this and other 'screams' from the film *Battleship Potemkin* (1925) by Sergei Eisenstein, from the scene where the schoolmistress screams on the Odessa Steps, her glasses broken.

Bacon denied that the lines that frame this and other figures were cages, claiming they were just a formal element to 'concentrate the image down'. He mixes in sand in this work for extra texture and, like all his paintings from the late 1940s, uses the unprimed back of the canvas for a more raw finish. He adopts a slicker technique from the 1960s, using combs and cloths to achieve effects.

The painter also denied he made preparatory sketches, although a number came to light after his death, dated by scholars to the late 1950s. Muybridge's photographs of male wrestlers appear

Triptych – August 1972,
1972
The left canvas of this
triptych pictures Bacon's
lover George Dyer, who had
committed suicide that year,
while the painter represents

himself in the right canvas.
The central canvas appears
to show the two wrestling, or
having sex, the ambiguity
evoking their famously
fractious relationship.

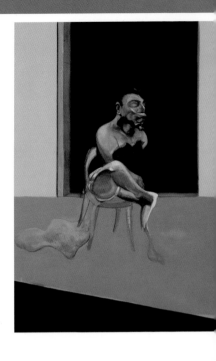

to relate to several of the sketches, as well as to
paintings of nudes like *Reclining Woman* (1961),
which Bacon only titled a female rather than a male
to hide his homosexuality, which was still illegal at
the time. 'Well, of course, we are meat, we are
potential carcasses,' Bacon observed. 'If I go into a
butcher's shop, I always think it's surprising that I
wasn't there instead of an animal.' In this painting,
Bacon is the butcher, with the man painted like a
leg of lamb, his muscles undefined and one bone
sticking out.

 Seated Figure (1961) is typical of the
suffocating interior scenes Bacon pursued during
the decade, featuring a solitary figure, often on a
couch. The head of the man is distorted here, but
in *Study for Portrait on Folding Bed* (1963) a whole
body is mangled – blood, guts and bone are all on

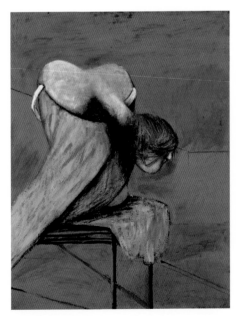

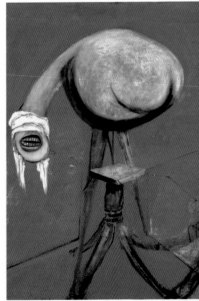

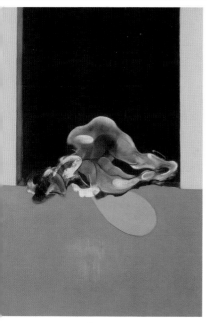

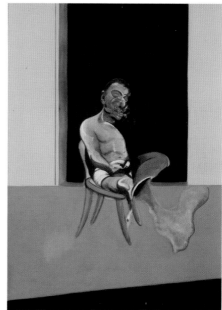

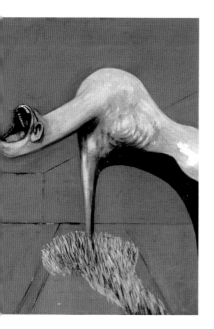

the surface, violence and homoeroticism once again fused. Bacon would commission photographs of the subjects of his portraits, such as artist Isabel Rawsthorne (1966), rather than asking them to sit for him. He felt inhibited in their presence, unable to inflict what he described as 'forms of injury'.

Two days before the opening of his retrospective at the Grand Palais in Paris, in 1971, his lover George Dyer committed suicide. *Triptych – August 1972* is one of a funereal series known as the Black Triptychs that respond to the tragedy. In 1988, four years before his own death, Bacon revisited his 1944 masterpiece, painting a new version twice as large that was to be his last triptych. Although painted in his then-smoother style, the creatures appear even more evil.

Three Studies for Figures at the Base of a Crucifixion, *c* 1944
The creatures in Bacon's first tour-de-force triptych were 'so unrelievedly awful', recalled one critic, 'that the mind shut up with a snap at the sight of them.' Another thought 'of entrails, of an anatomy or a vivisection'.

The **ARTS COUNCIL COLLECTION**, loaned temporarily to other institutions rather than on permanent display, holds *Head VI* (1949), the earliest surviving painting by Bacon to respond to *Pope Innocent X* (1650) by Velázquez, a work that would haunt the English painter throughout his life.

'Art is a method of opening up areas of feeling rather than merely an illustration of an object,' Bacon believed, although he was in awe of how Velázquez had achieved both in his famous portrait. The British painter concentrates only on pure, violent feeling in his response, painting at the centre of his canvas the Pope's wide-open scream.

The Arts Council also holds *Study for a Portrait of Van Gogh VI* (1957), part of a series in answer to the Dutch artist's *The Painter on the Road to Tarascon* (1888). The former's vivid palette mirrors the earlier artist and was also inspired by the time Bacon spent travelling in France and North Africa in the 1950s.

Bacon moved studios in South Kensington several times in his career before settling in **7 REECE MEWS**; this last studio has now been reconstructed in Dublin's Hugh Lane Gallery. He would paint in the morning, before gravitating towards Soho for lunch at Wheelers, a visit to his dealer Erica Brausen at the Hanover Gallery, and drinks at the Colony Room, which he frequented with Freud and other bohemians. None of these venues have been preserved in the same form, but Soho remains a magnet for artists.

Head VI, 1949
ARTS COUNCIL COLLECTION
This 'scream' is one of Bacon's first of many works inspired by Velázquez's portrait of Pope Innocent X. He studied medical books of oral diseases in an effort to hone the mouth, and the lips have been given a purple hue that matches the Pope's robes of office.

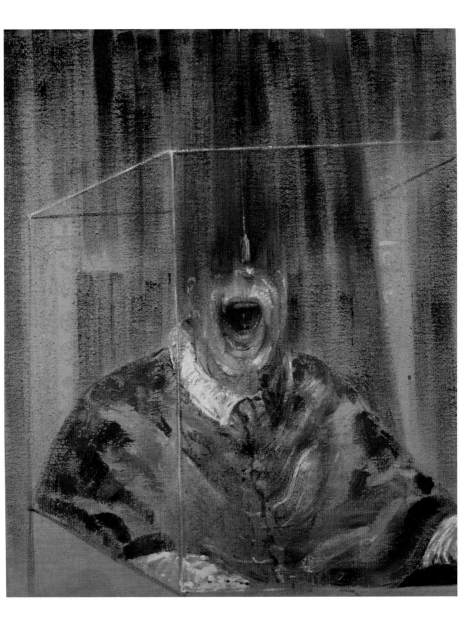

CONTEMPORARY ART

Londoners who love art have never had it so good. One can spend a day visiting venue after venue in one area in the city – listings magazine in hand, taking in commercial galleries, institutions, open studios, site-specific installations and public art – safe in the knowledge that, come tomorrow, one can do the same again, in another area a few stops away on the tube. London this century has become what New York and Paris were to the last: the centre of the contemporary art world.

The Big Bang in British art took place in 1997 when an exhibition entitled 'Sensation' went on view at the **ROYAL ACADEMY OF ARTS (RA)**, showing work by young British artists (YBAs) owned by advertising executive Charles Saatchi. Much of the art was provocative, such as sculptures of naked girls, melded and mutilated, by brothers Jake (1966–) and Dinos (1962–) Chapman, and a painting of the Virgin Mary, by Chris Ofili (1968–), that stood on elephant dung.

Most of the artists had already caused ripples with those in the know. As early as 1988 Damien Hirst (1965–) had organised 'Freeze', an exhibition in a Docklands warehouse featuring fellow art students from **GOLDSMITHS, UNIVERSITY OF LONDON**. It galvanised the group and encouraged others to put on self-promotional shows in derelict East End spaces. But 'Sensation' made the YBAs mainstream, the RA relevant and Saatchi the arbiter of contemporary art. He has given the nation over 200 works, displayed in rotation at Chelsea's **SAATCHI GALLERY**, to be renamed the Museum of Contemporary Art, London, after his retirement.

One of the YBAs' achievements was to help pique the British public's interest in the conceptually aware practice that, via a series of developments since the 1970s, had come to dominate international art. This interest has been reflected in visitor numbers to **TATE MODERN**, which have been far greater than expected since it opened in 2001.

Tate Modern remains the best venue to see recent practice in an art-historical context, as it continually acquires new art alongside old. It also commissions a major work for its mammoth Turbine Hall each year and, from 2012, performance pieces in two huge, disused oil tanks that have been reclaimed as part of its extension. More than 700 works acquired for the nation from London gallerist Anthony d'Offay supplement its holdings. These are displayed in Artist Rooms, where a space is temporarily devoted to a single artist, at Tate Modern, the National Galleries of Scotland and regional galleries to which the works travel.

London's economic growth has been a stimulus to the city's culture and creative industries. Private philanthropy has been critical for influential venues like the **SERPENTINE GALLERY**, located in the city's bucolic Kensington Gardens. Commercial galleries also feed off the super-rich and, like it or not, are as influential in the scene as public institutions. The best time for a contemporary art lover to be in London is mid-October, when the **FRIEZE ART FAIR** precipitates a wide range of contemporary art events. Spot the art stars of tomorrow in the summer shows at London's premier schools: Goldsmiths, **CENTRAL ST MARTINS**, the **ROYAL COLLEGE OF ART (RCA)** and the **RA**.

Ai WEIWEI
Sunflower Seeds, 2010
TATE MODERN

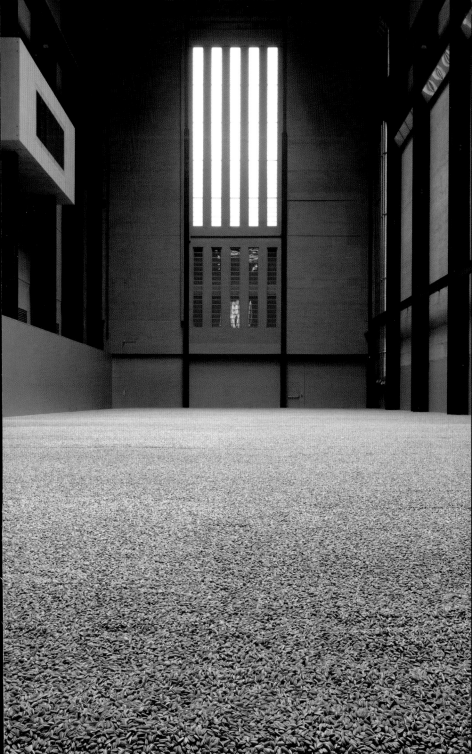

Carl ANDRE
Equivalent VIII, 1966
American artist Andre arranged 120 firebricks in different configurations, entitling the series *Equivalent* sculptures because their height, mass and volume remained the same. The work is famous for the virulent criticism it attracted from the British press, who saw it as a waste of public money.

A good place to start on a path to conceptual art is Minimalism. *IKB 79* (1959) by Frenchman Yves Klein (1928–62) is a canvas top-to-toe in International Klein Blue (IKB), a synthetic colour the artist developed as 'a Blue in itself, disengaged from all functional justification'. American artist Frank Stella (1936–) produced 'Black Paintings', concentric diamonds of white lines on black, represented at the Tate in the lithographs *Black Series II* (1967). They lack any illustrative or emotional potential, and compared to *Fall* (1963) by English painter Bridget Riley (1931–) – curves of white lines on black – there are no optical effects to be enjoyed.

American Minimalists like Stella aim for pared-down works that are true in themselves: self-

sufficient, literal, without reference to anything else. The 'stacks' of Donald Judd (1928–94), such as *Untitled* (1980), are oblong industrial units arranged in a strict order to rid them of personality. Ellsworth Kelly (1923–) rejects his characteristic colour planes in *White Curve* (1974), a fan-shaped relief that only serves to elucidate its own space. The material used by Dan Flavin (1933–96) is light, created by standard fluorescent bulbs. In *Shovel Plate Prop* (1969), Richard Serra (1939–) allows two lead sheets – one rolled, one flat – to rest against each other. *Equivalent VIII* (1966) by Carl Andre (1935–) is a rectangle of 120 bricks. 'People expect art to be mystifying,' Andre explained. 'Mine isn't.'

Sol LeWitt (1928–2007) reduces his art further in a piece of 1970: a set of written rules for a wall drawing, to be completed by assistants. Theorist Lucie Lippard explained LeWitt's work as the 'dematerialisation of the art object' – art transformed from the physical to the thought process of the artist. In LeWitt's words: 'The idea becomes a machine that makes the art.' Many practitioners share LeWitt's preoccupation with text, such as American Joseph Kosuth (1945–) and British collective Art & Language. The latter's *Map Not to Indicate* (1967) rethinks cartography by removing all but two states from a map of America, listing those missing underneath. American painter Edward Ruscha (1937–) brings together Pop Art and conceptualism with his painted words in the manner of billboards.

The text in *Room Situation* (1970) documents a performance by Vito Acconci (1940–), where the New York-based artist moved all his possessions to his dealer's gallery. The piece typifies performance art's anti-theatrical aesthetic and critical perspective on the commercialism of the art world. Although the modern form can be traced back to Dada, a more recent precedent is the Beatnik 'Happenings' in postwar America, spearheaded by composer and artist John Cage (1912–92): the print suite *The Crash* by Jim Dine

Ana MENDIETA
Untitled (Blood and Feathers #2), 1974
In a three-minute performance, Mendieta pours blood over her naked body, then plunges on a heap of white feathers, which stick

to her skin. By transforming herself into a sacrificial animal, the artist meditates on violence against women, as well as the Catholic and African-inherited rituals of her native Cuba.

(1935–) relates to one of these participative, multimedia events. Performances are conceptual, ephemeral exercises rather than objects to be bought, although video and photo records of events have subsequently become commodities. Many works feature the human body as material, such as a 1974 piece caught on film where Cuban-American Ana Mendieta (1948–85) smears herself with blood and feathers. The performances of the Vienna Actionists, such as Hermann Nitsch (1938–), and American Paul McCarthy (1945–) appear even more transgressive. *Two Correlated Rotations* (1970/2) by American

artist Dan Graham (1942–) integrates film into performance, with the two participants holding the cameras.

Italian Arte Povera artists on view, like Luciano Fabro (1936–2007), Jannis Kounellis (1936–), Mario Merz (1925–2003) and Michelangelo Pistoletto (1933–), share performance art's anti-capitalism. The latter's *Venus of the Rags* (1967/74) is typical in the way it uses 'poor' materials to reflect on society – it features a kitsch, garden-centre sculpture embracing a mound of second-hand clothes. The slashed canvases of Lucio Fontana (1899–1968), such as *Spatial*

Joseph BEUYS
The End of the Twentieth Century, 1983–5
Beuys planted 7,000 oak trees in Kassel, Germany, placing a basalt rock alongside each tree as a symbol of ancient, volcanic energy. Each rock in this related installation has been bored with a hole before being plugged with clay, felt and stone to suggest hope for the regeneration of society.

Concept 'Waiting' (1960), anticipate this unconventional use of materials.

British sculptor Barry Flanagan (1941–2009) mixed in an emphasis on process and chance; he filled cloth skins with sand for *aaing j gni aa* (1965), admiring 'how the shapes virtually made themselves'. French artist Niki de Saint Phalle (1930–2002) enclosed bags of bright paint in plaster, then asked friends to shoot them: the result is a relief work covered in pigment (1961). In an absurdist take (1967) on Minimalism by German-born Eva Hesse (1936–70), cords of rope fall down unpredictably from fixed intervals. German-Swiss

artist Dieter Roth (1930–98) deconsecrates the position of the painted canvas in *Self-Portrait as a Drowning Man* (1974), which was cut into pieces so it could fit into a suitcase. The Brazilian painter, sculpture and performance artist Hélio Oiticica (1937–80) presents pigments in a constructed box (1964) rather than preparing them as paint.

Joseph Beuys (1921–86) brings together these post-Minimalist practices in installations that immerse the viewer in his mystic imagination. *The End of the Twentieth Century* (1983–85) presents rectangular blocks of basalt on the floor, like fallen monuments from an extinct civilisation. Gustav

Metzger (1926–) echoes Beuys' environmental concerns in *Liquid Crystal Environment* (1965), where natural crystals transform themselves under heat, their mesmeric patterns projected on screens. Both German-born artists were associated with the anti-establishment avant-garde known as Fluxus.

The text, photographs and sculptures of British artists Richard Long (1945–) and Hamish Fulton (1946–) relate directly to the environment, as records of their Land Art – artistic interactions with the landscape, often in the form of walks. US-based Robert Smithson (1938–73), Christo (1935–) and Dennis Oppenheim (1938–) are shown as making more epic, large-scale interventions in landscapes.

John Baldessari (1931–) produces a post-Pop, postmodern commentary on our bombardment by the media in a wall installation of unrelated images (1991). Fellow American David Salle (1952–) has a similar aim, but paints the images within a canvas. Found material is manipulated by Germans Sigmar Polke (1941–2010) and Martin Kippenberger (1953–97) to parody art and image-making, and by the US-based Barbara Kruger (1945–) and Jenny Holzer (1950–) to focus on gender inequalities. Manhattanite Jeff Koons (1955–) displays vacuum cleaners in a glass vitrine (1981–7) in a deadpan gesture to highlight our seduction with banal, consumerist objects.

A cycle of four paintings inspired by the seasons (1993–5) show that Abstract Expressionist Cy Twombly (1929–) still values the power of non-figurative paint. In contrast, his old associate Philip Guston (1913–80) turns from shimmering abstractions back to representation. His tangle of cartoon legs, *Monument* (1976), is typical of the grotesque edge that came to figurative art from the late 1970s. Works made in self-consciously 'bad taste' include *Humanity Asleep* (1982) by American Julian Schnabel (1951–); *Midnight Sun II* (1982) by Italian Francesco Clemente (1952–); and *Adieu* (1982) by German Georg Baselitz

Jeff KOONS
New Hoover Convertibles, Green, Red, Brown, New Shelton Wet/Dry 10 Gallon Displaced Doubledecker, 1981–7
In an early series by the influential New Yorker, known broadly as *The New*, vacuum cleaners are presented as works of perfection. In this example, four are suspended in glass and lit from underneath with fluorescent light.

several spectacular sculptures and installations. *Labyrinth (My Mother's Album)* (1990) by pioneer Ilya Kabakov (1933–) leads the viewer down a spiral of corridors redolent of his native Russia. Hirst creates a pharmacy in chilling precision (1992), as contemplative on mortality as his dead animals suspended in formaldehyde. Light installation *Your Double-Lighthouse Projection*

(1938–), characteristic with its upside-down figures.

Baselitz and fellow Germans were labelled Neue Wilden (New Savages), although canvas *Lilith* (1987–9) by Anselm Kiefer (1945–) has sombre concerns, evocative of urban apocalypse. Another label was Neo-Expressionism, yet Gerhard Richter (1932–) avoids emotionalism in both abstract oils on view, such as *St John* (1988), where the artist allows chance to govern their appearance, and in his paintings that copy photographs of famous figures. Prints by Americans Richard Estes (1936–) and Chuck Close (1940–) also succeed in a photo-realist style. An exquisitely finished, pornographic-style portrait (1998) by Colorado-born John Currin (1962–) is an ironic statement on the female nude. The pictures of people and places by Belgian Luc Tuymans (1958–) are painted deceptively simply, their spare strokes hinting at horror.

Bill Viola (1951–) filmed his dying mother for one of the video panels of his *Nantes Triptych* (1992), not as a document but as a meditation on humanity and spirituality. In an earlier installation, *Violent Incident* (1986) by his fellow American Bruce Nauman (1941–), TV screens and sound effects are combined to more abrasive and satirical impact. Other video works on view range from the imaginative grand narrative of *Cremaster 5* (1997) by their compatriot Matthew Barney (1967–) to political allegory by Albanian Anri Sala (1974–).

A monumental steel spider (1999) by French-American Louise Bourgeois (1911–2010) is one of

Damien HIRST
Pharmacy, 1992
Cabinets line the walls, filled with packaged drugs, in an installation by this British artist that examines the lure of medicine. In a startling metaphor, bowls of honeycomb are placed in the room to attract flying insects, only for them to meet their death in an electric grid that hangs nearby.

(2002) by Danish-Icelandic Olafur Eliasson (1967–) disorients our perceptions of colour.

The Swing (after Fragonard) (2001) by Anglo-Nigerian artist Yinka Shonibare (1962–) replaces the French painter's *mademoiselle* with a mannequin dressed in African fabric, in a move that exemplifies contemporary art's reinterpretation of art history and national identity. In *Nightwatch*

(2004), Francis Alÿs (1959–) let loose a London fox in the National Portrait Gallery; the footage shown is taken from CCTV cameras. The Mexico City-based artist also epitomises 21st-century conceptualism: global in practice, plural in media, keen to overthrow all hierarchies – inside and outside the art world – in order to reveal a variety of alternative, poetic narratives.

A new generation of artists see themselves as activists, archivists, sociologists and historians. London-based collective the Otolith Group is an example, nominated in 2010 for the Turner Prize, British art's most important award. The annual exhibition of nominees is at **TATE BRITAIN** from October to January.

Some Turner winners this century have practised in paint, such as Tomma Abts (1967–) and Richard Wright (1960–), both in the collection. Tate Britain often displays canvases by Michael Andrews (1928–95), Howard Hodgkin (1932–) and Euan Uglow (1932–2000), part of the 'School of London', a term coined by RB Kitaj (1932–2007) for an important group of the city's painters; a huge tapestry in the **BRITISH LIBRARY** reproduces Kitaj's well-known *If Not, Not* (1975–6). Painter Feliks Topolski (1907–89) began his **TOPOLSKI CENTURY** in 1975, a labyrinthine mural installation under some Southbank railway arches. Both Tates tell us that Michael Craig-Martin (1941–), John Latham (1921–2006) and duo Gilbert (1943–) & George (1942–) took a different direction in the 1970s and 1980s, making conceptual works. Latham's home, **FLAT TIME HOUSE**, is a space dedicated to experimental art.

Tate Modern and Tate Britain present sculptors who have come to international fame since the 1980s, including Tony Cragg (1949–), known for his interest in material; Antony Gormley (1950–), famous for human figures in metal; and Anish Kapoor, whose abstracts tackle phenomenology and metaphysics. Rachel Whiteread (1963–) casts negative spaces, while Marc Quinn (1964–) apes Classical sculpture in his analysis of contemporary subjects.

A revitalised **RA** has many of the key sculptors as members, plus several YBAs, such as painters Gary Hume (1962–) and Fiona Rae (1963–), their Goldsmiths tutor Craig-Martin, and Tracey Emin (1963–), who notoriously exhibited her unmade bed for the Turner Prize in 1999. It was bought by Saatchi and is on show at the **SAATCHI GALLERY** with YBA work and pieces that reflect the global nature of contemporary art, including sculptures and installations by Indian artist Subodh Gupta (1964–), French-Algerian Kader Attia (1970–) and Beijing-based Zhang Dali (1963–). Another private collection-made-public is the **ZABLUDOWICZ COLLECTION**. One can request to see the latest British art in the **ARTS COUNCIL COLLECTION** and the **GOVERNMENT ART COLLECTION**, which hangs works in embassies worldwide.

A listings magazine is essential to know what exhibitions are on at public venues that have no permanent collection: the **BARBICAN ART GALLERY, CAMDEN ARTS CENTRE, INSTITUTE OF CONTEMPORARY ARTS (ICA), HAYWARD**

Kader ATTIA
Ghost, 2007
SAATCHI GALLERY
French-Algerian artist Attia
contemplates religion and
community with his room full
of aluminium foil figures, set
in rows to resemble Muslim
women in prayer. Although
their metal surface allures
the eye and creates their
almost supernatural
presence, the sculptures are
empty shells.

**GALLERY, SOUTH LONDON GALLERY,
SERPENTINE GALLERY** and the **WHITECHAPEL
GALLERY**. Some institutions specialise in particular
areas of contemporary art, for example the
**INSTITUTE OF INTERNATIONAL VISUAL ARTS
(INIVA)**, which represents cultural diversity. The
VICTORIA AND ALBERT MUSEUM (V&A) and the
DESIGN MUSEUM reveal the crossover between
design and art. Traditionalists will enjoy the annual
portrait award at the **NATIONAL PORTRAIT
GALLERY**.

Some great art can be seen at blue-chip
commercial galleries in the West End, such as
HAUNCH OF VENISON and **HAUSER & WIRTH**,
as well as less-established spaces in the East End.
WHITE CUBE, the city's most influential
dealership, has outposts in both areas. The
LISSON GALLERY off Edgware Road, **VICTORIA
MIRO** near Angel and the **GAGOSIAN GALLERY**
in King's Cross are also well worth a visit.

PHOTOGRAPHY

The optical basis of photography has been known for over two millennia: when light passes through a small hole into a camera obscura (a dark room or box), a reversed image of the world is projected inside. There is evidence that artists such as Caravaggio and Canaletto had introduced a lens to sharpen the image, and perhaps a mirror to reverse it back to its correct orientation. The result was an accurate projection of a subject that could then be traced over as groundwork for a composition.

The masterstroke of Louis-Jacques-Mandé Daguerre (1787–1851) and his rival across the English Channel, William Henry Fox Talbot (1800–77), was to perfect a chemical process to fix the projection in permanent form. Both men announced their different methods in January 1839. Daguerre developed a technique pioneered by Joseph Nicéphore Niépce (1765–1833). A silver-plated copper sheet was treated with iodine, then inserted in a portable camera obscura box. The projected image inside would become visible on the plate once it had been removed and exposed to mercury and salt. The Frenchman modestly named the result a 'daguerreotype'.

Talbot's solution was to instead insert a chemical-coated paper that captured a translucent 'photogenic drawing', or negative image. This negative was placed against a second piece of paper to produce a print in positive form, called a calotype. Daguerreotypes had a more beautiful finish but, critically, the negative process could create more than one reproduction. Talbot's method formed the foundation of photography from the 1850s until the digital age.

What this science meant for art was a matter of debate in the 19th century. Many painters happily worked from photographic material, notably Delacroix and the American Realist Thomas Eakins (1844–1916), or photographed their canvases for reproduction. A fever for photographic portraits had spread quickly and widely across the world, so easy, cheap and realistic was this new form. Could photography be considered an art in itself?

A group of French artists including Ingres signed a petition in opposition, anxious that photography threatened their livelihood. Baudelaire declared the medium 'the refuge of every would-be painter, every painter too ill-endowed or too lazy to complete his studies'. But some of the photographs of eminent Victorians on view at the **VICTORIA AND ALBERT MUSEUM (V&A)** and **NATIONAL PORTRAIT GALLERY**, such as those by British pioneer Julia Margaret Cameron (1815–79) of painters like GF Watts, show more talent than those produced of the same subjects in paint.

As the V&A's national collection best demonstrates, from the very beginning the finest photographers understood their own artifice, their power to mediate the objective world in the same way as a painter. Only a fraction of the museum's 500,000 photographs can be shown at one time, but you can request to see any works at the Print & Drawings Study Room. **TATE MODERN** focuses on avant-garde work from the 20th century, when photography gained the elite status of fine art. Major temporary exhibitions can also be seen at **THE PHOTOGRAPHERS' GALLERY**, the city's largest public space dedicated solely to photography.

Julia Margaret CAMERON
The Whisper of the Muse,
1865
V&A

John THOMSON
Covent Garden Labourers,
from *Street Life in London*,
1877–8
To see street photography
Victorian-style, take a look at
this series on London's
working-class by the

Edinburgh-born Thomson.
Although the subjects and
surroundings are authentic,
people are posed carefully,
and the Woodburytype print
process creates a highly
attractive purple-brown
finish.

Alfred STIEGLITZ
Equivalent, 1926
With his images of clouds
dissolving into each other,
the influential American
aimed to move beyond
representation towards the

emotional abstraction that he
admired in paint. 'I wanted to
photograph clouds to put
down my philosophy of life –
to show that my photographs
were not due to subject
matter.'

The portraits by Scottish calotypist Robert Adamson (1821–48) rise above other early examples thanks to sharp tonal contrasts and the artistic direction of his collaborator, painter David Octavius Hill (1802–70). The V&A also has portraits mounted on card (*cartes de visites*) by Gaspard-Félix Tournachon, nicknamed Nadar (1820–1910), who is notable for his attention to the fall of light on his famous sitters' faces. Lady Clementina Hawarden (1822–65) indulges her imagination instead, inventing characters for her daughters to play out in front of the camera.

Although 1840s daguerreotypes by Horatio Ross (1801–86) have an ethereal quality, *Photographic Views from Nature* (1852–4) by Benjamin Brecknell Turner (1815–94) set the benchmark for the design and execution of landscape photography. Gustave Le Gray (1820–84) creates his dramatic seascapes such as *Great Wave, Sète* (1856) by printing from two separate negatives, while Peter Henry Emerson (1856–1936) rejects post-production tricks for fidelity to nature in his Norfolk countryside scenes.

A view of a Crimean War battlefield empty but for cannonballs, *Valley of the Shadow of Death* (1854–5) by Roger Fenton (1819–69), is a poignant metaphor for the devastation of war. It would not be until the American Civil War in the next decade that corpses of soldiers were photographed. John Thomson (1837–1921) establishes social documentary as a genre from the 1870s with a famous series of street-life shots of the London poor. Paul Martin (1864–1942) later takes advantage of a hidden camera to catch people off their guard in the city and on holiday at the seaside.

Eugène Atget (1857–1927) maps turn-of-the-century Paris systematically with shots of buildings that, in their odd atmosphere, were later heralded by the Surrealists. Sociologist Lewis Hine (1874–1940) highlights the suffering of child workers in America before the First World War, while Netta Peacock (active 1903–10) creates a visual record of pre-revolutionary Russia. As a curious teenager, Jacques-Henri Lartigue (1894–1986) turns his eye to fashionable women walking in prewar Paris (1911).

The collection includes copies of *Camera Work*, the prewar journal edited by Alfred Stieglitz (1864–1946). Stieglitz's publications, gallery and prints were all influential in establishing photography as a fine art. In *The Steerage* (1907), his landmark picture of lower-class passengers on a ship, the angular forms of the deck, funnel, platform and stairs fragment the pictorial space. Stieglitz's circle chose similarly unconventional angles for symbolic and aesthetic effects; for example, Paul Strand

Henri CARTIER-BRESSON
Seville, 1933
The Frenchman forsook large-format cameras and tripods, relying instead on a handheld and his exemplary gifts for timing and composition. Improvised but artful shots of city life, like this scene in Seville, were his trademark and formed a cornerstone of the golden age of photojournalism from the 1930s.

(1890–1976) elevates a picket fence to significance (1916) with a close-up that blurs the buildings behind. Hungarian André Kertész (1894–1985) was a proponent of this approach in 1920s Paris.

Stieglitz moves decisively towards abstraction in *Equivalents* (1923–36), his photographs of skies covered in clouds. From 1921, the Dada-influenced American in Paris, Man Ray (1890–1976), creates 'rayographs' without a camera by placing ordinary objects directly on sensitised paper. Compare these to similar techniques used by Talbot in *The Pencil of Nature* (1844–6), the first book to be illustrated with photography, and to the more recent camera-less works by contemporary British artists Garry Fabian Miller (1957–) and Susan Derges (1955–). German John Heartfield (1891–1968) arranges and re-photographs

William **EGGLESTON**
Untitled from *Troubled Waters*, 1980
This American artist has spent his career taking photographs of the banal and commonplace around him, inspired by the aesthetic of family snapshots, such as this image of a living room. His subtle choice of viewpoints and dye transfer print process, which creates unrivalled rich hues, gave new status to colour photography practice.

association, Group f.64, was named after the very small aperture each would use to obtain their high-resolution images. Mexican Manuel Alvarez Bravo (1902–2002) was close to Weston and his lover, photographer Tina Modotti (1896–1942), although Paul Strand appears a greater influence on his characteristic short field depth and interest in the incidental.

Henri Cartier-Bresson (1908–2004) uses a hole in a brick wall to frame a scene of boys playing in a Seville street (1933), synthesising a strong sense of geometry with the spontaneous, intuitive spirit of the snapshot. The influential French photojournalist travelled with his light Leica camera in his hand, ready to capture what he called 'the decisive moment'. The collection includes British photographer Bill Brandt (1904–83) who probed London society for magazines such as *Picture Post*, influenced by his friend Brassaï (1899–1984), famed as 'the eye of Paris'. Brandt is also known for his female nudes and landscapes, inventively framed so that they appear abstract.

New York crime reporter Arthur Fellig (1899–1968), known as Weegee, tuned his radio into police broadcasts in order to beat the authorities to the scene. His compatriots Walker Evans (1903–75) and Dorothea Lange (1895–1965) compose moving portraits of the Depression-era rural poor, like the latter's *Migrant Mother, Nipomo* (*c* 1936).

fragments from existing photos in his photomontages.

Californian Edward Weston (1886–1958) heightens the monumental, abstract qualities of his elemental subjects, from a naked body of a boy (*Neil*, 1922) to sand dunes (*Oceano*, 1936). The depth of detail and tonal range of Weston is matched in the bewitching landscapes of compatriot Ansel Adams (1902–84). Their

an indelible image of the Vietnam War. Photographs by David Goldblatt (1930–) and Josef Koudelka (1938–) remind us of the chequered political histories of South Africa and Czechoslovakia respectively.

Colour photography had become affordable by the 1970s, but it was considered only suitable for commercial and amateur work. Memphis-born William Eggleston (1939–) raises it to fine art with his images of commonplace objects and places from unorthodox angles. There is no conscious symbolism, more a will to encourage a second look at the everyday. This neutrality is also evident in the landscapes of Robert Adams (1937–), Lewis Baltz (1945–) and Stephen Shore (1947–), members of the American New Topographics movement, and taken to an extreme in a life-long project by Germans Bernd and Hilla Becher (1931–2007/1934–) to document industrial structures in the same Minimalist, matter-of-fact mode.

This cooler, conceptual interest propels photography into the wider world of contemporary art from this time. David Hockney creates photo collages such as *Scrabble, Hollywood, 1 January 1983* that play with ideas of optics and representation. British multidisciplinary artist Helen Chadwick (1953–96) produces a 1989 series that juxtaposes cuts of meat with fine materials such as velvet. American Richard Prince (1949–) commands record prices for works that re-crop and enlarge found commercial photographs.

In contrast, the gritty black-and-white reportage of Chris Killip (1946–) and Homer Sykes (1949–) tell the stories of marginalised groups in 1970s and 1980s British society. Martin Parr (1952–) has a wry smile at the nation's leisure pursuits in garish

More emotionally neutral photographs of people are produced by August Sander (1876–1964), who intended a comprehensive index of the German population. A group of six prints by American Lee Miller (1907–77) demonstrate her evolution from Surrealist, as a protégé of Man Ray, to Second World War correspondent.

The US emerges as a powerhouse of photographic talent after the war, from the candid street photography of Louis Faurer (1916–2001) to the idiosyncratic abstract styles of the influential teacher Harry Callahan (1912–99) and Arizonan experimentalist Frederick Sommer (1905–99). Robert Frank (1924–) walks the foggy London streets in 1951, four years before he embarked on his game-changing Beat Generation essay on the US, *The Americans*. Frank's perception of irony and tension in the Land of the Free finds an echo in the 1960s in the portraits of Diane Arbus (1923–71) and tilted street shots of Garry Winogrand (1928–84). *Cincinnati, Ohio* (1963), a reflection of the street in a shop front, epitomises the fractured, asymmetrical images of city life by Lee Friedlander (1934–).

A portfolio of 36 portraits by David Bailey (1938–) evokes the cult of fashion and celebrity in the Swinging Sixties, nurtured earlier by the work of Cecil Beaton (1904–80) in Britain and Irving Penn (1917–2009) and Richard Avedon (1923–2004) in America. *Shell Shocked Soldier, Hue* (1968) by Don McCullin (1935–) is an icon of a different kind,

Nan GOLDIN
David and Butch Crying at Tin Pan Alley, New York City, 1981
Although printed for exhibition at a large scale, this photograph by Goldin has all the unrefined qualities of an amateur-style, album snapshot, such as red-eye and uneven lighting. The experiences of her friends and family are the artist's subjects and, like her aesthetic, are never sanitised.

Indre SERPYTYTE
From *Former NKVD-MVD-MGB-KGB Buildings*, 2009
Serpytyte further evolves Lithuania's fine tradition of socially aware photography. The artist commissioned hand-carved models of houses that were used by Soviet forces for torture between 1944 and 1953. Their presentation from a distance on a neutral background heightens their sense of pathos.

colour. *David and Butch Crying at Tin Pan Alley, New York City* (1981) and *The Son* (1987) are examples where Americans Nan Goldin (1953–) and Tina Barney (1945–) respectively make public intimate moments from the lives of their friends and family. German Wolfgang Tillmans (1968–) and Birmingham-born Richard Billingham (1970–) follow their approach from the 1990s.

In his series *At Dusk* (1993), Boris Mikhailov (1938–) saturates in blue his shots of Kharkov, Ukraine, to suggest an alternative reality after the collapse of Communism. *Untitled (May 1997)* by Hannah Starkey (1968–) and *Untitled (Temple Street)* (2006) by Gregory Crewdson (1962–) feature actors; their respective scenes of inner-city

London and American suburbia are staged rather than actual realities. Fantasy is more closely mixed with documentary by New York-based Philip-Lorca diCorcia (1951–), who pays a street hustler to pose in situ in a cinematic-style shot.

The museum's dedication to new developments is demonstrated by a series by Indre Serpytyte (1983–), made and acquired in 2009 when she finished art school. In her native Lithuania, family houses were used for the interrogation and torture of the anti-Soviet resistance. Instead of the buildings themselves, she photographs their recreations in model form.

Hiroshi SUGIMOTO
Ligurian Sea, 1993
TATE MODERN
Tokyo-born photographer
Sugimoto mixes
Romanticism, Minimalism

and metaphysics with his
signature series of
seascapes. Each
composition is split
horizontally into two equal
halves of sea and sky, but

differences in light,
exposure and focus create
a variety of visual effects. In
this example, water and air
merge together to form one
luminous whole.

TATE MODERN holds a concise, strong
selection of mid-20th-century masters, like
Frank, who donated contact sheets from his
seminal series *The Americans* (1955–6) to the
gallery. Its Artist Rooms collection includes
significant bodies of work by his compatriots Arbus
and Robert Mapplethorpe (1946–89).

But the Tate really excels in the confluence
between conceptual art and photography. The
gallery holds an extensive group of self-portraits by
Cindy Sherman (1954–), where the New Yorker
continually recreates herself in front of the camera.
Hired as a chambermaid, French artist Sophie
Calle (1953–) photographs the belongings of hotel
guests (1981).

Three of the Bechers' famous pupils from the
Kunstakademie Düsseldorf feature alongside their
teachers: Thomas Struth (1954–), whose

photograph of the National Gallery (1989) directs our gaze to the viewers of art; Andreas Gursky (1955–), his preoccupation in the structures and systems that control us shown in a panorama of an overcrowded stock trading floor (1999); and Thomas Ruff (1958–), who produces resolutely dispassionate passport-style portraits (1986). Dutch artist Rineke Dijkstra (1959–) further develops Ruff's enquiry into the nature of a 'truthful' portrait photograph.

While the series *Up in the Sky* (1997) by Australian Tracey Moffatt (1960) orchestrates a sequence of black-and-white stills to suggest a story, American Jeff Wall (1946–) absorbs a range of narratives in the one image *A View from an Apartment* (2004–5) via a complex process of multiple shoots and computer manipulation. Japanese artist Hiroshi Sugimoto (1948–) and American Thomas Joshua Cooper (1946–) travel in new directions in landscape photography.

TATE BRITAIN shows the best of modern and contemporary British work, such as that of Paul Graham (1956–), a fine art photographer who was one of the first to produce social documentary in colour, and young British artist Gillian Wearing (1963–), whose subjects express themselves directly by holding up their thoughts on pieces of paper (1992–3). The loan collections of the

BRITISH COUNCIL COLLECTION and the **ARTS COUNCIL COLLECTION** also hold some important indigenous photographers. The **NATIONAL PORTRAIT GALLERY** presents many others, like late Victorian snapper to the stars Frederick Hollyer (1838–1933), as well international leaders in the field, Lima-born Mario Testino (1954–) and American Annie Leibovitz (1949–).

THE PHOTOGRAPHERS' GALLERY presents an annual award that is photography's equivalent of the Turner Prize. The 'World Press Photo' exhibition at the **ROYAL FESTIVAL HALL** showcases the best photojournalism each year. The **BARBICAN ART GALLERY** and **HAYWARD GALLERY** stage significant shows, and the **SERPENTINE GALLERY** and **WHITECHAPEL GALLERY** often feature photographers with fine art credentials, as does the **SAATCHI GALLERY**. The **MICHAEL HOPPEN GALLERY** and **ATLAS GALLERY** are two recommended commercial spaces. The **MAGNUM PRINT ROOM**, the London branch of the prestigious photographic agency formed by Cartier-Bresson and Hungarian war photojournalist Robert Capa (1913–54), exhibits the works of its illustrious membership, which includes the Swiss-born René Burri (1933–) and Brit Chris Steele-Perkins (1947–).

Talbot's photographs, negatives and equipment were donated in part to the **SCIENCE MUSEUM**. Photography sheds light on the city's topographical and social development in the **MUSEUM OF LONDON**, and the country's military history in the **IMPERIAL WAR MUSEUM**.

Andreas GURSKY
Chicago, Board of Trade II,
1999
TATE MODERN
Although mindful of the
documentary rigour of his
Düsseldorf tutors, the
Bechers, Gursky remains
unafraid to use computer
software to serve his
purposes. In this work he
boosts all the colours of the
traders' clothes, so that the
eye can never settle, much
like the financial system the
image represents.

PUBLIC ART

Since the 1980s, architects, town planners and politicians have praised public art as a panacea for social ills, claiming its valuable contribution to the cohesion and well-being of a community as well as an area's visual environment and economic value. Together with any social benefits, real or imagined, a public sculpture can also offer up an icon, able to generate publicity and sustain recognition for its site. The looping steel tower *ArcelorMittal Orbit* in London's Olympic Park was commissioned out of concern for the legacy of the 2012 Games. How could we forget about the Olympic development out in the East End if on the skyline soared the country's largest artwork, at 115 metres, more than 20 metres higher than New York's Statue of Liberty?

The London-based artist Anish Kapoor, who designed the immense rollercoaster-like lattice, has risen to become the world's pre-eminent public artist and Britain's most famous sculptor since Henry Moore, who himself had scores of casts installed in parks and squares across the globe. Public art allows Kapoor and others the creative challenge of a site-specific commission, plus an opportunity to reach beyond the gallery and connect with a more numerous and varied audience – importantly, one not expecting to encounter art in their everyday life, who will approach pieces without preconceptions.

Artists who dedicate themselves to the public sphere, only rarely showing work in the context of an exhibition, include British monument-maker and designer/architect Thomas Heatherwick (1970–) who sees art as a driving force of urban renewal and not just an add-on afterthought: 'Artistic thinking could be the motor that creates distinctiveness and steers the future development of the city.'

In the past, London's public sculpture had a more simple central aim: to commemorate royalty, war heroes, politicians and others of influence. Walk from **WESTMINSTER ABBEY** to the **Houses of Parliament** and **Parliament Square**, and up **Whitehall** to **Trafalgar Square** and one sees likenesses in stone and metal of the great and the good from Medieval times to the present day. Art has been also used for centuries for the adornment of London's buildings, and if you keep your head up on your journey you can note countless allegorical and patterned sculptures and reliefs, from friezes on pediments to works on spandrels, corbels, capitals, keystones and doorways.

In the corners of Trafalgar Square, four plinths surround the soaring column dedicated to the naval leader Horatio Nelson. Three support memorials to national heroes, while the fourth, intended to support another, now features a different contemporary work each year. The Fourth Plinth Commission has created enormous interest and made Trafalgar Square a place where contemporary and traditional sculpture can be in constant dialogue. Another location of public art old and new is the **City of London**, the historic centre of power and commerce; empty at a weekend, one can sculpture-spot at leisure. There is also a trail of modern and contemporary works along the **Thames Path**, most notably near the **SOUTHBANK CENTRE**.

Anish KAPOOR
ArcelorMittal Orbit,
(computer-generated impression) due for completion in 2012
OLYMPIC PARK

Richard WESTMACOTT
Achilles, 1822
HYDE PARK

This colossal bronze of Achilles, the mythological warrior of Homer's *Iliad*, was cast as a tribute to a British war hero, the Duke of Wellington. The metal was taken from melted-down cannons captured from the Duke's enemies. The strident statue was one of a deluge of civic commissions for Westmacott, who finished his career with over 240 monuments to his name.

Robert HOOKE and Christopher WREN
The Monument, 1677
MONUMENT STREET
The Great Fire of 1666 changed the City of London irrevocably, destroying the majority of houses and public buildings. At the flaming urn at its top, Wren and Hooke's Doric memorial column is 61 metres tall, the exact distance between it and the bakery in Pudding Lane where the fire started.

As the burial site for English royalty for over a thousand years, **WESTMINSTER ABBEY** acts as a museum for the fine art of the Medieval funerary monument. Other early memorial works can be seen in the few City of London churches that survived the Great Fire of 1666, such as **St Helen's Bishopsgate**.

The earliest outdoor statues in the City are those of legendary King Lud and his two sons (1586), by the church of St Dunstan-in-the-West on **Fleet Street**. They once adorned Ludgate, one of the gateways that bounded the City, all no longer in existence, except the Wren-designed Temple Bar, relocated today in **Paternoster Square**.

Charles I, the first British monarch to truly understand the power of art, employed French Mannerist Hubert Le Sueur (c 1590–1658) for an equestrian portrait in bronze (1633), now to be found off **Trafalgar Square**, which presents the diminutive king to his people as an armour-clad, chivalric hero. Six years after the Restoration, the 1666 fire destroyed much of London's infrastructure, including its public sculpture. Wren and Robert Hooke (1635–1703) commemorated the fire with the world's largest Roman column, *The Monument* (1677), found at a junction of **Monument Street**. Danish-born Caius Gabriel Cibber (1630–1700) carved the fine allegorical relief *Charles II Directing Aid to London* at its base. Cibber's less accomplished statue of the king (1681) can be seen in **Soho Square Gardens**.

The City's trade associations, the Livery Companies, sponsored many sculptures of Charles II and his father in an effort to ingratiate themselves following the Restoration. Two of the most extravagant (1671) are by the Bernini-influenced John Bushnell (c 1630–1701), in the **Old Bailey**. They were earlier housed in Threadneedle Street's Royal Exchange, where the Companies once attempted a sculptural hall of fame of English royalty; the majority that remain there date to the 19th century. The Companies intended the **Great Hall of Guildhall** as another pantheon of national leaders. One highlight is a highly ambitious, allegorical monument (1782) to statesman William Pitt the Elder, unfortunately damaged by fire; the skills of its sculptor, John Bacon (1740–99), are better preserved in his marble to Thomas Guy (1779) at **Guy's Hospital**.

The exterior reliefs on **ST PAUL'S CATHEDRAL** by Francis Bird (1667–1731) include a dramatic pediment frieze, *The Conversion of St Paul* (1706), exceptional for its time. The statue of Queen Anne outside the church is a later replica of Bird's original. Inside one can enjoy memorials that include Flaxman's paean to Nelson (1818) and a theatrical tribute (1809) to General Abercromby

Alfred GILBERT
Eros, 1893
PICCADILLY CIRCUS
Gilbert's winged statue memorialises child-welfare campaigner Lord Shaftesbury and, as such, represents the god of selfless love, Anteros, rather than of romantic love, Eros. It was titled *The Angel of Christian Charity* to avoid confusion, but *Eros* stuck, as did Victorian criticism of the figure's nudity and small stature.

(1734–1801) that established the reputation of Richard Westmacott (1775–1856), the leading public artist of his day. Westminster Abbey features several of Bird's Baroque sculptures, as well as a marble (1749) to John Campbell, Duke of Argyll by Rococo master Louis-François Roubiliac; works by the Frenchman's Antwerp-born rivals, John Michael Rysbrack (1694–1770) and Peter Scheemakers (1691–1781); and Royal Academicians who made distinguished monuments in a Neoclassical manner, such as Flaxman, Westmacott, Thomas Banks (1735–1805) and Joseph Nollekens (1737–1823).

Westmacott revived bronze casting, beginning with his statue of Francis Russell (1809) in **Russell Square**. His *Achilles* (1822) in **Hyde Park** demonstrates the fashion for antique subjects and styles, as does the park's Grand Entrance, an edifice of arches and columns (1825) whose relief by John Henning (1771–1851) took the Parthenon frieze as a source. Portraitist Francis Chantrey (1781–1841) designed both the equestrian statues of George IV (1830) in Trafalgar Square, and the Duke of Wellington (1844) in front of the **Royal Exchange**; he kept the horses static to 'give a lasting duration to that which is in its nature transitory'.

The most spectacular royal monument is the memorial (1875) to Prince Albert in **Kensington Gardens**, designed by the age's foremost architect, George Gilbert Scott (1811–78). An immense mosaic-embellished canopy encloses the gold-leaf statue, which has a frieze at its base and groups of ancillary sculptures at its corners. The grand memorial (1911) to Queen Victoria by Thomas

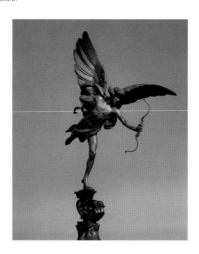

Brock (1847–1922), in front of **BUCKINGHAM PALACE**, is characteristic of New Sculpture, a late Victorian and Edwardian movement that rejected the frozen forms of Neoclassicism for a much more dynamic naturalism. Well-known specimens of the style include *Eros* (1893) in **Piccadilly Circus** by Alfred Gilbert and *Justice* (1906) by Frederick William Pomeroy (1856–1924) above the **Old Bailey**. Colossal bronzes by Pomeroy feature on **Vauxhall Bridge**, together with those by Alfred Drury (1856–1944), a fellow New Sculptor whose work decorates the entrance to the **VICTORIA AND ALBERT MUSEUM (V&A)**.

The fountains that brought fresh drinking water to poor Londoners also offered the opportunity for morally conscious sculpture; influential French artist Jules Dalou (1838–1902) created an example entitled *Charity* (1879) for outside the Royal Exchange. The heroism of working people is celebrated in relief works from this time, such as those of 1893 by Hamo Thornycroft (1850–1925) at the Institute of Chartered Accountants in the City's **Great Swan Alley**. Close to St Paul's in **Postman's Park**, Watts conceived a memorial (1900) to those who sacrificed themselves to save others – each everyday hero is commemorated with a text inscribed on tile. **Highgate** and **Kensal Green cemeteries** also offer an atmospheric insight into how Victorians commemorated their dead.

The Edwardians were shocked when a young Epstein created 18 large nudes (1908) for the facade of Zimbabwe House on **The Strand**. The artist intended to celebrate 'the great primal facts of man and woman'; later owners of the property

Charles Sargeant JAGGER
Royal Artillery Memorial,
1925
HYDE PARK CORNER
The four bronze figures
that flank Jagger's stone
memorial to First World War
artillerymen are sculpted in
a modern Realist manner,
rather than the Romantic
or Classical mode of the
previous century. One
soldier is shown dead,
defying the edict that
British fatalities should
not be shown in war art.

mutilated the works, on the pretext that they were in decay. Rodin was the acceptable face of modern art at the time, and a cast of his masterpiece *The Burghers of Calais* was installed in **Victoria Tower Gardens**, next to Parliament, in 1911. Gill also caused offence with one of his carvings of Shakespeare's Ariel (1932) for **BBC Broadcasting House**, its penis deemed out of proportion (the artist had to reduce it). Both Gill and Epstein, as well as others Modernists such as Moore, contributed reliefs (1928–9) for **55 Broadway**, next to St James's Park.

The reactionary taste of moneyed London was reflected by the choice of William Reid Dick (1879–1961) and Charles Wheeler (1892–1974) for the sculpture for the rebuilt **Bank of England** (1920–45). Both artists were more traditional than Gill and Epstein, although Wheeler's nudes were still considered too brazen. In the context of this conservatism, the *Royal Artillery Memorial* (1925) at **Hyde Park Corner** by Charles Sargeant Jagger (1885–1934) is even more notable, as it broke new ground by representing ordinary soldiers rather than generals. *The Cenotaph* (1920) in **Whitehall** is the city's most famous memorial to the First World War, used to officially commemorate all subsequent conflicts.

In *Time-Life Screen* (1952–3) on **New Bond Street**, Moore's highly abstract sculptures fill four holes cut completely through an architectural

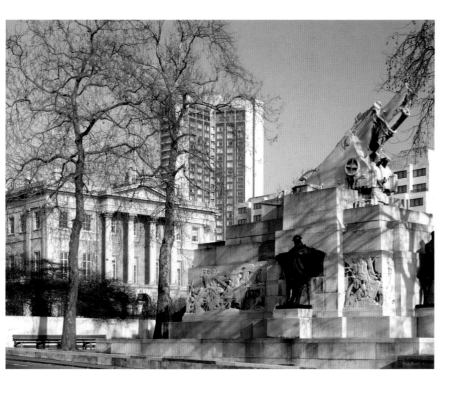

Naum GABO
Revolving Torsion, 1972
ST THOMAS' HOSPITAL
Gabo's riverside kinetic sculpture is a classically Constructivist exploration of space, motion and time. The

work only takes its true shape once it begins to turn, with mesmeric jets of water, and their consequent rainbow effects, becoming part of the work's volume as it rotates.

screen; his intention, never realised, was to set them on revolvable turntables. Other London locations for the sculptor include outside Parliament (*Knife Edge Two Piece*, 1962–5), adjacent to **TATE BRITAIN** (*Locking Piece*, 1963–4) and in the picturesque grounds of **KENWOOD HOUSE** (*Two Piece Reclining Figure No.5*, 1963–4), where one can also picnic next to Barbara Hepworth's *Monolith (Empyrean)* (1953). It rests at

ground level, better able to interact with its environment, like the sculptor's stunning *Single Form (Memorial)* (1961–2) in **Battersea Park**. You are likely to walk past her *Winged Figure* (1961–2), a web-like metal structure on the side of **John Lewis, Oxford Street**.

Moore's *Three Standing Figures* (1947) resides in Battersea Park in the same position that it was shown as part of a 1951 group exhibition of

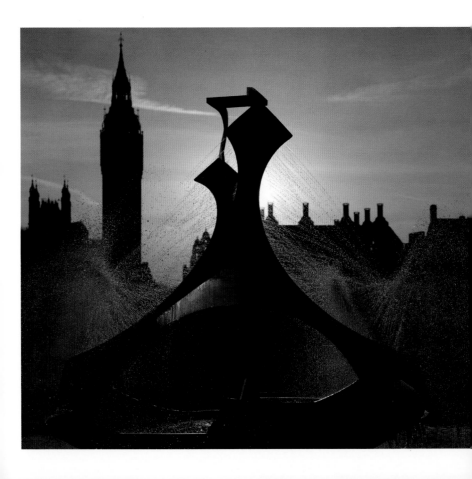

Barbara HEPWORTH
Single Form (Memorial),
1961–2
BATTERSEA PARK
Hepworth was happiest when
her sculpture was sited
outside, believing that 'with
space and the sky above, it
can expand and breathe'.
This eloquent abstract
bronze commemorates her
friend Dag Hammarskjöld,
former Secretary General of
the United Nations.

sculpture staged during the Festival of Britain. As the main site for the festival, the **South Bank** also featured a high density of public art, such as the plaster *London Pride* (1950–1) by Frank Dobson (1886–1963). Dobson's pair of curvaceous faux-Classical females is still situated along the Thames on **Queen's Walk** in the form of a later bronze cast.

This pathway forms an inner-city sculpture trail. The shiny stainless-steel *Zemran* (1971) by William Pye (1938–) and *Arena* (1986), a broken circle of angular concrete by John Maine (1942–), depart from bronze safe in the knowledge that their modern materials will weather just as well. Further towards **Westminster Bridge**, one can enjoy a semi-abstract memorial to the Franco-fighting International Brigade (1985) by Ian Walters (1930–), in **Jubilee Gardens**; on the bridge itself the huge and heroic South Bank Lion (1837) by William Frederick Woodington (1806–93); and after the bridge, in the gardens of **St Thomas' Hospital**, a superb spinning water-sculpture, *Revolving Torsion* (1972) by Belorussian-born Constructivist Naum Gabo. Other artworks spring up on the South Bank on a temporary basis, often in

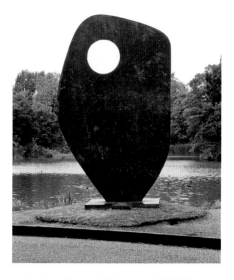

conjunction with an exhibition at the **HAYWARD GALLERY**.

Two memorials to Diana, Princess of Wales (1961–97), show how variously contemporary artists have addressed the commemorative form. In the grounds of the **SERPENTINE GALLERY** is a work comprised of eight benches, a tree-plaque and a carved stone circle by Ian Hamilton Finlay (1925–2006); across the road in Hyde Park is an official memorial, an expansive water feature (2004) by American landscape architect Kathryn Gustafson (1951–). Leading British architect Norman Foster (1935–) designed the National Police Memorial (2005) on **The Mall**, a creeper-covered, rectangular enclosure twinned with a transparent wall of glass, lightly illuminated in blue.

Broadgate in the City sets the standard for public art in commercial developments, with its eclectic international works ranging from Richard

Antony GORMLEY
Quantum Cloud,
(detail) 1999
GREENWICH PENINSULA
Commissioned to mark a new millennium, and situated next to Greenwich's Millennium Dome (now the O2 arena), Gormley's complex steel sculpture was created by aptly futuristic means: computer software self-generated the arrangement of rods, working on the basis of fractals and chaos theory.

Serra's *Fulcrum* (1987), five 15-metre-high plates of rusted steel that lean against each other, to a voluptuous, reclining Venus by Columbian artist Fernando Botero (1932–). Other districts with a public art programme include **Spitalfields** and **Canary Wharf**; one of the best permanent pieces at the latter is a tree of traffic lights on a roundabout by Paris-born artist Pierre Vivant (1952–).

Art on the Underground admirably places works across the city's Tube stations, although they tend to be poster prints that can get lost in the visual noise of an ever-increasing amount of adverts. The most memorable work in the transport system remains Paolozzi's vibrant mosaics (1984) inside **Tottenham Court Road station**. Public art can have a great impact in this kind of context, where one least anticipates it. **Artangel** in particular specialises in commissioning contemporary art works in unlikely locations across the capital. The **FRIEZE ART FAIR** creates an outdoor sculpture area in the southeast corner of **Regent's Park** every October.

The most successful contemporary works play with the expectations of our environment. One stand-out example is the giant plug socket (*c* 2001) by James Glancy Design on the corner of **Soho**'s **Ganton Street**, an absurdist gesture to mark an electricity substation; another is *A Slice of Reality* (2000) by Richard Wilson (1953–) on the foreshore of the Thames at **Greenwich Peninsula**, and in which an ocean-going ship has been vertically sliced so that only a 15 per cent section remains. When you visit Wilson's work, catch nearby *Quantum Cloud* (1999) by Antony Gormley, a 30-metre-high conglomeration of steel rods which, in its centre, compacts into the shape of a man.

Gormley and Tom Phillips (1937–) were among the artists who devised

street furniture (2001–2) for **Bellenden Road, Peckham**, and art and urban design come together even more memorably in Heatherwick's bridge (2004) in **Paddington Basin** that curls up from one side to allow boats to pass. In 2006, Ian Davenport (1966–) transformed the inside of a grimy London tunnel on **Southwark Street**, near Tate Modern, into Britain's largest outdoor painting, covering a 48-metre stretch with vertical lines of bright colour. The work was manufactured to be resistant to graffiti, which is ironic considering that, in the same year, street art started to become highly sought after, especially pieces by its most famous practitioner, Banksy (1974–). Many of his works have been removed or covered over by other graffiti artists, but a few, like *No Ball Games* (2009) on the **Tottenham High Road**, have been preserved behind Perspex.

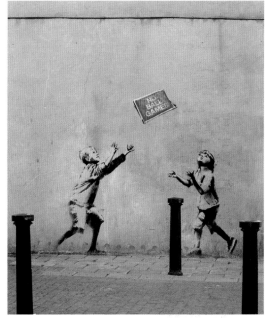

REFERENCE SECTION

MAP 1

MAP 2

MAP 3

INDEX OF ARTISTS

INDEX OF MUSEUMS
& GALLERIES

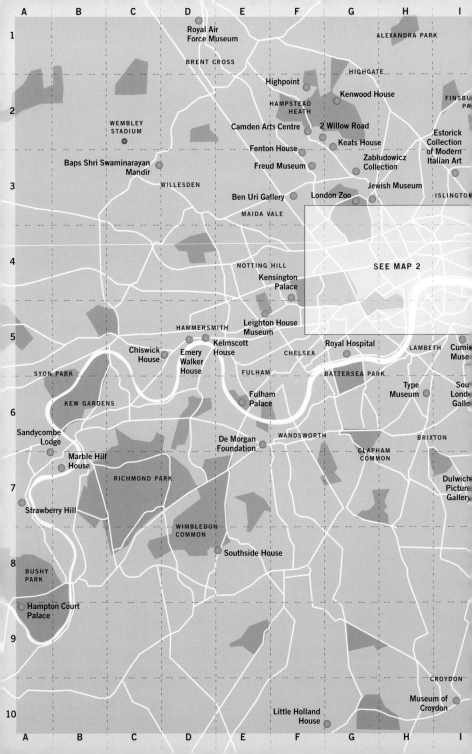

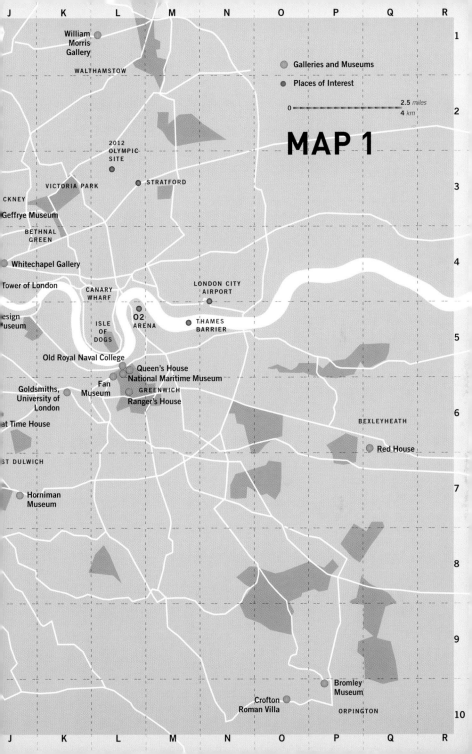

MAP 1

Galleries and Museums

Places of Interest

0 — 2.5 *miles*
4 *km*

1	William Morris Gallery
	WALTHAMSTOW
	2012 OLYMPIC SITE
	VICTORIA PARK
3	STRATFORD
	CKNEY
	Geffrye Museum
	BETHNAL GREEN
4	Whitechapel Gallery
	Tower of London
	CANARY WHARF
	LONDON CITY AIRPORT
	esign useum
	ISLE OF DOGS
	O2 ARENA
5	THAMES BARRIER
	Old Royal Naval College
	Queen's House
	Fan Museum
	National Maritime Museum
	GREENWICH
	Goldsmiths, University of London
	Ranger's House
6	BEXLEYHEATH
	at Time House
	Red House
	ST DULWICH
7	Horniman Museum
8	
9	
	Bromley Museum
	Crofton Roman Villa
10	ORPINGTON

J K L M N O P Q R

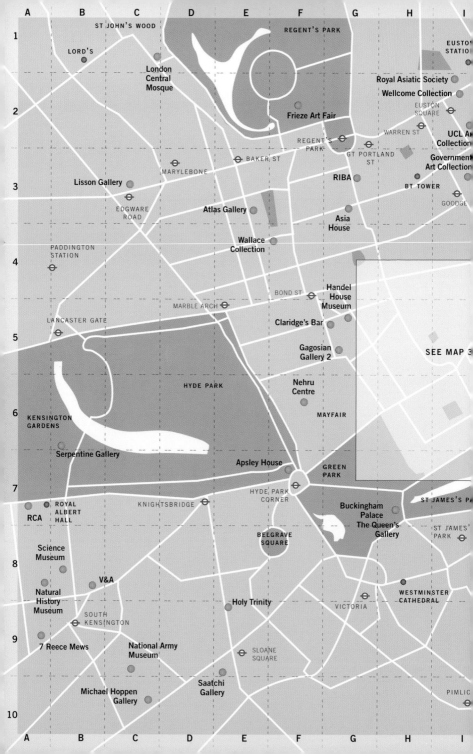

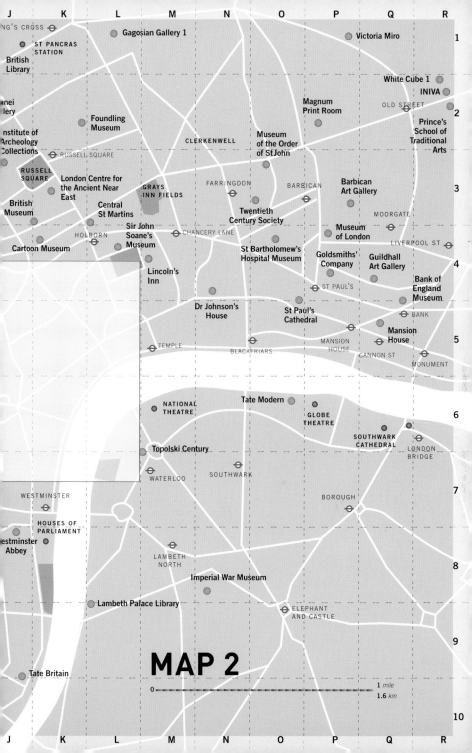

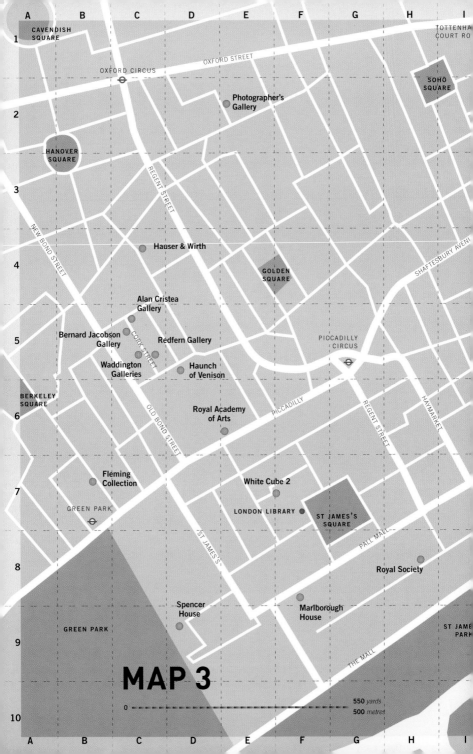

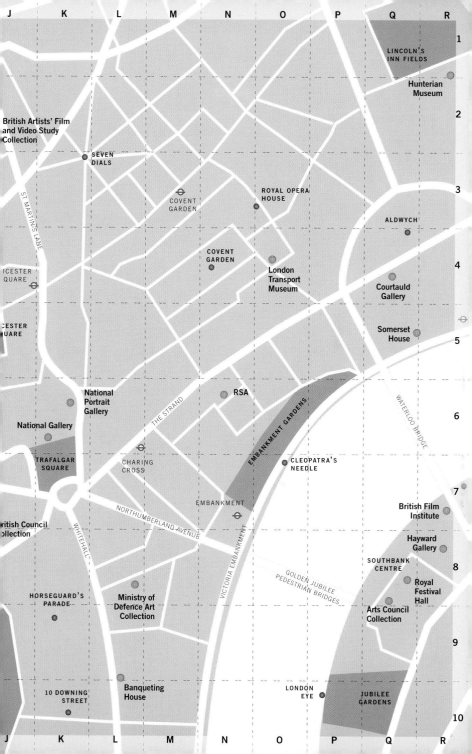

*numbers in **bold** indicate that an artist's work is illustrated on these pages*

Bromley Museum
The Priory, Church Hill,
Orpington, BR6 0HH
+44 [0]1689 873826
www.bromley.gov.uk / leisure/
museums / brommuseum
April – October:
Mo – Sa: 10:00–17:00;
Su & Bank Holidays: 13:00–17:00;
November – March:
Mo – Sa: 10:00–1700
p 46
MAP 1: 10 P

Brunei Gallery
School of Oriental and African
Studies, University of London,
Thornhaugh Street, WC1H 0XG
+44 [0]20 7898 4915
www.soas.ac.uk/gallery
Tu – Sa: 10:30–17:00
pp 27, 36
MAP 2: 2 J

Buckingham Palace
Buckingham Palace, SW1A 1AA
[+44] [0]20 7766 7300
www.royalcollection.org.uk
1 August – 25 September (2011
season):
Daily: 09:45–18:30
pp 46, 62, 106, 210
MAP 2: 7 H

Camden Arts Centre
Arkwright Road, NW3 6DG
+44 [0]20 7472 5500
www.camdenartscentre.org
Tu – Su: 10:00–18:00;
We: 10:00–21:00
p 192
MAP 1: 2 F

Cartoon Museum
35 Little Russell Street, WC1A 2HH
+44 [0]207 580 8155
www.cartoonmuseum.org
Tu – Sa: 10:30–17:30;
Su: 12:00 – 17:30
p 107
MAP 2: 4 K

Central St Martins
Southampton Row, WC1B 4AP
[until Autumn 2011]
+44 [0]20 7514 7000
www.csm.arts.ac.uk
Phone for details
p 184
MAP 2: 3 L

Chiswick House
Burlington Lane, W4 2RP
+44 [0] 20 8995 0508
www.chgt.org.uk
1 – 30 April:
Daily: 10:00–17:00
1 May – 31 Oct:
Su, Mo, Tu, We & Bank
Holidays: 10:00–17:00
pp 81, 100
MAP 1: 5 D

Claridge's Bar
Brook Street, W1K 4HR
+44 [0]207 629 8860
www.claridges.co.uk
Phone for details
p 164
MAP 2: 5 G

Courtauld Gallery
Somerset House, Strand,
WC2R 0RN
+44 [0]20 7848 2526
www.courtauld.ac.uk/gallery
Daily: 10:00–18:00
pp 27, 36, 56, 70, 81, 91, 92, 98,
106, 115, 122, 134, **135**, **136–43**,
146, 154, **164**, 174
MAP 3: 4 Q

Crofton Roman Villa
Crofton Road, Orpington, BR6 8AF
+44 [0]20 8460 1442
www.bromley.gov.uk/leisure/
museums/croftonvilla
April – October:
We & Fr: 10:00–13:00 &
14:00–17:00
Su [1st & 3rd in the month only]:
14:00–17:00
p 46
MAP 1: 10 O

Cuming Museum
Old Walworth Town Hall
151 Walworth Road, SE17 1RY
+44 [0]20 7525 2332
www.southwark.gov.uk/
cumingmuseum
Tu – Sa: 10:00–17:00
p 46
MAP 1: 5 I

De Morgan Foundation
38 West Hill, SW18 1RZ
+44 [0]20 8871 1144
www.demorgan.org.uk
Currently closed to the public; phone
for details
p 129
MAP 1: 6 E

Design Museum
28 Shad Thames, SE1 2YD
+44 [0]870 833 9955
www.designmuseum.org
Daily: 10:00–17:45
pp 155, 164, 193
MAP 1: 5 J

Dr Johnson's House
17 Gough Square, EC4A 3DE
+44 [0]207 353 3745
www.drjohnsonshouse.org
Mo – Sa: 11:00–17:00
[17:30 in summer]
p 107
MAP 2: 4 N

Dulwich Picture Gallery
Gallery Road, SE21 7AD
+44 [0]20 8693 5254
www.dulwichpicturegallery.org.uk
Tu – Fri & Bank Holiday Mondays:
10:00–17:00;
Sa – Su: 11:00–17:00
pp 70, 81, 91, 98, 106, 119
MAP 1: 7 I

Emery Walker House
7 Hammersmith Terrace, W6 9TS
+44 [0]20 8741 4104
www.emerywalker.org.uk
Prebooked tours only: Th, Fr & some
weekends. Book online or phone
p 129
MAP 1: 5 D

Estorick Collection
of Modern Italian Art
39a Canonbury Square, N1 2AN
+44 [0]20 7704 9522
www.estorickcollection.com
We, Fr, Sa: 11:00–18:00;
Th: 11:00–20:00;
Su: 12:00–17:00
pp 155, 165, 174
MAP 1: 3 I

Haunch of Venison
6 Burlington Gardens, W1S 3ET
+44 [0]20 7495 5050
www.haunchofvenison.com
Mo – Fr: 10:00–18:00;
Sa: 10:00–17:00
p 193
MAP 3: 5 D

Hauser & Wirth
23 Savile Row, W1S 2ET
+44 [0]20 7287 2300
www.hauserwirth.com
Tu – Sa: 10:00–18:00
p 193
MAP 3: 4 C

Hayward Gallery
Southbank Centre
Belvedere Road, SE1 8XX
+44 [0]844 875 0073
www.haywardgallery.org.uk
Mo, We, Sa, Su: 10:00–18:00;
Th, Fr: 10:00–20:00
pp 166, 192, 203, 213
MAP 3: 8 R

Highpoint
North Hill, N6 4BA
www.housingprototypes.org/
project?File_No=ENG002
Not open to the public
p 164
MAP 1: 2 F

Holy Trinity Sloane Square
Sloane Street, SW1X 9BZ
+44 [0]20 7730 7270
www.holytrinitysloanesquare.co.uk
Phone for details
p 128
MAP 2: 9 E

Horniman Museum
100 London Rd, SE23 3PQ
+44 [0]20 8699 1872
www.horniman.ac.uk
Daily: 10:30–17:30
p 36
MAP 1: 7 J

Hunterian Museum
The Royal College of Surgeons of
England, 35–43 Lincoln's Inn
Fields, WC2A 3PE
+44 [0]20 7869 6560
www.rcseng.ac.uk/museums
Tu – Sa: 10:00–17:00
p 81
MAP 3: 1 R

Imperial War Museum
Lambeth Road, SE1 6HZ
+44 [0]20 7416 5000
www.iwm.org.uk
Daily: 10:00–18:00
pp 156, **165**, 203
MAP 2: 8 N

**Institute of Archeology Collections
(UCL)**
University College London, 31–34
Gordon Square, WC1H 0PY
+44 [0]20 7679 4789
www.ucl.ac.uk/museums/
archaeology
Phone for an appointment
p 46
MAP 2: 3 J

Institute of Contemporary Arts (ICA)
The Mall, SW1Y 5AH
+44 [0]20 7930 3647
www.ica.org.uk
We: 12:00–23:00;
Th – Sa: 12:00–13:00;
Su: 12:00–21:00
pp 166, 174, 192
MAP 3: 8 I

**Institute of International Visual Arts
(INIVA)**
Rivington Place, EC2A 3BA
+44 [0]20 7729 9616
www.iniva.org
Tu – Fr: 11:00–18:00;
Th: 11:00–21:00;
Sa: 12:00–18:00
p 193
MAP 2: 2 R

Jewish Museum London
Raymond Burton House
129–131 Albert Street, NW1 7NB
+44 [0]20 7284 7384
www.jewishmuseum.org.uk
*Su – Th: 10:00 – 17:00; Fr: 10:00–
14:00*
p 56
MAP 1: 3 G

Keats House
Keats Grove, NW3 2RR
+44 [0]20 7332 3868
www.keatshouse.cityoflondon
.gov.uk
26 April 2010 – October 31 2011:
Tu – Su: 13:00–17:00
1 November 2010 – 25 April 2011:
Fr – Su: 13:00–17:00
p 115
MAP 1: 2 G

Kelmscott House
26 Upper Mall, W6 9TA
+44 [0]20 8741 3735
www.morrissociety.org/
Kelmscott_House.html
Th & Sa: 14:00–17:00
p 129
MAP 1: 5 D

Kensington Palace
Kensington Gardens, W8 4PX
+44 [0]844 482 7777
www.hrp.org.uk/kensingtonpalace
*1 March – 31 October: Daily: 10:00–
18:00*
1 November – 28 February:
Daily: 10:00–17:00
pp 42, 62, 106
MAP 1: 4 F

Kenwood House
Hampstead, NW3 7JR
+44 [0]20 8348 1286,
www.english-heritage.org.uk/
daysout/properties/kenwood-house
Daily: 11:30 –16:00
pp 91, 98, 107, 114, 122, 212
MAP 1: 2G

Lambeth Palace Library
Lambeth Palace Road, SE1 7JU
+44 [0]20 7898 1400
www.lambethpalacelibrary.org
Mo – Fr: 10:00 – 17:00
p 56
MAP 2: 9 L

Leighton House Museum
12 Holland Park Road, W14 8LZ
+44 [0]20 7602 3316
www.rbkc.gov.uk/subsites/
museums/leightonhousemuseum.
aspx
Daily (except Tu): 10:00 to 17:30
pp 27, 129
MAP 1: 5 E

Lincoln's Inn
Lincoln's Inn, WC2A 3TL
+44 [0]20 7405 1393
www.lincolnsinn.org.uk
Phone for details
p 107
MAP 2: 4 M

Reader's Notes

Details:
pp 2–3: William Hogarth, *Marriage A-la Mode: 2, The Tête à Tête*, c 1743 (see p 104)
pp 6–7: David Bomberg, *Racehorses*, 1913 (see p 155)
pp 10–11: Bridget Riley, *Reflection 1*, 1994
pp 14–15: Benin plaque: the Oba with Europeans, Edo peoples (Nigeria), 16th century (see p 32)
pp 60–1: Simon Bening, *Genealogy of Dom Fernando of Portugal*, 1530–4 (see p 80)
pp 132–3: Ernst Ludwig Kirchner, *Bathers at Moritzburg*, 1909/26 (see p 149)

Endpapers:
London map © Iqon Editions

AN IQON BOOK

This book was designed and produced by
Iqon Editions Limited
Sheridan House
112 – 116a Western Road
Hove BN3 1DD

Publisher, concept and direction:
David Breuer

Design and cartography:
Isambard Thomas

Editor and Picture Research:
Caroline Ellerby

Printed in China

First published in the United States
of America in 2011 by
Skira Rizzoli Publications, Inc.
300 Park Avenue South
New York, NY 10010

www.rizzoliusa.com

2011 2012 2013 2014 / 10 9 8 7 6 5 4 3 2 1

ISBN: 978-0-8478-3628-4

Library of Congress Control Number:
2010932873

Cover:
Claude Monet, *The Thames Below
Westminster* (detail), 1871
© National Gallery, London / The Bridgeman
Art Library

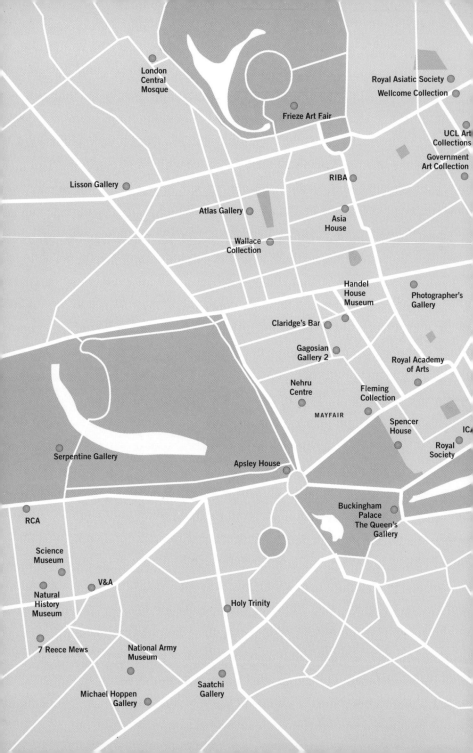